"In the turbulent and uncertain world of today, American civil society is at risk. Too many of our leaders, officials, and fellow workers follow a self-centered philosophy. Richard Cheshire issues a call for more and better leadership, but of a new design. His inspired book offers guidance that can lead us toward a return to civility with the required new model of leadership."

—James M. Greenfield, Association of Fundraising Professionals
2000 Outstanding Fundraising Executive

"Richard Cheshire's book is an inspiring, creative and insightful view of organizations as living organisms. It is very conceptual yet has high visual, concrete impact. It is an enlightening application of the varied laws of nature to our everyday actions."

—Naomi W. Nagaki, Senior Vice President and Chief Analyst of
West Hudson, Inc., management consultants
to medical centers throughout the U.S.

"Who should read this book? Anyone looking to take any sort of leadership role in any aspect of life at any time in their life. In short, anyone! This book is innovative, thought provoking, mind expanding, and makes one think outside the box."

—Patrick Guzman, Guzman & Gray Certified Public Accountants

"Richard Cheshire's book underscores the vital importance of voluntary leadership and provides a paradigm that can guide both individuals and communities to achieve their leadership potential. As I read it, I was reminded of those individuals whose leadership provided a beacon of light during the dark days of the Holocaust. These Holocaust rescuers made the quantum leap that he describes, exhibiting the courage and creativity that saved lives and sustained community."

—Marilyn J. Harran, Stern Chair in Holocaust Education and Director,
Rodgers Center for Holocaust Education, Chapman University

"Cheshire's work is important to the goal of an enlightened society where all are conscious of their creative abilities. A true teacher is not the one with the most knowledge, but the one who awakens more people to their own wisdom. Knowledge can be forgotten, but the wisdom of realizing our true quantum selves is forever. Helping us do so is what Cheshire's work does."

—Terry M. Giles, Attorney and 1994 Award Winner,
Horatio Alger Association of Distinguished Americans

LEADING BY HEART

Through the World of
Quantum Civics

RICHARD D. CHESHIRE, PH.D.

2003 · Fithian Press
Santa Barbara, California

Cover illustration by Stanley Harris
Cover designed by Katheryne Gall

Published by Fithian Press
A division of Daniel and Daniel, Publishers, Inc.
Post Office Box 1525
Santa Barbara, CA 93102
www.danielpublishing.com

LIBRARY OF CONGRESS CATALOGING-IN-PUBLICATION DATA
Cheshire, Richard D., (date)
 Leading by heart : through the world of quantum civics / by Richard D.
Cheshire.
 p. cm.
 ISBN 1-56474-411-6 (pbk. : alk. paper)
 1. Leadership. 2. Nonprofit organizations—Management. 3. Civics. I. Title.
HD57.7 .C487 2003
658.4'092—dc21
 2002008530

To my mother and father,
Catherine Hope Courtenay Chesire
and Leslie Gould Cheshire II,
who were my loving examples.

CONTENTS

10. Can We See It?

List of Figures

FOREWORD

In fifty years plus of ministering to philanthropies, I have counseled many thousands of volunteer leaders at many hundreds of not-for-profit organizations. Most have been colleges, universities, and schools, but many others have been hospitals, museums, and churches located across the United States and occasionally overseas. What follows in this book by Dick Cheshire represents a greatly needed quantum leap in thinking about leading volunteers and voluntary organizations of every type.

Dick began talking with me more than a dozen years ago about an emerging phenomenon he called "civicization." He had in mind the increasing numbers of public-private partnerships being formed as voluntary associations or nonprofit organizations to do what could not be done alone either by the public sector of government or by the private sector of business. He suggested that the so-called nonprofit sector, thought to be the "third sector," was really becoming a higher profile "civic sector," and agreed with me that it was time for it be recognized as the "first sector" of our society and economy. Here is where, as we saw it, joint public-private ventures would function more effectively for the higher purpose of human community on neutral ground. We presented joint papers on the subject at meetings of the Center for Nonprofit Excellence in Denver in 1991, the International Computers and Communications Council in Washington D.C. in 1992, and the International Council for Innovation in Higher Education in Phoenix in 1993.

In 1995, when Dick accepted an appointment as professor of organizational leadership and director of a new Center for Nonprofit Leadership at Chapman University in Orange County, California, I said I

would help in any way I could. As a client of mine more than a decade earlier, Chapman had conducted what was then the most successful small college capital campaign ever run. It was a special place, it was time for change in the world of philanthropy, and I was excited to help Dick develop an alternative to the prevailing model of nonprofit management. During the next five years, I made numerous cross-country trips to meet with him and his outstanding group of professional collaborators. I led sessions in each of the five classes of students who enrolled in his unique, pioneering graduate-level extended education "Executive Certificate in Voluntary Leadership," and became a first-hand witness to their struggles and aspirations.

We placed primary emphasis on the significance of the "new civics" that we saw quietly becoming a major factor in our common future. Business and government, we thought, could not carry on as usual on their own and make a go of it in community matters where the quality of citizenship makes the difference in the fabric of everyday civic life. Nonprofit organizations would have to set up and step up to make more of a difference to sustain their communities. We foresaw a new time when civics would be the field of voluntary action where rights and responsibilities of citizenship are exercised as a duty.

The civic enterprises we had in mind were nonprofit organizations that combine public responsibility and private initiative with volunteer-led governance and voluntary support. The emphasis would combine the civility and citizenship of people working together in community and acting individually with responsibility. Civic enterprise would turn the voluntary actions of free people to the common cause of a free society.

In the new civic sector we saw a pattern evolving from the foundations of the old nonprofit world. The new nonprofit world is actually the loosely structured expression of a civic society. In a civic society, community matters are addressed by citizens taking voluntary action to get beyond the self-serving agendas of special interest lobbies. They are led by the combined stewardship and advocacy of enlightened nonprofit trustees, energetic public administrators, and enterprising private entrepreneurs.

Civicization would enable growing public responsibility without government ownership. Civicization would reduce bureaucracy. Civicization would involve greater community entrepreneurship. Civicization would be an outcome of the need for action with the active support of voluntary efforts by concerned citizens. That's the way we saw it.

Today, we are seeing the effects of high technology discoveries on economics, politics, social systems, and even religion. We are adapting to quantum leap change, that is, to new phenomena produced by transformations that are leading us toward a global society. In the quantum dynamics of the new world in which we live, we are recognizing the end of certainty and the growing interdependence of our everyday lives. We see an increasingly digital society that we hardly understand. And we see the need for high performance organizations of all kinds to lead, not just manage, the changes taking place all about us.

Increasingly, we see degrees of obsolescence in our private and public lives. We face changes in our views affecting who we are, who we want to be, and how to apply our values in all that we do. We are discovering the need to be more intuitively civic-minded.

The changes we see require new visions of short-term and long-term leadership. These visions challenge us to overcome the comfort of the status quo, and enable us to take giant steps toward what should and can be. We are learning to imagine the impossible and strive to make it possible. We are finding that leaders must be builders of an emerging future, not custodians of the status quo, because the status quo guarantees obsolescence. As Dick likes to say, "The status quo is always changing."

In early America, as Alexis de Tocqueville so astutely observed, voluntary associations sprang up for every conceivable purpose. Philanthropy emerged as an increasingly organized activity dedicated to meeting all sorts of needs in a mission of "love for humankind." Philanthropy goes back a long way, with noteworthy instances recorded throughout human history. One of my favorites is the biblical story in the Gospel of Luke which told of the rich people who put their gifts into the treasury and the widow who cast in just two mites (small copper coins), whereupon Jesus said, "Truly I tell you, this poor widow has put in more than all of

them; for all of them have contributed out of their abundance, but she out of her poverty has put in all she has to live on." To this fabled widow, giving was the essence of life itself.

Philanthropies, charities, and voluntary service organizations, as they are called, are tax exempt under the United States Internal Revenue Code, Section 501 (c) in two dozen sub-sections. There are more than two million of them, according to the latest Gammon & Grange, P.C. estimates I have seen, and more than half—those in 501 (c) 3—are not only exempt from certain taxes, but also may receive tax deductible gifts and grants from donors. In the year 2000, an estimated 84 million Americans, about 44 percent of all adults, volunteered their time and talent, worth more than $239 billion. In addition, the latest estimate of annual financial support to these organizations in the year 2000 is $211 billion. The grand total of $450 billion, if it had to be funded by government, would require many times more to meet the same human needs.

Now, those who have learned to think in quantum leaps and who are part of the emerging civicization, are designing their destinies differently. The idea of civicization is being used to transfer certain government operations to non-governmental, not-for-profit, civic organizations which can often manage them more effectively and economically. This leads anew down an old road to adventure that de Tocqueville had observed.

This book is a gigantic, quantum basis for achieving the unprecedented philanthropic visions of living persons who will be inheriting trillions of dollars. The paradigm of quantum civics Dick Cheshire sets forth contains the essential properties of a new leadership process he challenges us to learn. It taps the creative impulses of our minds in a way unlike any other to connect with the dynamics of everyday life that are awaiting a civic leadership revolution now coming into view.

Our global society has enormous hidden resources of quantum energy that can lead change, through quantum leadership that creates a more compassionate society, assisted by quantum philanthropy that supercharges greater productivity. Quantum civics immediately capitalizes on the incredible power lying in the hearts and minds of countless

millions to mobilize their compassion to new heights beginning now.

This book has its origins in an increasing concern about leadership apathy on the volunteer-led governing boards of nonprofit organizations upon which so much more of our future depends. Dick Cheshire caps a remarkable array of career experience with lessons learned and insights about the frontiers where leadership is heading in the 21st century. In my experience, his focus on voluntary leadership really applies to the leadership of every type of organization truly driven by its service to clients. His authentic message can be summed up as the compelling power of leading by heart, that is, from memory, as a habit, with compassion. When we do so, we can crack the genetic code of humanitarian leadership that we need so much in the quantum world of the future. We begin to create the future anew as we absorb and apply the vision contained in this book.

ARTHUR C. FRANTZREB
MCLEAN, VIRGINIA

PREFACE

Leading voluntary action is the American imperative in the aftermath of the horrific events of September 11, 2001. The terrible attacks on that day are a call to arms, not only to all Americans, but to global citizens everywhere. But what should we do? Where may we turn for help?

There is an often overlooked resource that I think distinguishes America in the world. That is the realm of voluntary action and organization in which countless people toil every day in the struggle for humanitarian causes of noble purpose. The volunteers and staff who are responsible for them know about the struggles of leading voluntary action. They have a sense about how different it is from managing a business or administering a public agency.

The aim of this book, which was largely finished before the events of September 11, is to set forth the process of voluntary action as a specialized system with a moral discipline of its own and a leadership technology to be adapted by its users. It proposes no quick fixes, short cuts, or sure solutions. Rather, it lights a way of hope that draws on the experience of generations past as well as discoveries that hold new prospects for the future we increasingly must deal with together. Because peace and freedom are the heart of human values, and because these values govern the challenges of leading voluntary action, I believe we can use them to create more effective responses to the new post-September 11 world.

I have learned from a lot of lucky breaks. From family and friends, teachers and mentors, to associates and acquaintances among the rich and famous as well as the talented and ambitious, I have had more than my

share. I grew up in a suburban village that was ethnically mixed and socio-economically diverse, got a scholarship to college, later another one to graduate school, and married my high school sweetheart. I planned to spend my career in education, one way or another.

My first job was as a full-time teacher and part-time coach at a wealthy suburban high school. A year later, I was recruited by my alma mater to be an assistant to the vice president in charge of development. This meant I was to help him with his responsibilities for college fund raising and its collateral duties in public, alumni, and community relations. The pay wasn't much but a lot better than I was receiving. I began with some trepidation but soon became hooked on living the college life.

Higher education was to be the center of my experience over the next forty years. Eventually I became a chief development officer, earned a Ph.D. in administration, did another tour of duty at my alma mater, and became a college president. After a sabbatical year almost a decade later in which I began a leadership development project that had long been on my mind, I had a succession of assignments at a think tank, a theater project, and another small college which led me, over the last five years before retirement, to devote nearly all my time to the research, development, and teaching of a working model for aspiring leaders of nonprofit organizations where I had spent virtually all my career. The fascinating discoveries I have made since then, in collaboration with an extraordinary group of professional colleagues and participating students, form the basis of this book.

The lessons I learned raising money for colleges provided the foundation. Over all those years I helped raise more than the equivalent of half a billion dollars, the good news, but should have raised the equivalent of at least another half a billion dollars had I managed better than I did, the bad news. In any case, I learned a heck of a lot about what works and why it works from both the successes and the failures. Lesson number one, I learned, was that everything seemed to boil down to the issue of leadership. Now, as most of us know rather painfully perhaps, fund raising for nonprofit causes in general, not just colleges in particular, is not a preferred pursuit of very many. Most people want to avoid it. Yet I

loved it. How strange was my experience?

While I am not sure I have the answer to that, I have come to believe that a major part of the reason for the aversion to fund raising has to do with a lack of experience in leadership that could be trusted. In fund raising, one meets some of the finest people around. One also encounters some of the greatest challenges one could face. People do not give money except for what they believe in, and to be believed, one must be trustworthy. My hope for this book is that it will help develop leadership in which we may place our trust.

Foremost among all the wonderful people who have helped me during the five formative years of the voluntary leadership project are the original collaborating faculty, all practicing professionals in the field, who gave me so much of their time and effort above and beyond anything I expected. Their kind and generous advice, and especially their leadership in the classroom during these years, made an enormous difference. Though they bear no responsibility for the outcomes in this book, their observations have increased my understanding of how voluntary leadership works among the people and organizations they know best.

They are: Arthur C. Frantzreb of McLean, Virginia, my mentor of mentors, consultant in philanthropy, speaker, and author, who in 1998 was named "The Outstanding Spokesperson for Philanthropy of this Half-Century" by The Institute for Charitable Giving; Chris Alexander of Synergy Executive Education in Lake Forest, California, business consultant, author, speaker, radio and television personality; Earl Babbie, professor of sociology at Chapman University and author of the bestselling text, *The Practice of Social Research;* Carol J. Geisbauer, grants writer and trainer in Yorba Linda, California; James M. Greenfield of Newport Beach, California, fund raising practitioner, author, and teacher who was honored by the Association of Fundraising Professionals as "Outstanding Fund Raising Executive" of the year in 2000; Patrick S. Guzman of Long Beach, California, a C.P.A. specializing in nonprofit organizations; George W. Kessinger of Bethesda, Maryland, president and CEO of Goodwill Industries International; and Rochelle S. McReynolds, chief

advancement officer of the Sierra Club in San Francisco.

Former students of mine who have organized the Institute for Voluntary Leadership as a nonprofit organization to carry on the work of the project and who are valuable associates in developing and presenting classroom material are our chair, Patrick S. Melia, former Probe Engineering Team Chief of the Galileo Mission to Jupiter for NASA, and Claudia Rose, our administrator, a consultant, facilitator, author, and speaker; and board members, Tilly Hill, Hank Lamb, Celso C. Morrison, Naomi W. Nagaki, Lucila C. Rivera, James A. Torres, and Jane R. Vogel.

Other exceptional colleagues who have shared insights, taught in class sessions, and/or influenced the direction of my work on the voluntary leadership project are Chapman University professors Marilyn Harran, Allen Levy, Michael W. Martin, J. Mark Maier, and Janell Shearer. In addition, other colleagues, all practicing professionals in the field who have helped lead classes and counseled me in numerous ways are Pat Callahan, Martha Farrington, Vince Fraumeni, Sheryl France-Moran, Tim Geddes, Dennis Johnson, Irene Martinez, Kathleen McNeil, Fritz Mehrtens, Tom Trautwein, and Bill Williams.

Through all the years of this project, as well as long before and after, my most critical and loving supporter has been my wife, Bobbie, without whom I could not have completed this book.

Richard D. Cheshire
Anaheim Hills, California
February 22, 2002

LEADING BY HEART

"In democratic countries the science of associations is the mother science; the progress of all the rest depends upon the progress it has made."
—*Alexis de Tocqueville*

1. TRANSFORMING COMPASSION:

Habits of the Heart

The heart is the prime generator of creative energy, and the most powerful organ of our bodies. Doctors tell us that the heart's electromagnetic force is five thousand times stronger than the brain's. The heart stores and circulates to the rest of the body the creative information-containing energy that defines the essence of who we are as persons. The heart is conductor of the leading force that brings with it the infinite majesty of universal creativity to the finite world of our individual and collective lives on Earth.

From our hearts we receive the creative and compassionate impulses that characterize our voluntary action on behalf of others. When the heart of one is joined with the hearts of many, the power of a person is transformed into the power of a community. The heart of a community unites our collective spirit. It can be stronger than any power that attempts to divide us. So I have found in my experience, and so I have better understood from Paul Pearsall in his wonderful book on *The Heart's Code.*

Leading our lives is leading by heart. This is the way we should lead other people, too, when we have the opportunity to play leading roles. It means that, whether we are leading our own lives or leading others, we are doing so with integrity that is instinctive, from the essence of our being as humans.

Leading by heart means not only leading from memory, but also leading with compassion. It is expressed through core values as a matter of habit. It is powerful enough to affect others, sometimes greatly.

The core values that are so evident when we are leading by heart are part of our human nature, developed over thousands of years as a matter of survival. By nature we are interdependent, collaborative beings with great capacity for caring, especially for those who mean something special to us.

Our challenge is to recognize and draw out this enormous energy that is there in every person. It is a potential that can be tapped like a rich vein of gold. Yes, we do have hearts of gold!

My purpose is to uncover how we may find the leading energy hidden in the hearts of people, all of whom have good embedded in their natures, even where it is not much in evidence. **We will be identifying five leading properties of our nature as habits of the heart,** to use the phrase made famous by Robert Bellah and his associates in their wonderful book of the same title.

These leading properties or habits of the heart must work together, in tandem, to make a good spirit, a strong heart, a sound mind, a healthy body, and plentiful supplies for any organized group of people to succeed. This is especially noticeable in voluntary organizations where it is the customary way of working. It is just as necessary for ultimate success in serving people through organized business and government.

The leading properties are creative information, collaborative participation, visionary cause, concerted strategy, and connecting resources. We will look at what they mean for organizing leadership by examining their inner workings as well as their outer appearances. It helps to think of them as a mixture of widening ripples in a circle of water, rushing currents in a powerful whirlpool, or reverberating shock waves of a sudden explosion, each one of which is a moving combination of force.

The relationships of these properties are very important. When they are recognized and used under the right conditions, they can generate explosive energy in the form of compassion that produces transforming, quantum leap change. This is what we want in order to accom-

plish change of real magnitude, that is, to make a genuine difference in people's lives.

Leading always involves change, or it wouldn't be leading. And change always involves different levels of energy, more or less, whether we are gearing up or gearing down. The kind of change we will be most interested in here is change which increases complexity and consciousness to the higher levels of energy where forces of greater magnitude are found. This is the kind discovered by the extraordinary French priest and paleontologist, Teilhard de Chardin, who wrote of it in his landmark book on *The Phenomenon of Man*.

Significant change such as this requires surges of energy that are sustainable over time. People who experience such change are those who have built capacity. They have developed strength, which is another way of talking about their level of energy.

QUANTUM PRINCIPLES

The elemental, sub-atomic energy levels of physical systems, such as our own, are accurately explained by the principles of quantum physics which describe the principles of how dynamic patterns of motion work. These patterns take the form of radiated energy such as sunlight, condensed energy such as tangible materials, conscious energy such as plants and animals, and self-conscious energy such as human beings. **Everything is energy manifested in one form or another.**

Because energy levels generated by *non*physical systems are also expressed in our cellular memories and body language, I believe we can look to quantum physics for assistance in the assessment of those systems as well. As we shall see, we need not be physicists to learn how these principles work. This is what we are about to do in order to see clearly how we may develop our potential to full capacity.

Quantum principles may apply to individual people as well as organized groups. Most importantly for our purposes here, they **may be used to transform the actions of individual people into the momentum**

of an organized group. This, in fact, is the basis we will be using to describe and interpret the impetus of leadership. **My thesis is that this impetus, or driving force, is the stimulus of organized activity and the foundation of high energy leadership.**

To produce continuous renewal and improvement, this impetus must engage our hearts and minds, as well as our bodies and spirits. This is true individually and organizationally. All must be in alignment, like the wheels on a car, for greatest speed and efficiency. Organizations are like cars in that their hardware is ultimately dependent on their human software in order to function. People are the driving force of both.

For peak performance levels to be reached, the driving force must lead voluntary action in appropriate ways. People follow leads because they wish to get meaningful things done. And they make their choices accordingly.

The moment of choice marks the beginning of creative action. Energy generates as the spirit is moved, the heart is aroused, the mind is alerted, the body responds, and motion occurs. People act creatively in accordance with stimulating visions in their mind's eyes. This is most noticeably true in cases where a vision has particular meaning for them, where it has the character of an imperative that demands attention.

Creative thinking and action work like the processes and systems described by quantum physics and other new sciences, such as chaos theory and complexity science, that manifest in the whole human being. This is the view of Danah Zohar, an American expatriate living in Oxford, England, where she is brilliantly pioneering the application of quantum principles to organizational challenges for global companies. Her book on *Rewiring the Corporate Brain* is especially insightful.

Zohar's research suggests a strong resemblance between consciousness and quantum activity. From basic awareness to high intelligence she detects the spurts and bursts of pulsing energy of quantum origin deep in the hidden ocean of energy that is present everywhere in our universe. Indeed, quantum science tells us that everything in the universe is energy in one form or another, "specific, recognizable patterns of dynamic energy," Zohar explains.

Consciousness is where we search for the essence of self in each person. The essential self in anyone seems to transcend any single point in the brain and seems to be present everywhere all at once throughout the whole person, who is a dynamically conscious or quantum being. Somewhere, somehow, in the consciousness of the self resides the activating spirit that pumps the heart and pulses through the human system.

When we look at our organizations, we must learn to do the same as we do with persons. The corporation as a formal organization is not only a legal person, it is also an assemblage of persons who make it what it is. We must learn to look at organizational consciousness, or corporate culture as we call it, for its true identity. We will return to this later, when we examine the apparent parallels between the human genetic code and a proposed counterpart for the collections of humans we call organizations.

Now, when we turn to the dynamics of our quantum consciousness, we find that there is an inexplicable faith present that carries certain expectations about the future. As this guiding faith in the future matures, it plays a growing role in decisions people make that generate creative energy. This creative energy is manifest in a productive spirit that stimulates the heart, mind, and body to sustaining performance.

The outcome we develop is a quantum intelligence that connects our finite bodies to the infinite universe, to the timeless nonphysical world and the time-bound physical world, simultaneously. In this networked context, human consciousness self-organizes in concert with the synchronous energy-fired vibrations of the various neurons being stimulated within the body. That body could be literally singular or plural, depending on whether we are considering an individual or an organization.

As these vibrations of energy proliferate, they sporadically generate quantum leaps from one kind of reality to another. During one of his visits to Chapman (his book on *Visions* is a provocative discussion of how science will revolutionize the 21st century), nuclear physicist and author Michio Kaku alluded to a fish who jumped out of the fish bowl and for the first time saw the water in which it had been living. In the process, the

fish changed its outlook, which previously had been confined to its home inside the fish bowl. Now, we can raise our sights like Kaku's fish who saw the water from above for the first time, and we can see a new reality that demands greater horizons of thought. When we do so, we must realize that we are going to be making visual and therefore spiritual, mental, and ultimately physical adjustments to unfamiliar territory.

We will not truly understand what we see and, as science has revealed, we should not expect to, because our brains have been wired over ages past for times that were different. We must, therefore, at least at first, simply accept that the new descriptions we find of quantum reality are the most complete that our knowledge and our faith in science have so far advanced. So, we must begin anew. We must make a fresh start.

We must work with this new quantum, creative way of thinking and begin learning new expressions of faith in the future as we get used to this mysteriously dynamic, intelligent, and hospitable universe in which we live. **Increasingly we can imagine how quantum energy is everywhere present, connecting all things and all people at a level beyond and beneath the surface of our everyday capacity to see.**

We come to sense that here, in the quantum connections between the physical and the nonphysical, is where our creative energy originates and later returns. "The Lord God is subtle," Einstein once observed, "but malicious He is not." The quantum self is an excitation, something raised to a higher energy state, of the energy-filled space of the entire universe, as Zohar suggests, like a thought in the mind of God. In this way we are spiritual beings seeking physical expression before we are physical beings seeking spiritual expression. We are both physical and spiritual beings, and it is important to consider this distinction about how they may relate, because it calls attention to our ultimate energy source within.

The transcending quantum world we are now beginning to see has certain characteristics. A quantum is the fixed elemental unit of energy that is found throughout the universe. Quantum theory tells us that energy is the stuff of the universe, and that it is absorbed and radiated not continuously but discontinuously, in multiples of definite indivisible units. Quantum physics, or quantum mechanics, describes the motion of

objects by the principles of quantum theory. **Quantum leaps, or quantum jumps, are sudden alterations in the energy level of atoms and molecules that produce extensive change in the reality of situations.** The quantum world is the world of the very small that penetrates and inhabits everything in the universe.

There are five peculiar features of the quantum world that we will identify because they offer significant windows through which we may see to create our own everyday visions and strategies for the more resourceful futures we desire. These features are ambiguity, self-organization, co-creation, unpredictability, and connectivity. Let's take a closer look at them.

Ambiguity. We live in an indefinite world, hard to pin down except in the minute particulars—not clear, but vague, and often obscure. The famous **uncertainty principle** applies here. It simply says that we may not measure position and momentum simultaneously. It is not possible to know the whole story at any given moment. However, it is possible to know one aspect at a time with clarity. This requires human creativity and puts a premium on the flow of information. It is step one.

Self-organization. We cannot control the way in which things come together. We can only influence them. The **complementarity principle** tells us that all phenomena have an opposite to which they are attached. They are flip sides of a coin. While one side is in view, the other is not, but has only disappeared temporarily. For example, we may reflect that everyone is a child of the universe made in the image of its Creator. Each person, in concert with others, is a participant in the work of the world. Anyone can potentially succeed with a good idea. This is step two.

Co-creation. Our choices as observers make us contributing architects of the world we choose to see. The **observer-participancy principle** tells us that we choose what we wish to observe and then decide what we do in response to our observations. Our visions are paramount. They pull us into the future, as George Land and Beth Jarman point out in their book on *Breakpoint and Beyond*. This "future pull" is even more powerful than the push we feel from the pressures of our past. Vision, and especially a cause, is the key that unlocks the gate. This is step three.

Unpredictability. Within the constraints of inheritance and environment, nothing determines outcomes except for our interplay with possibilities we cannot foresee with precision. The **probability principle** tells us that all phenomena are products of the tendency to exist. This, of course, varies. And it is for the observer to calculate which possibilities are most worth turning into probabilities. Potential is the rule in all situations. The issue is what to make of it. This leads us to form strategies that will help us achieve our goals. This is step four.

Connectivity. Everything and everyone is connected at the subsurface level of quantum occurrences. The **non-locality principle** tells us of the connectivity of all things in a giant web that networks the universe. We are not fixed to a point from which we cannot extricate ourselves. We can reach out anywhere with the necessary effort. This leads to connecting with the necessary resources to sustain ourselves over time, which is step five.

Together, these features describe a strange and unfamiliar world, the quantum world—ambiguous, self-organized, co-created, unpredictable, and connected—which we are just beginning to see as the mother lode for a new technology of high performance leadership.

HIGH TECHNOLOGY REVOLUTION

High technology innovations require a new leadership revolution to keep pace with the rising tides and relentless waves of change. Twentieth century discoveries of what came to be called quantum physics and its engineering in quantum mechanics have been the leading force of the high technology revolution that is sweeping the world and bringing with it the global information age. According to the observations of Jerry Schad in his book on *Physical Science,* **well over half the world's entire economy is now linked to applications of quantum mechanics such as television, CDs, computers, lasers, semi-conductors, super fluids, and fiber optics.**

The quantum effects of these high tech applications are increasingly faster, smarter, smaller, and cheaper than earlier generations of

technology, and therefore, more efficient and productive. They apply the laws of physics to the very small scale of atoms and sub-atomic systems, the inner workings of everything. They are riding the waves of change to transform new possibilities into advancing actualities.

Today we are constantly running risks of being surprised by turbulent, disruptive, and violent change for which we are not prepared. The old ways of managing these frightening new threats simply don't work. New ways have been introduced in the last decade. Pioneers such as Danah Zohar, George Land and Beth Jarman, Margaret Wheatley in *Leadership and the New Science*, and Mark Youngblood in *Life at the Edge of Chaos*, have led the way. Their work involves **solutions that use the quantum energy source of the high tech industrial revolution to fuel a high tech leadership revolution for guiding it according to humane values.** The promise of 21st century change depends both on quantum high technology hardware and on quantum high performance software, that is, the brainpower and mindsets of people who are prepared to lead by heart into the face of unprecedented challenge.

Potentially, leadership is the most powerful force on Earth. That is because it is needed to surmount every challenge, and mediate every complex dilemma among any people at any time for any reason. It is the means that nature has given us to get beyond difficulties and access opportunities both by following leads and leading followers.

TECHNOLOGY OF LEADERSHIP

Quantum physics, and the laws of quantum mechanics to which it gives birth, pervade modern technology, and also a new technology of leadership. If it seems strange to suggest a *technology* of leadership, please note that technology is a method or process used to organize a system for achieving our goals and objectives, what we want or need. That is what leadership does when it is working. **My intention in this book is to indicate a technology of leadership derived from quantum principles that can be dedicated to civic applications by nonprofit organizations or by**

any other organization, company, or agency that is concerned about service to a community, a constituency, a clientele, or to customers of any type.

We will build a prototype to model the leading properties of high performance innovation that serves a community of practice, that is, people who in some way identify themselves by what they do together. Such communities go beyond teams, according to Etienne Wegner and William Snyder, who identify these communities as being at the organizational frontier where community members informally or voluntarily share expertise and passion for a joint enterprise of any type.

Because communities consist of citizens who participate in a civic society by engaging in recognizable patterns of dynamic interaction, we will refer to our prototype as the *quantum civics leadership paradigm*. We will see it as **a prototype according to which any group models community behavior and may be held to account.** This paradigm is built from a set of principles that are native to nonprofit organizations in the civic sector of our society. It develops a terminology for systematically developing communities of practice from very small affinity groups, where everyone knows everyone else, to very large ones where people who do not know one another do hold similar values and therefore share certain identities.

Such groups could be service organizations or associations of helping professionals or groups of almost any kind that are dedicated to a cause greater than their individual members. Business corporations and government agencies of all types gradually are coming to see themselves, in essence, as communities of practice who serve a common purpose that meets the needs of specified groups with particular interests in similar products or services.

Our main focus will be on some two million voluntary organizations, primarily tax-exempt nonprofit corporations recognized by law under the Internal Revenue Service Code Section 501(c)3. We will look at them not as the nonprofit sector or third sector of society as they have been known for a long time. Rather, we will look at them as the *civic sector* or *first sector* home of all people. We will not look at them as taking either

a literal or figurative back seat to business and government. We will look at them as the primary obligation of a civic society where effective communities are necessary to make effective businesses and effective governments, not the other way around.

We will look at civic society as the context in which all people are citizens in practice, if not by law, because they are human and they function as persons all day every day. We will look at all people, then, as the principal assets of any community. And we will look at each person as having equal value morally, legally, *and* practically, as having a potential contribution of importance to make for the common good.

We will look at all communities in the same way. This does not mean, of course, that the market value of some people or communities is not more or less than any other at any given point in time. It does mean that the human value of all is the same at all times. We will, therefore, be looking at human values, such as they are or may be, as paramount, superior to market or political or social or economic or any other values.

The technology of leadership must focus on the human values of a community. Because communities are undergoing such accelerating change more or less everywhere, leading technology must be concerned with leading change. The alternative is to be victimized by change, to be pawns in the grip of forces beyond us, to be powerless in the face of superior force. This would be corruption of the worst sort, corruption of the spirit, the soul, the very essence of what it means to be human, because we would be giving up what distinguishes us in the world.

Change, we now know, comes from shifting patterns of dynamic energy, patterns that can often be recognized and addressed in their own terms. These patterns are themselves constantly changing as they evolve in recognizable patterns. So, we have both change and continuity. This is life as we know it, a truism of the universe.

Now that we have identified quantum energy as the stuff of the universe, developed and evolving in different forms of radiation, condensation, consciousness, and self-consciousness, we must turn to its governing laws to guide us. There are five in particular, those that underlie the peculiar features of the quantum world mentioned earlier, that I believe

we must look at especially closely because of the significance they appear to have as contributing forces to our ultimate quantum reality. The structure of our quantum civics paradigm is built on these five principles. So, we will be devoting our effort to taking a close look at what they are and what they appear to mean.

We will do that with the understanding that our look will be imperfect, our interpretations incomplete, and our implementation of them subject to improvement. We cannot allow these cautions to stop us from looking ahead and going forward. The alternative would be to risk unnecessary disaster. We would then have forfeited the future to our fear of factors beyond us, the height of irresponsibility that could lead to the death of our children and the scorching of Earth itself.

THE QUANTUM CIVICS PARADIGM

Creativity and the innovation it generates are required by the world of change and continuity in which we live. In this world, we are governed by the uncertainty principle of quantum mechanics. This is the experimentally demonstrated principle that it is impossible to measure simultaneously and exactly two related phenomena, such as the position and the momentum of an electron. There are always unseen circumstances outside our focus that prevent complete understanding of our experiences and challenge our faith in the meanings we attach to them.

Innovation is, therefore, essential for survival and success as we adjust our actions and reactions to the ambiguous, indefinite, and often obscure situations we encounter. **We must create the realities we seek from the circumstances we are given or face the realities we are given from the circumstances we have.** Creativity is part of our human nature. We all have a capacity for it and, actually, use it both consciously and unconsciously as we respond to the newness of everyday activities. This is a prime tool of living and leading our lives.

Each of us is a self-conscious information processing system that sorts out the nature and strength of what we encounter. Our capacity to

discern one phenomenon from another is fundamental. As we do so, the information we sense by sight, sound, touch, taste, or smell helps us to shape what we do next. In addition, our intuitive capability, by which we know or learn something without the use of conscious reasoning, is a very powerful sixth sense in our decision making. Information, as Margaret Wheatley has pointed out in her path-breaking book on *Leadership and the New Science*, becomes in-formation, that is, it creates the future toward which it is gravitating.

Creativity, therefore, is indispensable to our futures. It is our response to the question **"Why are we here?"** We are here because we interpret the situations we encounter the way we do. And this drives us to respond to them accordingly. If we want to know where we are coming from, we will ask ourselves that question, and we will sense the answers in our feelings that flow from the question. This will be the beginning of our empowerment. All of which is to explain why creativity is the key. It empowers.

Who, then, will lead us creatively? Anyone, potentially. This is the implication of the complementarity principle. According to this experimentally demonstrated principle, **the human mind is the complement of the cosmos, that is, the missing piece necessary to fully complete it. Without the human mind, there would be no awareness of the cosmos. The two go together, are linked, and do interact.**

Because of this wonderful linkage, the human mind is able to reflect on itself as well as on the cosmos. We are the only self-conscious beings on Earth, and in the universe so far as we know. We are an interdependent part of a greater context. The powerful message of this interdependence is that we need our natural allies to survive and to succeed. Our natural allies are who and what we know best, with which we are most familiar. People. Places. Ideas. Emotions. Sights. Sounds.

Though we don't think about them much, complementary relationships are a staple of every day life. Complements are apparent opposites that are actually partners. Polarities, such as north and south, male and female, good and bad, positive and negative, are examples of the tendency of related phenomena to have contrary powers.

Realizing this partnership of opposites helps us to see relationships we otherwise might not see, to make connections we otherwise might not make, and to consider possibilities we might not otherwise ponder. This could be a decisive advantage for those who aspire to new and better realities for themselves and others. It could lead to innovations that create these realities that would otherwise be impossible to achieve.

The key question we must answer at this stage is **"Who are we?"** That is, when we carefully consider the range of possibilities, both sides of the coin, what is obvious as well as what may be hidden, who would we describe ourselves as being? Whoever will lead innovation will be those who are empowered by having the finest and most timely answers to that question.

Then, what will innovation look like? In Bill Gates' recent book on *Business @ The Speed of Thought*, he directs our attention to developing what he calls a "digital nervous system." This amounts to co-workers being wired together in an electronic network used for faster, better, and cheaper information sharing, a fascinating view of an innovative future.

Here in this book, we will look at what I suggest is **a more fundamental thought, leading at the speed of vision** (or more technically, its velocity which indicates speed in a certain direction). What we see in our mind's eye we become aware of at the speed of light, both physical and nonphysical. It is the light that makes vision possible. Vision comes to us in the light of awareness. It determines what innovation will look like. That is because it is we who decide what to do with our circumstances. When we boil it all down to the core, it is we who choose. We have the responsibility for making and following our choices.

The principle of observer-participancy, as it is called, tells us that the observer of a situation is always a participant in it. The observer decides what to watch and what to make of what he or she sees. An experimenting scientist, for example, decides what measures to make and what instruments to use for making a measurement in testing a particular phenomenon of interest. In doing so, that scientist affects what is likely to be found by narrowing the range of possibilities that could show up in the testing. This is true in all things.

Vision—where the future is leading us. The nature and clarity of the mental pictures we have in our mind's eye guide us, in effect, at the speed of light toward the future that is in store for us. We can change our minds by changing the pictures we prefer to have, and these pictures will pull us toward the future by their powers of attraction. It is important that we paint very clear pictures of these desired futures we seek.

We must have clear and compelling visions before we can have effective strategies to implement them or sufficient resources to support them. In this way, we engage in leading at the speed of vision. The clearer the vision, the more powerful it is. The more powerful it is, the surer its transmission can be. The surer its transmission, the more likely it is to reach those for whom it is intended.

The question we must answer at this stage is **"What do we see?"** How innovation will look depends on that. Our vision is the expression we give to our empowerment.

As soon as we respond to the vision question, we are faced with the strategy question, **"How will we do it?"** How, more specifically, will we make innovation work? Here is where we encounter the probability principle which says, in essence, that potential is the rule. There is a veritable ocean of possibilities out there, so to speak, and we must determine which seem more probable and which less at any given moment.

Probability is a hallmark of science, and of life itself. As an experimentally demonstrated principle, it tells us that all phenomena are the result of various tendencies to exist. In any situation, there are usually a host of different possibilities available from which to choose the steps to take that will get us where we want to go. The issue is how best to use the real potential in a situation to form and enact an effective strategy.

The choices we make will determine the commitments to which we must adhere. These choices and commitments must be closely aligned with the vision we share in order to implement it effectively. Strategy must be highly integrated in all its components in order to be successful.

The control point, paradoxically, is voluntary action. That is, the clearer and more consistently held is the vision, the more closely aligned will be the people taking responsibility for making it happen in their

various activities. **We will make innovation work by converting a clearly shared vision into a tightly aligned strategy that constantly focuses on the changes needed to meet and overcome resistance.**

Finally, where are we most likely to find the pay-off of innovation? Before we can go on to repeat the cycle of innovation, the generic question is **"Where are the rewards?"** We must have the answers at least tentatively in sight before we begin in order to draw them out more effectively as we go. The experimentally demonstrated non-locality principle is our guide at this final stage in the cycle. It says, in effect, that there is a potential connectivity among all things lying beneath the surface of the everyday reality we seek to experience.

The connections we make right from the start establish the bases upon which we can build resourceful relationships that are mutually rewarding. These relationships will produce the revenue and return on investment that sustain our future. Resources come from the people who consider themselves served by what we are offering, by what we are doing, by what they think they are receiving from our efforts.

Where we serve will be where we are served. This could be local or global, regional or national, depending on the nature of the undertaking. Wherever they are, resources always come from people who have them, know how to find them, or how to get them. These resourceful people will invest their time, talent, and treasure in whatever they consider to be worthwhile. They look for prospective results they value. Their investments invariably reflect the interests and the involvement with which they identify most.

VOLUNTARY LEADERSHIP

The most challenging of all forms of leadership is that which is acknowledged to be voluntary, freely chosen by conscious decision, which all leadership actually is, more or less. In the case of voluntary leadership that explicitly involves volunteers in nonprofit voluntary organizations—our focus in this book—leadership shows up and slips away at will. The

first test, therefore, is to get the volunteers coming, and then coming back.

Voluntary leadership in its highest form is transformational, causing a metamorphosis of people to a desired state clearly beyond current reality, which James MacGregor Burns called attention to in his Pulitzer Prize-winning book, *Leadership*. An advanced form of voluntary and transformational leadership is servant leadership, which Robert Greenleaf originated in his exceptional work, *The Servant As Leader*. The best test of servant leadership, he said, is the answer to a single question: "Do those served grow as persons; do they, *while being served*, become healthier, wiser, freer, more autonomous, more likely *themselves* to become servants?"

Voluntary leadership is a matter of heart. It works through compassion. It projects empathy to others as a means of sharing their thoughts and feelings. It converts the passion of excitement one feels into a compassion of caring that is shared. It produces a compelling effect in others. It attracts committed followers who become co-leaders. Compassion becomes the creative energy that drives the intense emotions and strong feelings of the voluntary leadership process.

Voluntary leadership is epitomized by volunteers who participate in the leadership process, such as board members who are actively performing in leading roles. Most especially, voluntary leadership is exemplified by those who champion the cause for which the volunteers are striving. **Volunteer champions are prized above all** for their hard work and unstinting advocacy in the face of indifference or even hostility. It is these stellar persons who make the difference between the ordinary and the extraordinary in the organizations that welcome them.

Voluntary leadership revolves around a cause, actually a visionary cause, that embraces a high moral imperative strong enough to compel the engagement of people who have other things they could be doing with their time. A cause goes beyond the purposefulness of a mission and the excitement of a vision to a compulsion of profound influence. This is particularly true, as Richard Farson explains in *Management of the Absurd*, if it is a lost cause that is involved. When faced with apparent impossibil-

ity, people who feel strongly about a greater good they envisage will move mountains to snatch success from the jaws of failure on its behalf.

Voluntary leadership is implemented through stewardship. The ultimate stewards of voluntary organizations are trustees, members of the governing board who have formal responsibility for its affairs as legal guardians. Trustees are ultimately obligated to determine and carry out the greater interests of the organizations with which they have been entrusted.

The manner in which trustees organize themselves and conduct their business determines the fortunes of the organization they hold in trust. In voluntary organizations, boards of trustees function as if they hold ownership. In fact, they are fiduciaries, persons who hold something in trust for others, and are recognized in law as being guardians of a public trust. They are expected to perform their duties autonomously, and always in ways that are deserving of the faith, confidence, and support of the public.

Voluntary leadership expresses its support through philanthropy, as shown by gifts to the charitable or humanitarian institutions with which it is involved. The idea of philanthropy can be traced to the Greek love of humankind and the desire to help others accordingly. It actually goes back to the origins of the species that have evolved over the millennia through collaboration and mutual assistance. In voluntary organizations, philanthropy takes the form of voluntary service and voluntary support. Trustees are responsible for building philanthropy on their behalf.

As exemplified in tax-exempt 501(c)3 organizations, voluntary leadership runs on compassion, by volunteers, for a cause, through stewardship, with the use of philanthropy. These distinctions are unique to nonprofits in the civic sector of our society. They are also adaptable by businesses and governments that genuinely define themselves by the services they provide to their private sector customers and their public sector constituents.

NEW THINKING

In the 1965 annual report of the Carnegie Corporation, one of the world's leading foundations, its widely respected president John Gardner strikingly described what he called the *Anti-Leadership Vaccine* that so often thwarted resolution of complex public issues in the face of demands for stronger leadership. People, he concluded, were of two minds about leadership. They did not like what they saw of it, yet they instinctively seemed to need it. Since then, the vast leadership crisis that Gardner observed then pervading our society has triggered an avalanche of research and a revolution in leadership that has begun, but only begun, to change the way our world is run. We have a long way to go.

In a 1989 issue of the *Harvard Business Review*, elder statesman of management Peter Drucker boldly declared that "Our nonprofit organizations are becoming America's management leaders. In two areas, strategy and the effectiveness of the board, they are practicing what most American businesses only preach. And in the most crucial area—the motivation and productivity of knowledge workers—they are truly pioneers, working out the policies and practices that corporations will have to learn tomorrow." Since then, there has been a perceptible gravitation of interest toward the lessons in leadership that nonprofits offer.

More recently there was a startling report from Harvard University on the January 6, 2000 *Wall Street Journal* front page that "Nonprofit managers may teach a thing or two to corporate counterparts. The people who run charities and other nonprofits," it said, "have a long history of managing under uncertain conditions, satisfying multiple stakeholders, building passionate work forces and developing nonfinancial measurement of goals—the kind of issues that are becoming hot topics in corporate management."

Spokesperson Judith Kidd reported that "getting more people to think about 'nonquantifiable' issues is key. So is building viewpoints of many stakeholders into a company's strategic plan." The report added that "nonprofits excel at finding the next generation of leaders."

The 1965 Carnegie alert and the Harvard reports of 1989 and

2000 have helped call attention to a surprising new direction for leadership in general. No sector of society is immune from a pervasive leadership disease that appears to have crept into our everyday affairs as a cancer that erodes the capacity of a body to function and eventually takes its life away. This disease seems to have become increasingly evident as industrial age management has fallen short of final answers to information age issues. These issues more and more appear to revolve around the orientation of "knowledge workers," who prefer leadership in their search for answers.

Knowledge workers, whose presence in the new economy is growing every day, recognize themselves by what they know. They work with whom they like and whose capabilities they respect. When they choose a direction to follow, their actions are their own. They identify with the causes they know. They take responsibility for what they do. They serve purposes which they believe are deserving of their support. They act, in short, very much like the volunteer champions of nonprofit organizations in the civic sector.

Just think of the implications. What is the proper relationship between the authority of management and the influence of leadership? We have now begun to distinguish the two as complements in a natural arrangement for getting things done and for finding new paths when old ones fail. I believe that the new leadership we now are pursuing is the "mother science," in de Tocqueville's ringing words of years ago, upon which all the rest depends. Leadership is not an extension of executive management, but a discipline in its own right with fundamental properties we must understand and respect. They come from lessons we learn as we examine how to lead healthy lives and, therefore, how to lead healthy organizations. This amounts to leading by heart, and invites us into the world of quantum civics where we will meet the 21st century challenges we all face.

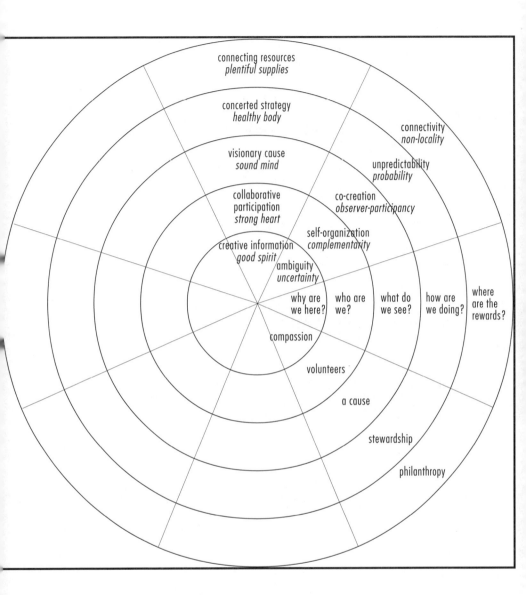

FIGURE 1: QUANTUM CIVICS PARADIGM A

Start reading from the north axis and read from the center toward the circumference, then proceed in like manner clockwise around the concentric circles to identify: (1) leading properties and civic values, (2) peculiar features and quantum principles, (3) key questions, and (4) distinctive aspects of foluntary leadership.

"Our nonprofit organizations are becoming
America's management leaders."
—*Peter Drucker*

2. LEADING FORCE:

Dynamics of a World in Motion

It was January, 1984, and Jesse Jackson was on campus at the University of Tampa for a political speech in the midst of the Presidential primary season. The student political caucus had asked me, as president of the university, to introduce any candidates they could get, and they had invited them all. How could I say no? Besides, my mother was down for a visit and I wanted her to come. I said "Mom, I know you don't care for Jesse's politics, but when will you ever get to see me introduce a Presidential candidate again? I really want to do a good job of it because he's put so much emphasis on education."

She agreed to come. My wife Bobbie was coming, and so my mother came along with her. When the time came, Jesse and I strode out onto the platform before a thousand wildly enthusiastic Tampa people. I'm not sure how many UT students. I went immediately to the podium and gave Jesse the very best introduction I could. The crowd loved it and so apparently did Jesse. When he reached the mic, he was all smiles and said: "Mr. President, that was one fine introduction. You know, I haven't yet selected my vice presidential running mate and I thought you would be an outstanding one." Pandemonium broke loose. I was hilarious. The crowd calmed down and he went into his speech. Of course, it was never mentioned again.

Afterward, when I saw mom, I asked her what she thought of Jesse. "Not bad," she said, "better than I thought." Well, she was of course using what I'll call "mom's test." What would something mean for her son? We should remember "mom's test" because it really means for us that leadership is all about what it means for those whom we care most about. Jesse then and now is magnetic because he knows how to get to people. He knows you get to them through what they love unless you are going through the back door to what they don't. Real leadership, as I see it, always uses "mom's test"; it plays to the good that people see. Momentum comes with the perception of something better.

A DYNAMIC COMBINATION OF INFLUENCES

As I have come to know it, leading involves a dynamic combination of influences. The idea of a *leading force* represents the potency of this combination. The potency or strength of this combination of influences is reflected in its active energy level. In a leadership situation, the potential energy of an assembled body of people is converted into the kinetic energy the body is capable of generating. The definition of leadership I am proposing in this book is based on the driving force of impetus, a dynamic combination of influences. In this definition, **leadership is the impetus that transforms the actions of individual people into the momentum of a unified group.** We will use this definition to explore the possibilities of joining the leading properties of the quantum civics paradigm in a combination that, under the right conditions, has the potential of producing quantum leap change of extraordinary proportions.

The leading force is a uniquely powerful force that is reflected in the energy level of people who are moved to action and who cohere into a group as a result of a leadership process. The leading force is represented by those who are playing roles that help to lead a group on the way to somewhere.

The "somewhere" toward which the leading force would have us go, in one way or another, is toward a greater realization of our organized

possibilities as members of human communities. The leading force, therefore, opposes any abuse of power that subverts human creativity, suppresses the release of human possibilities, or corrupts the ongoing evolution of humankind toward greater prosperity and peace.

Volunteer champions are the new fighters who are most important to the future of humankind. They are not the soldiers we salute, important as they are in armed conflict following attack. Rather, they are the collaborators willing to fight for greater community at local and global scales who help avoid armed conflict by working for the prosperity and peace that lessens the prospect of conflict in the first place. The new warriors are volunteer champions, fighters for the visionary causes in which we pursue a new leadership ethic—the greatest good for the largest number over the longest period with the least use of precious resources. This is where the heart of our humanity belongs.

At heart, I believe the impetus of leadership is a spiritual phenomenon in which a release of energy initiates a physical force. The magnitude of this energy force determines the capacity of leadership for attracting followers. In this way, leadership transposes the powers of electromagnetic energy from the natural forces of the universe into the social forces of human community.

Leadership can be initiated by anyone who is willing to go first. It is most often and effectively enacted by capable practitioners who have an understanding of how and why it works. In the new complexities of the information age, leadership has become as important as management became for the industrial age. The emerging paradigm for 21st century leadership is exemplified by service-oriented voluntary organizations dedicated to a cause and supported by philanthropy, that is, by acts of benevolence to help humankind. This new voluntary leadership paradigm represents a prospective frontier for leading organizations of all types in every sphere of human activity. Greed will always be with us, but not as a model of the future to be emulated. Generosity has a stronger link to survival and success, as we will see. Generosity is at the heart of the matter.

Leadership can now be seen as more than just an art form that has grown out of the cutting edge of management. **Leadership is a new**

science with radical alternatives for leading change in all organizations, however formally or informally they may work. **This new science is** *quantum civics*, the new civics that applies to the actions of citizens in civic projects, organizations and institutions where volunteers play critical roles. Just as political science, management science, and military science have become disciplines for study and research, so must leadership science. All are social sciences dealing with the interactions of people in different situations.

Quantum civics is formulated on the premise that, whatever the influences at play, people ultimately are free to choose, voluntarily decide, what they will do as ordinary citizens. Ultimately, people rely on their humanity, or lack of it, in making decisions, and express that humanity in some form as citizens, as people who live and work in communities. Their communities may be clusters of family, neighbors, friends, associates, but eventually touch larger, more complex communities that cross the boundaries of the smaller ones. In the end, the smaller communities are likely to need one or more of the larger communities in order to achieve their missions. At that point, they take on the characteristics of civic organization.

Where private sector business, public sector government, and voluntary organizations encounter one another is what I believe is the *civic sector*, **and I believe this is actually the first sector of both our society and our economy because it is where people and organizations of all types ultimately live.** I believe it is imperative that we begin thinking of civic life as our first sector because the moral and political order of society depends on it. As Heinz Pagels observed in *The Cosmic Code*: "The challenge to our civilization which has come from our knowledge of the cosmic energies that fuel the stars, the movement of light and electrons through matter, the intricate molecular order which is the biological basis of life, must be met by the creation of a moral and political order which will accommodate these forces or we will be destroyed." Order with a heart. Now more so than ever as our global information society becomes increasingly interconnected.

In the civic society I am suggesting, the paramount challenges to

leadership are situations in which the decisions of prospective followers are marked by a high degree of opportunity to choose. Only the most compelling messages attract significant attention and support. Because *quantum civics is about creating kinetic energy out of potential energy, about doing so by generating the impetus that transforms individual actions into group momentum,* its major task is to develop a shared vision with which people will choose to associate themselves. The magnetism of the message will engender its momentum. A healthy heart pumps hearty life into otherwise lifeless bodies.

Seen in this way, leadership literally cannot be a commanding force if it does not come from within. Because the follower attracted to leadership has a choice not to follow, the capacity to control and, therefore, to command is removed. Leadership is not about imposing one's will upon others. Leadership is about inspiring others to act upon their own will. Dictatorial action that leaves no role for choice is not leadership; it is autocratic management whether exercised by benevolent despots or crazed tyrants.

TRANSCENDING DYNAMICS

Leadership is the single most powerful combination of forces available to meet the multiple challenges facing the human community today. I believe this is so because acts of leadership are the human force that moves all other forces. The heart is our life beat, and the mind is our creative direction that comes from it. Our spirits lift us to action. Leadership is a spiritual act in that the excitement produced by our states of mind is catching, infectious, contagious, and inspirational. Leadership is the indomitable spirit that moves people at the micro-interpersonal level of grassroots organization to the macro-international levels of global organization. It is as true in small families and neighborhoods as it is in whole nations and cultures.

As a spiritual act, leadership ultimately comes from transcending dynamics lying outside the boundaries of the physical universe which, in

the West, we usually refer to as God, the Creator. The timeless power of this nonphysical, supernatural being lies in the ineffable connection with all of humanity, all of life, and all phenomena in the physical universe. As the source of our spiritual intelligence, western thought sees God as creator and sustainer of all. Eastern thought contains related concepts using different terms and expressions that produce values and practices complementary with those in the West, and vice versa.

In both East and West, leadership is critical to everything else because it is transcending, surpassing, exceeding, above and beyond what we are used to dealing with in our everyday lives. It mobilizes people, gets them to work together on important tasks, and persuades them to put aside selfish notions for common visions. In its highest form, it is caring and collaborative. No purpose requiring much persistence and many people can succeed without leadership. The greater and more complex the nature of the purpose, the amount of persistence, and the talents of the people, the greater is the quality of leadership that will be necessary for success.

But, the current practice of leadership generally is not up to these challenges. Not at any level nor in any sphere is leadership commonly and consistently succeeding. Not yet. **Of all the major challenges facing our world today, leadership itself is the first challenge because it is the gateway to addressing all the other challenges**. Every other challenge we face needs leadership in some form and degree to succeed.

At a Chapman University symposium in 1996, the Center for Strategic & International Studies of Washington, D.C., where I served in the late eighties, presented an analysis of the global future in which it identified seven revolutions that are leading to a world of either peril or promise by the year 2020, depending on the leadership of nation states. These **seven revolutions** were identified in the realms of demographics, environment, technology, knowledge, economics, politics, and war. They constitute the increasingly powerful combination of factors that make up the greater global information revolution that is driving our transformation from the ebbing industrial age.

All together, as I see it, these seven revolutions strongly **imply the**

need for an eighth revolution, a leadership revolution able to address the challenges of the other seven. This view of a radically changing world is, in essence, a view of revolutionary times that require new thinking for survival and success of the species.

For these revolutionary times, leadership needs a new identity beyond the common hunch and crunch gut-level practice that is poorly informed about the art of leadership and uninformed about the science of leadership. The leadership theory on which we are operating today approaches leadership, in effect, as an exercise of power. People with power dominate others without it by using techniques of managed leadership based on their social, economic, and political ideologies, not on a grand vision of humankind.

More often than we realize, this brushes the edge of tyranny instead of embracing the heart of leadership. Leadership without heart is not really leadership at all. Von Foerster's Theorem, as quoted by Danah Zohar, sums up the point very well: "The more rigidly connected are the elements of a system, the less influence they will have on the system as a whole. The more rigid the connections, the more each element of the system will exhibit a greater degree of 'alienation' from the whole." This is an important lesson to be learned by everyone who aspires to lead any kind of organization, small or large.

Leadership is more than an art exercised by powerful people, even when it is done well. Leadership is also a science that may be exercised by anyone. **Although leadership is a science in its infancy, it is nonetheless a science that frames the choices of creative technique, and disciplines our implementation of these choices. It is a science of our collective hearts.**

As I see it, leadership is not a transactional force in which decisions are made that simply rearrange the way things already are and do not change the order of magnitude of the total energy available for improving a situation. Leadership is more than cutting deals, more than slicing financial pies, more than dividing up the spoils. Leadership transcends the dimensions of the present and changes these dimensions to something different based on a reconsideration of the way things are. While leadership is a persuasive influence that may be ignored, it also observes

certain laws of the universe that may not be ignored without risk of failure.

QUANTUM DYNAMICS

The frontiers of leadership science lie in exploring and developing the energy levels of organized groups. We may begin by thinking of an organized group as a system of energy, that is, as an arrangement of phenomena so interrelated they form a unity, or organic whole with its own set of system dynamics. This is what Barry Oshry shows us in his book, *Seeing Systems,* that, as he says, unlock the mysteries of organizational life.

In the case of leadership, the organized group is human and forms a social system. All systems, including social systems, are like flexible organic machines with hearts. They run on energy. Energy is literally the capacity for doing work, or in a word, it is strength. An energy level is a state in which the energy of a physical system is well defined by quantum mechanics. By focusing on energy, we can more effectively create new strength that lasts.

Quantum mechanics describes the motion of objects according to the laws of the universe and the forces of nature in which energy is absorbed and radiated only in multiples of definite, indivisible units called quanta. **A quantum is the fixed elemental unit of energy that exists everywhere in the universe as a dynamic particle-wave pattern from which all other phenomena arise.** This miniscule energy "chip" throbs like a pulse in a quantum beat throughout the universe, including throughout you and me. As such, quantum energy is the "stuff" of the universe through which the electromagnetic current of creative energy vibrates. The strength of an organized system can be measured by the energy level of creative information being generated in accord with the dynamics of quantum mechanics.

Leadership is activated by the quantum dynamics of a universal energy "chip," present in all beings and in all things, that is analogous to a computer memory chip. How may we plug into its energy? We may do

so when we turn our mind's eye to the inner workings of the infinite, invisible universe which mysteriously envelops us and influences us. This sets us in motion on a journey into undocumented territory where the physical and non-physical worlds meet across many boundaries.

Only recently have adventurous pioneers in the world of organizational management and leadership—I am thinking particularly of Danah Zohar and Margaret Wheatley—begun to probe the workings of nature itself for answers to vexing questions about why social systems so frequently fail and at such great cost. They have discovered a gold mine in the branch of physics known as quantum mechanics.

The rise of 20th century high technology traces its origins to the high energy dynamics uncovered by quantum mechanics. High technology has relentlessly accelerated the pace of change to unprecedented levels of complexity with no sign of a slowdown soon. What if the same source of energy that has made possible the high technology industry could be tapped for the high performance organization necessary to lead such industry? In the global environment of today, no organization can escape the influence of the high technology world. What if we converted quantum energy to develop organic systems for quantum-powered organizations? This is the way organizational pioneers are beginning to think and act. The implications for our future are enormous.

In adapting quantum theory to the leadership of organizations, we need to think differently about the people with whom we are working. We must change the way we work with them. And we must make a long-term commitment to doing so. Only then will our efforts begin changing the culture of our organizations so that they may emerge as collaborative communities, communities that have the strength and staying power to help lead us into the new millennium. Communities with heart.

People are the self-conscious leaders of the universe. They work together in groups that are, in essence, self-propelling and self-organizing. They are co-led by volunteer champions who emerge from their numbers. In physical terms, group leadership is, quite literally, comprised of invisible electromagnetic force fields in which energy is radiated in waves. This is quite different from the material force of condensed energy

that is leveraged by visible mass and exercised by muscle.

Leadership is not really a material force in the sense we have thought. It does not push people around. It does not manipulate people as if they are puppets on strings. It does not micro-manage. It does not pull rank. When decisions are made in those ways, we are experiencing the authoritative relationship of management rather than the influencing relationship of leadership. Management implements. Leadership inspires. There is an everlasting symbiotic relationship between the two.

CIVIC DYNAMICS

When we talk about civics we generally mean a branch of the social sciences that deals with the rights and responsibilities of citizenship. When we think about civic (or civil) rights and responsibilities, we usually are thinking about the freedom enjoyed by citizens and the duty they have to preserve it. In civic affairs, we are concerned about what is going on in our communities at the grassroots level primarily, but also at global levels wherever grassroots issues are touched by great boundary-crossing challenges. As the saying goes: "Think globally. Act locally." Or, as politicians say, "All politics is local."

As an invited participant at California's 1998 Civic Entrepreneurship Summit held in San Diego and sponsored by The James Irvine Foundation, I had the opportunity to meet with many leaders of a grassroots movement of collaborative regional initiatives focusing on how "civic entrepreneurs" are building "economic communities" to help everyone. Civic entrepreneurs are people from all sectors and walks of life who join with others, as volunteers, to work for better communities in which people may lead more prosperous lives. Economic communities are those regions or sub-regions where the spirit of enterprise and the spirit of compassion are united through the efforts of collaborating citizens working through a variety of regionally-based community organizations.

The civic entrepreneurship movement in California is no isolated case. It is part of a wider movement spreading across America and the

world that recognizes both the potentials and limitations of big business and big government, and is placing increasing emphasis on various kinds of public-private partnerships in the form of voluntary organizations. Private enterprise and public enterprise are now joined by civic enterprise. Businesses and governments are awakening to the necessity for high energy voluntary organizations and institutions to bridge the gaps between what business and government can do and what our communities need all across the world.

Already at work, and toiling mightily to fill these gaps, is a huge aggregation of volunteer-led not-for-profit organizations, more than two million nation-wide. These organizations are mission driven and are required to plow any funds they generate back into the work they do for others. More than half of them are qualified by the Internal Revenue Service to receive tax-deductible gifts. They benefit from the volunteered services of slightly less than half of all American adults, estimated to be about 84 million people, whose time was worth about $239 billion at last count. In addition, the total of voluntary support from individuals, corporations, and foundations for nonprofit organizations was estimated to be $211 billion in the year 2000.

When the value of this time, talent and treasure is put together with those of the professionals hired to staff these organizations, we are looking at the equivalent of about ten per cent of the $9 trillion-plus American economy in 2000. This investment is, in turn, reaching almost every household in the country in one or more ways year in and year out.

What in recent decades we have come to call the nonprofit sector or third sector of our economy and society is now emerging into a more critical role, but not as the nonprofit or third sector. The sector self-generates half or more of all its revenues as earned income, or payments for services rendered. More than half the rest comes from government contracts for specified projects. The remainder comes from voluntary contributions for both general and specific purposes. If the value of volunteered services were included as revenue, the total value of volunteered time and treasure would nearly equal that of all earned income.

However, the term "nonprofit" is to most people a non-starter. It is

non-descriptive. It is negative. It presumes to say something important about what an organization is *not* without suggesting something important about what it *is*. Worse still, it is actually false in that organizations retain small surpluses in good years that they use to bolster their programs, and increasing numbers of them undertake related commercial enterprises wherever they can for the same reason. Use of the term nonprofit means that no staff person or volunteer may personally profit from the work of the organization; all surpluses must be turned back into its work.

In any case, the people of this sector are the *foundation not the fringe* of the private and public sectors. Without the civic responsibility they take, the creative strength of local community and global society falters. Volunteer champions lead the voluntary community services that are essential for higher quality of life everywhere, and the absence of such services is a killer for attracting and holding the top talent needed for success of all kinds.

Voluntary organizations must increasingly compete with other priorities in people's lives that cut across the old boundaries of family, business, and community life. Voluntary organizations must compete more realistically and effectively in order to be recognized by the public at large for what they actually are, organizations dedicated to improving the lives of people who need extra help to achieve a better quality of life. Voluntary organizations are dedicated to civic purposes in support of a civic society without which democratic capitalism would die. They are the heart of our lives together.

We are witnessing the emergence of a first sector as the civic sector, dedicated to the quality of citizenship through volunteer-led organized groups. Alms-seeking charities are evolving into philanthropy-seeking nonprofit corporations. This was a major point made to each of my Chapman classes by George Kessinger, then president and CEO of Goodwill Industries in Orange County, California, and now president and CEO of Goodwill Industries International in Bethesda, Maryland. In doing so, amateur-run charities seeking alms are growing into professionally-managed philanthropies seeking investment. Like Goodwill

Industries in its important work on behalf of people with disabilities, they are the new volunteer-led nonprofit organizations of the future.

Nonprofit organizations are civic enterprises. They are led by volunteers serving on boards of trustees. They have a multiplicity of purposes. None of them is there to make a profit, though creating profitable services that may be turned back into their charitable purposes may be an important part of what they do. None of them is there to wield partisan power, though they may help further a nonpartisan purpose. All of them are there to help build greater community.

No business and no government can succeed without the prior existence of a certain critical mass of community-minded people who care about the bigger picture. A world class community is not possible without a world class economy. Neither is possible without world class education, health care, and social services. These are the observations of increasing numbers of civic-minded people.

These observations are well illustrated by Douglas Henton, John Melville and Kimberly Walesh in their book, *Grassroots Leaders for a New Economy,* that explains how civic entrepreneurs are building prosperous communities across the country and overseas. For a variety of reasons, activists from business, government, education, and voluntary organizations are stepping forward with initiatives that would change unsatisfactory circumstances into community magnets.

The assertiveness and affirmations of these civic entrepreneurs are all the testimony we need to recognize the civic sector as the first sector of a society on the march toward a better future. The sooner we realize this, the sooner we can begin reorganizing ourselves around this realization. It will lift our sights to new horizons that require greater expectations, unprecedented alliances, and prosperity for those now left out. It will lead us to the heart of what keeps us alive and healthy in our communities.

Although we do not think of him as a civic entrepreneur, we do well to consider the leading message attributed to Jesus of Nazareth a long time ago. "The first shall be last, and the last shall be first," he said in the Gospel according to Mark 9:35-37. "Whoever would become the greatest must become the least." This is an admonition to those who

would see beyond immediate gratification to long-term impact, whatever one's philosophical or spiritual foundation.

In leadership science, expressed in this book as quantum civics, we focus on the quantum energy generated by people acting as volunteers, as citizens who are engaged in community action, or civic affairs, regardless of what their particular roles may be at a given moment. When we identify this new science as quantum civics, we identify a new field in the making that enables practitioners to profile leadership in demonstrable forms as living energy. *The living energy of quantum civics is the impetus for transforming the potential energy of citizens getting together into the kinetic energy of a community at work.*

To understand leadership in this way, that is, as a field of social science, we must turn to the new physics of the 20th century to discover the mysterious source of leadership energy. There we find Einstein's universe of insights about energy-matter convertibility in relativity theory as well as the laws of quantum mechanics that explain interactions of energy in motion.

We learn that matter is made of tiny molecules, which in turn are made of tinier atoms and still tinier sub-atomic units of energy. And we see that matter is actually energy in condensed form, as Einstein showed in his famous equation, $E=mc^2$, which demonstrates that energy is equal to mass times the velocity of light squared. By this universal law of physical creation, very small mass can be transformed into very great energy and very great energy into very small mass. There are significant implications here for converting a leading force into great momentum that we will be pursuing as we travel on toward a deeper understanding of how leadership actually works.

To discover the real power of leadership, we must investigate its inner workings. There we find energy-filled matter. Energy is a carrier of matter, and matter is condensed energy. Human beings are, of course, the unique expression of evolutionary matter in the form of self-conscious energy.

I envisage organizations of all types as super-organisms, extensions of real people who are human organisms, that we develop to do

what we cannot do alone. In each organization there are leading properties that may be used to guide organizational growth toward the highest civic purpose it can fulfill. Whether or not these leading properties may be tapped depends on whether or not they are recognized for what they are, the premium values we rely upon to lead our personal and organizational lives.

Recognition of these leading properties can lead to optimum organizational performance levels in productivity and efficiency. This can happen when the talents and dignity of an organization's people are seen, individually and collectively, as the prime parts of the organizational body whose cultivated development is the starting point of its agenda. When this is the case, a level of trust begins to build into organizational consciousness, and its expectations become part of everyone's mindset. These expectations then become customs observed by the organizational community.

Leading properties correspond to attributes of human nature and its biophysical context, Mother Nature. The driving force is energy in the form of *creative information*, which is the input, throughput, and output of the quantum system. The system then follows the information into participation, vision, strategy, and resources, or more descriptively, *collaborative participation*, a *visionary cause*, *concerted strategy*, and *connecting resources*. These leading properties are necessary to produce the quantum effects of emerging leadership throughout an organization.

I see each one representing a quantum leap, or change of state, from the preceding stage of its evolutionary growth cycle. These quantum leaps are the foundations of leadership rooted in the social science of quantum civics. **In these five interactive dimensions—creative energy, collaborative participation, a visionary cause, concerted strategy, and connecting resources—quantum civics serves as a 21st century paradigm of leadership science with the promise of generating optimal energy for the greatest purpose an organization represents.** In this way, the application of quantum mechanics to civic action can work at the highest energy levels. *Civic action is stimulated to its highest levels by quantum transformations of the potential energy of individual citizens into the kinetic energy of whole communities.*

Quantum civics is the new civics, that is, it is derived from the new sciences of the 20th century, in particular, quantum physics, relativity theory, and complexity science. **In order to be fully perceived and pursued with the power of mobilized human energy, leadership is re-framed as quantum civics. As such, it is a new science, a social science, one that is powered by the natural energy source of the physical universe known as the quantum** *whose activation converts potential energy into kinetic energy.*

Leadership in its highest and most powerful form, I believe, is a collaborative civic force. In its most powerful form, it is not an ordinary commercial or legal force, not an ordinary business or governmental force, though it is not antithetical to any of these. It is just that high-end leadership seeks more than profit, power, or prestige. High-end leadership seeks whatever it does for reasons that join whatever means it uses with the ends of higher moral purpose ultimately connected to some form of civic-mindedness beyond the usual work of business or government alone.

The practice of quantum civics, as the tableau of leadership I am proposing here, can best be understood as arising from the roots of life. These roots can be traced in science to the evolution of the species throughout human history. The guiding principles of leadership, therefore, must spring from the DNA seeds of life, the laws of the physical universe, and the universal forces of nature all the way back to the quantum energy permeating everything.

We will take a look at how each of these wellsprings of life may be related to our quantum system of leadership. They will help us understand just how powerful leadership can be if it is allowed to be. Each step of the way, we must remember that the impetus of leadership is ultimately an intelligent spirit emanating from the transcending and infinite power of nonphysical being where the heart of our greater universe lies.

DYNAMICS OF LIFE

Leadership requires creative energy to begin with, to survive with, and to

succeed with. In no other way can it come to life and serve its purpose to the fullest. It must have the creative, generative, sustaining energy of life before it can be whatever it is supposed to be. We tend to overlook this in our organizations, always at our peril. In his book, *The Living Company*, Arie de Geus, formerly of the Royal Dutch Shell Group, explains that: "Companies die because their managers focus on the economic activity of producing goods and services, and they forget that their organizations' true nature is that of a community of humans. The legal establishment, business educators, and the financial community all join them in this mistake."

In his foreword to de Geus' book, Peter Senge of the Massachusetts Institute of Technology notes that organizations suffer from "learning disabilities" because they fail to see themselves as "living beings" with their "own person-hood." Such an organization, Senge says, "evolves naturally" and is "capable of regenerating itself" like a living being does. And he asks: "Why, then, can't we regard more complex organisms, like families or societies or companies, as being alive as well?"

So, what does it mean for an organization to be alive, to be a living and learning organization that is able to create and regenerate its own energy? It means that we must learn to see an organization as a super-organism, an extension of the human beings who are part of it and who are themselves living organisms. An organization actually functions as its human members do organically. Just as a human has a body consisting of its members, so is an organization a body consisting of its members and those associated with it. A more or less healthy human body is energized by the life-giving, oxygen-filled bloodstream flowing through its organs, such as the heart and the brain, and moves with the help of the rest of its parts.

This is true for organizations as well. They, too, are energized by a life-giving stream of information-filled messages (spirits) passed through their people (hearts), pursuing their purposes (minds), working through their processes (bodies), and being paid by some system of rewards (energy). These more or less healthy flows of information through people, purposes, processes, and payments may be usefully translated

into leadership situations as civic energizers. The information flows into the system as creative energy. The people are activated as collaborating participants. The purposes are uplifted as visionary causes. Processes are reinforced through concerted strategies. Payments are made by means of connecting resources. And the wheels turn.

Genes contain the "information that governs the characteristics, growth, and behavior of living things," as Paul Berg and Maxine Singer explain in their book, *Dealing with Genes*. Genes are found in the DNA or life molecule, as it is known, which contains the specific genetic codes of all living beings. Organizations are themselves the living extensions of the human beings who comprise them. They, too, have quantum energy chips of stored memory. Therefore, our organizations have what amounts to a gene code of their own which is built of DNA-like components, or "super genes" as I suggest we call them, that make up the genetic characteristics of the people who are mobilized to work for the organization's purpose.

I suggest that we identify this set of genetic dynamics as the organizational DNA or ODNA of our voluntarily organized systems. This will indicate that the life-giving energy of these organized systems comes from the same type of source as that exhibited by an individual person. Just as a person is an organism that is more than the sum of his or her body parts, so is an organized group a super-organism that is more than the sum of its participating individuals. And, just as an individual is a whole different level of being than its body parts because it has a heart and mind of its own, the same thing is true of an organized group. It, too, has a heart and mind of its own.

Consciousness is present in both an individual person and an organizational body. As Danah Zohar explains, consciousness itself is reflected in the mind as an advanced system of quantum origin powered by the energy within it to interact with its environment. As human consciousness works through the heart, the brain, and the central nervous system, it emerges from the interaction of its genetic origins with its external environment. So does an organization as a body of persons. Organizations, too, are living systems. They, too, have a consciousness we identify ordinarily in the forms of organizational vision, values, and culture.

Now, in our search for the inner core of leadership, we travel deeper into the life molecule of DNA to the world of atoms and their sub-atomic parts where we encounter the laws of the universe. What we can say about nature is a product of what we are able to see. What we are able to see was dramatically revolutionized by the development of quantum theory which has become the most accurate explanation available to us about how the natural universe really works. And there are just two words to remember about quantum theory or any other theory, as Thomas Petzinger, Jr. reminds us: "It's important." We need to know theory because it supplies the why along with the how about something that enables us to understand that something. We need to understand something in order to master it. We need to master leadership in order to sustain ourselves on Earth.

Our introduction to these laws has come courtesy of the 20th century's new physics, developed and demonstrated from the earliest discoveries of Nobel laureates Neils Bohr, Max Born, Louis de Broglie, Paul Dirac, Albert Einstein, Werner Heisenberg, Wolfgang Pauli, Max Planck, Erwin Schrodinger, and others. I believe that certain of these laws from the new physics, known as quantum physics, are of particular relevance to our task of leading organized groups as quantum systems.

As I have mentioned, five laws appear to have special significance. The sequence in which I suggest we consider them corresponds to the sequence of impact I see them making on the leading properties of quantum systems, such as the leadership process itself, that touch our everyday material world. In actuality, I believe that each of these laws has some impact on every one of the properties of these systems. However, I am specifically associating each one of these laws of quantum physics with one of the leading properties in quantum civics that I believe most closely corresponds to it in the leadership process.

The first of these physical laws is the *uncertainty principle*. It says that an observer may not clearly see, and therefore may not accurately measure, both the position of a recurring phenomenon and the momen-

tum of that same recurring phenomenon at the same instant. Because we cannot simultaneously determine both the position and the momentum of an object at a given instant, we cannot plot an exact trajectory for its future with certainty. **The implication of this for leadership is that the creative energy of the universe produces futures that are shaped by evolutionary processes which always possess some degree of uncertainty, and this represents a creative opportunity for volunteer champions and their collaborators.** In the quantum civics paradigm this universal law of nature is transposed as the *principle of creative information* which expresses leadership impetus through the dynamics of uncertainty by transforming the potential energy of individual people to the kinetic energy of a unified group.

Second of these physical laws is the *complementarity principle*. It says that these same recurring phenomena exhibit complementary qualities that are different, mutually exclusive perspectives of the same reality. These perspectives exist as combinations, such as mass and force, particles and waves, right brains and left brains, females and males, the universe and humankind, bound together in a balance of complementary variables.

The implication for leadership is that our minds are matched to the universe so that our perceptions are able to interpret its possibilities; the mind and the universe require each other to produce the reality we come to know. In the quantum civics paradigm this universal law of nature is transposed as the *principle of collaborative participation* in which action is initiated in the minds of collaborators who come together around ideas of mutual interest.

Third of these physical laws is the *observer-participancy principle*. It says that every observer chooses the terms of measurement in any situation and, therefore, is also a participant whose action has an unavoidable impact on the outcome. The intent of the participant is the decisive factor.

The implication for leadership is that each participant chooses what vision to follow and what responsibility to take in a particular situation. In the quantum civics paradigm of leadership this universal law of

nature is transposed as the *principle of visionary cause* which represents the field of energy being developed and shared by those who comprise the leading group. Volunteer champions of the cause are the epitome of the collaborating participants who embody the cause.

Fourth of these physical laws is the *probability principle*. It says that all phenomena are the result of tendencies to exist, that is, they are produced from an array of potentials. The universe is an ocean of potentials, some more likely and some less likely.

The implication for leadership is that self-directed participants, co-led by volunteer champions and their collaborators, choose which potentials to enact and make commitments based on them. In the quantum civics paradigm this universal law of nature is transposed as the *principle of concerted strategy* which is the increasingly focused and intense level of energy being implemented in various activities to give life to the visionary cause.

Fifth of these physical laws is the *non-locality principle*. It says that all phenomena in the universe are ultimately connected to all other phenomena in a giant web that networks the entire universe.

The implication of this for voluntary leadership is that volunteer champions and their self-directed co-leaders connect with their universes according to the choices and commitments they already have made, and these connections become reflected in the resources they generate. In the quantum civics paradigm of leadership this universal law of nature is transposed as the *principle of connecting resources* which addresses the level of energy being supplied in support of the action being taken for the visionary cause to which the participants are dedicated.

DYNAMICS OF NATURE

Now, going still deeper into the heart of our quantum civics paradigm, let's look at the ways in which we can see the four forces of nature as they are guiding these quantum laws of our universe. Here, I believe, we can find the natural strength in which our leadership principles are firmly

rooted. These forces of nature operate according to powers of magnitude that reflect multiples of themselves for each increasing power. For example, ten to the fourth power or 10^4 is 10,000, ten to the fifth power or 10^5 is 100,000, and ten to the sixth power or 10^6 is 1,000,000. In the case of ten, each single increase is a multiple of ten. A change of one magnitude creates an impact ten times greater.

All of the forces of nature are part of the constantly changing quantum energy flow of which the universe is made. Out of this flow emerge dynamic systems that self-organize and self-destruct over time. At any given moment their futures are indeterminate, unknowable, not predictable. At this primordial level of physical being, out of which all material being arises, the *uncertainty principle* of quantum physics and the energizing *principle of creative information* in quantum civics that can be inferred from it, reign supreme. **Let us think of this changing quantum energy flow as the *leading force* of creative energy that leads to the powers of magnitude in nature. I believe this leading force generates the impetus that fuels the formation, activity, and momentum of new systems according to the forces of nature.**

Most powerful of the four fundamental forces of nature is the strong force. It operates in the nuclei of atoms and binds together the elementary particles of matter. It drives the formation of increasing levels of complexity and consciousness in living systems. It functions at the 41st power of magnitude, highest in the physical universe. Imagine this force as the leading correlate of the *complementarity principle* of quantum physics and of the *principle of collaborative participation* of quantum civics, with both of which I am associating it. **Let us think of this strong force as the *binding force* that leads the other forces of nature in the innermost dynamics of the leadership process. This binding force is the force that is deeply embedded and powerfully embodied in the volunteer champions who emerge from among collaborating participants in the leadership process.**

The second most powerful force of nature produces all forms of electromagnetic radiation, including light, and bundles atoms into the molecules of life. It is responsible for the structure of matter as we know

it. It functions at the 39th power of magnitude throughout the universe. Imagine this force as a correlate of the quantum physics *observer-participancy principle* and of the quantum civics *principle of visionary cause* with which I believe it corresponds. **Let us think of this force as the *magnifying force* that transmits the currents of formative energy to the other forces that are embedded in the messages of the volunteer champions and their collaborators.**

Third is a force that is substantially weaker than the stronger forces that bind and magnify, but still operates throughout the universe at the 28th power of magnitude. This force is decisive in making possible the evolution of living matter in the universe by mediating the radiation of energy that coalesces into the particles of which matter is made up. In the process, it reduces the prospect of collision with obstacles and greatly enhances the capacity to penetrate resistance. This much weaker but still very powerful force, called the weak force, is crucial to making things happen, literally. Imagine this force as the correlate of the quantum physics *probability principle* and the quantum civics *principle of concerted strategy* with which I am associating it. **Let us think of this force as the *empowering force* that facilitates the release of energy involved as volunteer champions and collaborating participants translate the visionary cause into inspired action.**

Fourth is a force far weaker than the other forces, operating at the 1st power of magnitude, best known to us as the gravitational force. Despite its immensely smaller magnitude, it, too, is decisive in that it contains the final margin of pulling power that keeps our feet on the ground and keeps us from flying off the face of the earth. Imagine this force to be the correlate of the quantum physics *nonlocality principle* and the quantum civics *principle of connecting resources* with which I associate it. **Let us think of it as the *grounding force* that gives us the stability and balance we need to keep on going with what we are doing.** Volunteer champions and collaborators must be resourceful in their connections in order to sustain the momentum required for growth and development.

I see these forces of nature, along with the laws of the universe and the DNA seeds of life, as the foundation of the quantum civics paradigm

of leadership. In his groundbreaking new book, *Consilience: The Unity of Knowledge*, Edward O. Wilson argues that "Every contour of the terrain, every plant and animal living in it, and the human intellect that masters them all, can be understood more completely as a physical entity.... No barrier stands between the material world of science and the sensibilities of the hunter and the poet." Wilson sees fascinatingly important connections between bodies of knowledge that we usually think of as being separate and unrelated. By discovering the linkages, he believes we are on the path toward greater purpose and power in our increasingly interconnected but fragmented world. My instincts are excited by his insights.

Together, the bodies of knowledge we have looked at so far provide a basis for a sturdy and unyielding framework by which we can define the universe within which leadership is always working. The force of this physical universe is controlling, as far as it goes. Flexible though it may be, it can be stretched only so far. Paying attention to it is essential. Failure to align with its limits is disastrous, the reason for common failures of leadership in every area of organized human activity.

DYNAMICS OF ENERGY

Now, let us look at what leadership can do when it is developed as an energizing dynamic that gets our hearts pumping. In this way, as I have suggested, we can see how leadership serves as the impetus that transforms the actions of individual people into the momentum of a unified group. *We can visualize the currents of leadership flowing through a quantum civics system and creating kinetic energy from potential energy as it circulates through the system.* We can imagine the system exhibiting greater vitality as the leadership impetus surges. We will look at each of our five quantum civics principles that energize the process to see how they exchange and direct the flow of creative energy, which is the impetus of the other four energizers, then consider the implications for how to perform leadership differently from accustomed ways.

Creative energy is the leading force from which the impetus of the universe arises. This impetus organizes itself into increasingly complex patterns of creative information that ultimately reaches a state of self-consciousness in humans. This creative information is the formative life stream of leadership in the paradigm of quantum civics. That is, it constantly circulates around and through the quantum energy system that forms the field of influence, literally the electromagnetic universe of a leadership situation, carrying messages that inform the ongoing process.

Creative information is ever present in all aspects of the energized leadership process. Each of the forces of nature plays a role in the flow of creative information, depending upon the phase through which the process is passing. During this process, the energy of creative information pulses to a quantum beat according to the uncertainty principle which explains why we cannot clearly see two opposing patterns at once, why we cannot look both ways at the same time. It stimulates the question "Why are we here?" We need to understand this in order to begin walking together.

Collaborative participation is the initiating point where the action process surfaces. People begin stepping forward, speaking out, and joining in. And they keep on doing so, thereby sustaining the process until the job is done. I believe that the urge for collaborative participation has its roots in the binding force, which is the most powerful of the natural forces. It is invigorated there when it is recognized as the nuclear power of the process and respected for what it can do when its potential is released.

Collaborative participation corresponds to the complementarity principle which explains the tension of opposites as contrary perspectives of the same reality which are necessary to complete the whole. It leads the action process. It makes or breaks a project from start to finish. It asks the question, "Who are we?" The key is the magnitude of energy created by the participants. It needs to be recognized as quantum energy that can be moved by powerful civic intention to transform into a noble cause. Citizens coming together under the banner of a cause have zeal and determination that is unsurpassed.

Visionary cause is incubated in the essential next phase of the leadership process. It is the civic energizer that corresponds to the magnifying force, second only to the binding force in the natural order of things. The light waves of this electromagnetic force have an illuminating quality that enables participants to see ahead to their common ground. Its magnification is correlated with the observer-participancy principle in which participants themselves must choose the direction in which they will build their self-conscious energy into the visionary cause of collaborators.

When vision is truly shared, it becomes the bond of leadership that is sustained as long as the bond is held. The key now is the degree to which the energy of collaborating participants overlaps and interconnects. Visionary cause wants to know of collaborative participants, "What do we see?" As the thoughts of the participants become increasingly collaborative, a quantum effect begins to take shape, that is, the thoughts they have are expressed in significant enough multiples of themselves to make real change that goes beyond where backsliding is possible. A shared vision brightens to an order of magnitude that is greater than the sum of its parts, and it transforms into a visionary cause. Citizens who have come together in the name of a cause become its volunteer champions. And such champions do not give up easily.

Concerted strategy is the implementing phase in the leadership process in which collaborating energies are increasingly quantized, that is to say, gaining momentum in a growing surge of higher energy force multiples. Strategy arises as an integrated set of activities flowing out of the vision shared by collaborators. It is analogous to the empowering force of nature which, though substantially weaker than the binding force and the magnifying force, is decisive in transforming vision into action that makes things happen in the world of everyday reality. The empowering force, in essence, finds the open spaces where action has the greatest potential for success. Strategic energy sees around and beyond apparent barriers down a pathway of achievement.

Concerted strategy corresponds with the probability principle which, from all the available possibilities, selects a pathway that has the

best opportunities for serving the cause. It is accompanied by a growing level of commitment as each step leads further and further into involvement. It asks the question "How are we doing?" Concerted strategy converts the energy of excited people working together into the implementation phase of a civic project. More citizens are now coming together for the good of the cause. Volunteer champions of the cause are speaking in louder voice with greater impact.

Connecting resources convert the strategic energy of implementation into quantum leap improvement and renewal in the level of civic energy being generated. It seems hard to believe that resources in general and financing or funding in particular should come as the final phase of the leadership cycle instead of sooner. There is a frequent inclination to insist on taking a short cut, thinking that "if we can get the money first, then we can demonstrate our leadership." But there is no short cut. It is the reverse that works: "If we show promise of leadership, we can get the money." This requires that we show leadership right from the start, which involves paying attention to the leading energizers of civic movements. In this phase, we are looking at the action and asking "Where are the rewards?" Our movement then adjusts primarily to that direction.

Connecting resources actualize in the grounding force. This force of nature is by far the weakest of the four universal forces. But, its pulling power is essential for stability, to keep one's feet on the ground, to sustain a pace of continuing improvement, to be green and growing. Connecting resources follow the non-locality principle which points toward connections with our universe according to the choices and commitments we have made as the leadership process evolves. They actualize the process of quantized leadership and, in so doing, lay an improving basis for the renewal of momentum that continues a positive spiral of energy toward the end in view.

What is this overall picture portraying? When we add up the impacts of the contributing factors, what does it amount to? Let's review the premises we are working with so far.

1. Leadership is an identifiable and measurable combination of physical influences we are calling the "leading force".
2. Leadership is magnetic and has the power to attract.
3. Leadership is transcending and a catalyst for other influences.
4. Leadership is dynamic, quantum at its core, tapping the energy systems that permeate the entire universe.
5. Leadership is a civic influence in that it draws people together by appealing most deeply to their collaborative natures.
6. Leadership is a living impetus that draws strength from its parallels with the DNA gene code from which all beings grow.
7. Leading relationships correspond to laws of the universe.
8. The phases of leadership correspond with the dynamics of nature.
9. Leadership is an energizing dynamic that transforms potentials into action and momentum.
10. Leadership is an autonomous self-energizing force that can be used to reach extraordinary goals. (We will look at this premise in the next chapter.)

But, before we look at how, I want to introduce a special case that illustrates our story and that we will be pursuing through this book. It is a composite of two very different types of real-life college presidents in Florida when I was there. The situations are fictionalized to respect professional courtesy.

A TALE OF TWO LEADERS

Camden Gould and Jacqueline Hope were new presidents at two small independent colleges in Florida. Both were signed to renewable three-year contracts; when they were signed, the average tenure of a college presidency was running about six years. The institutions were remarkably similar in many ways. They were both coeducational, enrolled about a thousand residential students, located in leafy suburbs of metropolitan areas, had small endowments and limited budgets, occupied charming old campuses with aging buildings in need of modernization, employed a dedicated faculty most of whose members were tenured, and offered a curriculum heavily influenced by the liberal arts tradition.

Both colleges realized that their futures required changes. That's why Camden and Jacqueline were selected. They enjoyed reputations for leading change in their previous institutions, both of which experienced growth in quality and quantity during their times of leadership. Camden served as president of his institution and was known as a firmly forceful executive who could be tough when he needed to be, yet innovative when the situation demanded it. Jacqueline served as dean of her institution, the number two position, and was known as a friendly, purposeful administrator who was always there when needed, adapting her actions to suit the circumstances.

Both Camden and Jacqueline faced challenging issues, somewhat different in their complexions, but with dramatic impact potential for the futures of their colleges. Camden saw his challenge as strengthening the programs he inherited in order to build a stronger base from the inside out. Jacqueline saw her challenge as strengthening the enrollment patterns she inherited in order to develop a stronger stimulus from the outside in. They made their plans accordingly, as we shall see.

A TALE OF TWO LEADERS

Camden Gould

Previously a college president

A firmly forceful
executive

Challenged to strengthen
programs

Sought stronger base from
inside out

Jacqueline Hope

Previously a college dean

A friendly purposeful
administrator

Challenged to strengthen
enrollments

Sought stronger stimulus from
outside in

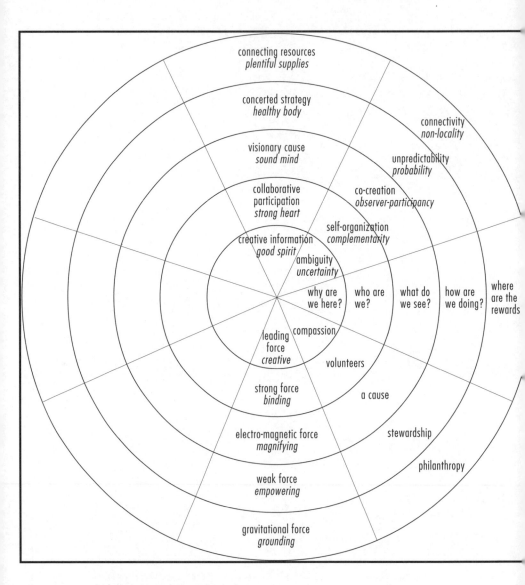

FIGURE 2: QUANTUM CIVICS PARADIGM B

Start reading from the north axis and read from the center toward the circumference, then proceed in like manner clockwise around the concentric circles to identify (1) the leading properties, (2) peculiar features and quantum principles, (3) key questions, (4) distinctive aspects voluntary leadership, and (5) the natural alignment of forces.

"Where is the Life we have lost in living?
Where is the wisdom we have lost in knowledge?
Where is the knowledge we have lost in information?"
—*T. S. Eliot, Choruses From 'The Rock"*

3. CREATIVE INFORMATION:

The Self-Energizing Spirit

When I arrived at the University of Tampa as president, it was in the wake of a leadership crisis. The institution was in a state of withdrawal from the loss of a high profile football program that had produced future National Football League stars, like Freddy Solomon of the San Francisco 49ers and John Matuzak of the Oakland Raiders, but had achieved much ballyhooed success on the field at the expense of abusing its institutional relationship. Not only was the program losing lots of money, it was on the verge of bankrupting the institution. Amid great controversy and the arrival of the NFL Tampa Bay Buccaneers, the University's board of trustees voted in a split decision to end the program.

My predecessor had resigned in the aftermath of his clear-headed decision to recommend termination of the program in order to save the university. I was asked to refocus and build support for the university's academic mission, and was naively surprised at the non-academic complications I would face in doing so. Because I had spent the past fourteen years working closely with the presidents of three other institutions on some very challenging institutional issues, I thought I had pretty well seen it all. How wrong I was!

First off, we needed to get the energy flowing in some kind of positive direction that we would determine together as a university community. We needed to get a healthy heartbeat going. That translated into

making university governance top priority. Decision-makers had come together for the first time in the presidential search process, and that paved the way. Fran Pray, a nationally respected consultant who was a mentor of mine and Art Frantzreb's long-time partner, had semi-retired to Clearwater, just across the bay, and was at work with University board members on revision of institutional bylaws, which helped very much, too. Board communications with faculty, staff, and students had been almost non-existent. There were plenty of bad feelings.

After much discussion during the first year, in which there was a great deal of input from virtually all parts of the institution, and a lot of communication all around, we completely revamped our system of governance so that people who desired could participate in some aspect of policy-making where they had first-hand knowledge. The board would lead at the level of institutional policy, the faculty would lead at the level of academic policy, the student government would lead in matters of extra-curricular and residential affairs, and the administrative staff would lead on matters of institutional operations. The system was reorganized so that leaders from each group could be heard in forums that included the other groups when overlapping policy interests required.

As we developed the new system and began putting it into place, we found that we were able, in each of the key groups, to facilitate decisions about programs and practices with renewed confidence that they would contribute to the overall effectiveness of the institution. An atmosphere of good will emerged that greatly helped us get into tougher decisions in the days ahead. Our collective energy level was way up, like new voltage had been turned on and our lights were burning brighter. We had a healthy heartbeat. And we really needed this because the hard part still lay ahead of us.

We needed to rethink our mission and formulate a plan for the future that could be a basis not only for academic decision-making, but also the starting point for a major campaign to raise funds. We ran small meetings and big meetings, of single groups and multiple groups, on campus and off campus for weeks and months, testing the patience of almost everyone. The energy level continued to run high. But differences

were now out on the floor and hotly debated.

Our collaborative spirit was sorely tested. There was plenty of dissension and at least as much cooperation, with the balance seesawing back and forth. Obviously, this was a place many people cared about deeply. An open process, such as we were conducting, brought out many old pains from the past. It also provided a venue for new ideas about the future. Compromises were negotiated. Decisions were eventually reached. No one was totally happy. We had to go forward as best we could.

A new mission was adopted. A new vision for the future was developed. A capital campaign marking our fiftieth anniversary was drafted and widely discussed, and the board agreed to provide leadership for it. Were it not for the creative energy generated from the outset by an open process and a new system to organize its work, the university would have had little possibility of beginning anew.

From this and related experiences I learned a great deal. Perhaps the basic question I learned to ask, one way or another, was "Why are we here?" What is it we have on our minds that prompts us, agitates us, stirs us up to take the time and energy to be here at all? Where do our hearts lie? If we can answer that, we will have far more insight with which to get a new leadership process off on the right foot. Let's take a closer look.

ENERGY PRODUCERS

Simply put, leadership amounts to energy concentrated on a purpose. *Leadership stimulates the conversion of potential energy into kinetic energy.* Energy is the fundamental dynamic of the physical universe as we know it. Leadership reaches down to ignite this dynamic. This dynamic is governed by the peculiar rules of quantum mechanics. **The quantum is the elemental unit of energy on which, through which, and in which is carried the creative information to form all our structures of matter, both inorganic and organic. Quantum energy, therefore, is the carrier of leadership** *because it is the carrier of potential energy that transforms into kinetic*

energy.

The quantized interactions of the tiny electrons and protons inside the atom lead to the formulation of molecules. The interactions of proteins and nucleic acids build the molecular DNA into cells. The interactions of the cells eventually develop the bodies of conscious organisms. Energy is the carrier of information, the protoplasm or life stream of cells, which develops matter into physical structure. **Quantized, or quantum leadership, organically stimulated by these high-energy dynamics, is potentially the highest form of organization that can be reached in living systems because it is the product of human beings working together naturally and autonomously.**

The creative force of information governs and organizes us. It is an expression of the leading force of the universe and all the phenomena of our biosphere, from living creatures and their organizations to inanimate objects and their formations. The dynamic energy that carries this formative information leads evolution into higher levels of complexity and consciousness. This, in turn, enables higher levels of organizational performance. **So, the most effective organizations are those which are the most productive attractors and generators of energy and, therefore, the most efficient processors of information.**

Seen in this light, creative information is the builder of organizational systems, working at their leading edges as well as at their inner cores, their hearts. Thus, those organizations best able to tap into their sources of quantum energy and sustain their capacity for building its volume are the ones that will lead their fields into the future. Our challenge, then, is to develop our energy-producing systems. In order to do that, we must learn how to mine the energy supply of quantum power available around and within us for productive purposes.

Human organizations are social systems created and recreated by the people who run them, from inside out and top to bottom, throughout the ranks. A key to understanding them as living systems is to understand their integral relationship with a physical universe which itself is a life-giving and life-supportive universe. We will see our universe as friendly,

not hostile, made to create and sustain life in all its forms, not to hurt or harm.

With Joseph Provenzano of the Jet Propulsion Laboratory at the California Institute of Technology, in his provocative book, *The Philosophy of Conscious Energy*, we recognize the evolution of life on Earth from cosmic atoms and microscopic cells to increasingly complex and conscious beings, then finally to self-conscious humans and their forms of organized activity. We see an evolutionary universe woven together with common threads spun from ancient roots and developed over millennia into higher and higher forms of organized systems.

The creative energy generated by evolutionary processes, expressed in genetic and cultural interactions over time and at any particular time, pulls the future out of the present and its ancestry in the past. The impetus of our creative energies leads us, and this explains *why* we are engaged the way we are in leadership processes. Whatever the external pressure, it is the responsive impulse from within that governs our action. This is what leading by heart means. And the heart is the most powerful organ in the human body.

THE LAW OF COMPLEXITY AND CONSCIOUSNESS

What is the significance of seeing living beings as having evolved from tiny quantum energy patterns into highly organized dynamic systems? The significance lies in our understanding people, the quintessential living beings, as the lens through which we may see our world as part of a living universe supportive of life. **Is it not possible, even probable, that we humans exist to see the world and, in seeing it, to help realize its potential? To find its heart and to make it as healthy as we can?**

I believe it is time we join the legendary priest and paleontologist, Pierre Teilard de Chardin, in seeing that "everything happening in the universe is the result of the success or failure of a primal urge, present in all matter and energy, to combine into structures of increased complexity and consciousness." Life itself is a reflection, the ultimate expression, of

the shining light that comes to us from the Law of Complexity and Consciousness. Our living systems are *open* not closed systems. These systems are changing, and there is a fundamental direction to their change.

Living systems are capable of creating kinetic energy from potential energy. As Nobel laureate Erwin Schrodinger explained in his book, *What Is Life?*, life itself feeds on "negative entropy flow," that is, on the transformation of potential energy not in use into kinetic energy actually in use. In other words, living beings depend on creative energy systems to sustain their own lives.

This does not guarantee anything specific to a single situation that, in a quantum system cannot be tracked, since all quantum systems involve population distributions that reflect the probability principle. But it does indicate, beyond the ups and downs and the ins and outs, that there are observable patterns of orderliness in the universe, and that disorder eventually resolves itself into new order over and over. Change produces uncertainty, yet inevitably is moving toward advancing forms of organization. The challenge is how to lead this change without drowning in its growing waves of complexity.

Nobel laureate Ilya Prigogine tells us in *The End of Certainty* that "We are in a world of multiple fluctuations, some of which have evolved, while others have regressed." He says that "These fluctuations are the macroscopic manifestations of fundamental properties of fluctuations arising on the microscopic level of unstable dynamical systems." He finds that "the flow of time starts at the dynamical level. It is amplified at the macroscopic level, then at the level of life, and finally at the level of human activity. What drove these transitions from one level to the next remains largely unknown, but at least we have achieved a non-contradictory description of nature rooted in dynamical instability. The descriptions of nature as presented by biology and physics now begin to converge."

This means that the starting point of change itself is an energizing phenomenon emerging from the hidden dynamics of what is called *pre-life* all the way through essentially *reactive* life to actively *thoughtful* life. From this vantage point we can see life emerging from a cosmic dance of energy, as the great physicist David Bohm saw it, featuring a digital

world of quantum two-steps in which particle-wave patterns moving across vast surfaces of space repel and attract each other as energy is radiated and absorbed. As the dance goes on, new partners are acquired in growing numbers even as old partners are left behind.

In the conditions of pre-life, energy evolves from radiated energy to condensed energy, or inanimate matter, and then continues on to become conscious energy, in the form of plants and animals, and eventually emerges as self-conscious energy in human beings. At each threshold of change, that is, from radiated to condensed energy, from condensed energy to conscious energy, and from conscious energy to self-conscious energy, a quantum leap occurs which changes energy from one state of nature into another. As Prigogine says, "We don't know for sure why or how these leaping transitions occur, but we know that they do occur, and that our actions are everyday evolutions of their dynamic movement." We are connected to nature itself. We are part of it.

At the top of this evolutionary trend of organization, individual persons are an embodiment of the law of complexity and consciousness in their uniquely specific lives. A formal organization is considered to be a corporate person in truly organic as well as in technically legal terms because it is a particularly defined group of individual persons. **Organizations are the expression of the people who comprise them.** Organizations have hearts, just as people do.

THE CREATIVE SUPER GENE

Organizational consciousness emanates from its own ODNA, that is, from the leadership of those responsible for running the organization, however leading is defined. In an organization, people are the functional equivalent of vibrant living cells, invigorated by their hearts and minds, like cells responding to the strong forces emanating in their nuclei. The organization as a body is, like the human body, made up of identifiable parts that function together as an organic whole. **ODNA is more than a composite of individual DNAs. An organization is a super-organism**

with its own ODNA. It has super genes or gene constellations of its own. An organization is a living social system itself.

The power source of an organization as a social system is what I will call its creative super gene. The energy generated by this creative super gene corresponds with the dynamics of life emanating from the protoplasm circulating through a living cell. The development of an organization is guided by the intensity and flow of the energy released from its dynamic genetic code that arises from its creative super gene.

Now, to understand how this works, let's take a look at DNA. It resides in the nucleus of each cell and develops out of the cell's life stream or protoplasm. It has four chemical bases of life which are known by their letters: A for adenine, G for guanine, T for thymine and C for cytosine. These bases are organized in four equal complements spread over billions of different combinations inside the DNA life molecule which take the form of genetic codes. These genetic codes, with their different combinations of just these four equal but distinct complements, literally shape the development of all living beings. In an analogous way, their apparent correlates in organizational leadership shape the development of all organized groups as social systems.

Let's take a closer look at the symmetry inside the DNA system, so we can begin seeing the possibilities. This will give us a better idea of just what we've got to work with. Don't worry about the details, but do keep your eye on the pattern of relationships, because they are analogous to the relationships of our leading properties.

The A base and the G base are the so-called purine compounds, siblings that form a *nine*-sided "big base" type. The T base and the C base are pyrimidine compounds, siblings that form a *six*-sided "small base" type. Also, the A base and the T base are mates that form a "base pair" linked by *two* hydrogen bonds. The G base and the C base are mates that form a base pair linked by *three* hydrogen bonds. It is important to note that the relationships are all equivalent. The nine-sided types have a 3:2 relationship with the six-sided types. The triple-bonded pair have a 3:2 relationship with the double-bonded pair.

As we can see, there are two base types; A-G and T-C. There are

also two base pairs: A-T and G-C. All four are equivalent complements with five relationship points each. A has two bonds and G has three, totaling five bonds. T also has two bonds and C also has three bonds, totaling five bonds. With nine sides for A and six sides for T, A has a 3:2 proportionality with T in the number of their sides, making a proportionate total of five. Also with nine sides for G compared to six sides for C, G and C too have a 3:2 proportional relationship making a total of five. These relationships are critical.

Let's imagine how they work with the help of a few lines from "The Music Makers" by Arthur William Edgar O'Shaughnessy as reported by Danah Zohar:

> *We are the music makers,*
> * And we are the dreamers of dreams…*
> *Yet we are the movers and shakers*
> * Of the world forever it seems.*

If we liken the two complementary base pairs of A-T and G-C to O'Shaughnessy's *movers* and *shakers*, the movers would be the less tightly bound mates, more flexible, action-oriented ODNA bases corresponding to the A-T base pair. The shakers would be the more tightly bound mates, less flexible, momentum producing ODNA bases corresponding to the G-C base pair. We will use this analogy of movers and shakers to help us develop a clearer picture of the leadership discipline that I believe is firmly rooted in nature.

Also part of this discipline are the other two sets of complementary bases, the A and G purines as well as the T and C pyrimidines. In these roles, they are also the *starters* and *finishers* of our leadership analogy. The starters are the larger siblings, more complex bases corresponding to the purine compounds, A and G. The finishers are the smaller siblings, less complex bases corresponding to the pyrimidine compounds, T and C. We need the siblings who are starters and the finishers along with the mates who are movers and the shakers to complete the circuit and make our system whole.

The equivalencies of these four complementary sets of bases make a good fit inside the cylindrical two-stranded spiral staircase-shaped double helix of real DNA molecules whose diameters are consistent end-to-end. For the analogous relationship to hold between the DNA of living beings and the ODNA of leadership systems, it is necessary that our proposed ODNA correlates are strictly observed. Otherwise the system will malfunction and default, just as the DNA does in such situations. Just as the DNA bases consist of a set of complementary relationships, so does the ODNA.

In the DNA itself, the A, G, T and C bases are strung together in two intertwined tubular strands of energy fields with consistent diameters. These strands sub-divide and re-combine in an evolving energy tunnel propelled by a pulse of messages that vibrate through the phases of their different life cycles. The two tubular strands of the DNA molecule are complementary, like a mirror image of each other.

Each of these tubular strands of DNA are perfectly calibrated with the other in order for the match to hold in the intertwined double helix form. This is very important, because there would be no match-up nor any replication of the DNA without this symmetry, or balanced proportion, in its nature. **Symmetry has virtually no tolerance for error. The ODNA does not digest objects foreign to its make-up. Parameters are inherent in the constraints of its nature. The ability to replicate DNA, and therefore ODNA, lies in respecting the beauty and balance of their symmetry.**

In this way we can see that the entire body of an individual person or, analogously, an organized group of persons, grows out of how our genetic codes organize these DNA bases, forming the germinal seed of life for each one in its own unique way, into billions of different combinations. **Each base plays a specific role, in combination with the others, to build living organisms, living organizations, and living communities. In each case, the result is a unique combination of genes for individual organisms or super genes for super-organisms.** There are no clones, though there are close relatives. These relatives from close families help to build collaborative communities. Improving the biochemistry of healthy bodies and minds helps to build better relationships at every level

of organization.

A person is a human being who thinks, evaluates, and acts according to a unique set of mental and physical characteristics arising from a genetic code specific to that individual alone. The genetic code of just four chemical bases, strung out in billions of combinations along the double-stranded DNA molecule of every living being, is like the 26 letters in the English alphabet from which all our stories are written, or like the keys in music from which every song is sung. The four DNA bases of life guide the future of each person's development as a living being throughout life.

The DNA molecule of life is formed at the conception of a living being, is present at its birth, and remains active through its life. Every person is guided into the future based on his or her life-giving gene-generating DNA molecule. No matter what happens, the genetic code helps direct the action a person takes in response to any situation. This is a person's response-ability. If the genetic code could be accurately read, it would present all the possibilities of response-ability that might lie ahead over a person's lifetime.

But these life-giving possibilities are not unlimited. DNA is the basis of all the potentials one has, and has not. DNA is more than a blueprint, more than an architecture, more than a picture. DNA is the seed of what a person can be. It is an "in-formation" bank with the power to steer us toward the choices before us. It is the genesis of each cell in our bodies, and the inner guide of our growth and development.

We may think of DNA as a hologram, the three-dimensional laser-made photograph of an object that projects its spatial dimensions without any of its substantive mass. A holographic picture is one in which, unlike the usual two-dimensional photographs, every part contains in condensed form an image of the whole picture. The whole picture can be seen from an enlargement of any fragment. Each member of a human body contains in its cells a configuration of the whole body. We can tell the whole from the part.

It is not hard to imagine what the implications are for the human organization. An organization has, I believe, a genetic code that is analogous to the composite of the genetic codes of the living beings who

comprise it, weighted for the relative influence each one has in the organization. While the genetic code of the organization as a whole is a massive aggregate of human energy fields, its whole can be seen in a hologram of the energy field radiated by a single member. This is because the organization is built, person by person and cell by cell, just like the human body, so that the parts reflect the whole as a guide to its own functioning as well as to be a mirror to the world.

When we think of our organizations as holograms, we will have a new perspective about the information we share with each of our members. Members will naturally reflect an image that encompasses their experience with the organization as part of their life experiences. They will have certain characteristics that identify them with the organization. Their energies will intersect the organizational context and reflect the culture that pervades it.

The information carried by the creative super gene is more effectively conducted through a truly holographic organization whose image is readily discernible to anyone who approaches it. If we think of our organizations as prospective superconductors, in which there is friction-free information flow, we will more clearly see how their in-formation banks can transmit valuable energy to their necessary receivers via the creative super gene.

THE TENTH PREMISE

In light of what I have suggested so far (in the previous chapter we examined the first nine premises), the launch pad for **leadership is an autonomous self-energizing dynamic** which is the tenth premise of the combined leader force, and which corresponds with the creative energy that is the focus of this chapter. It returns us to the proposition I began with, specifically, that leadership is **the impetus that transforms the actions of individual people into the momentum of a unified group.** But how does it work?

In this proposition, the impetus of leadership is the combination

of influences analogous to the conversion of potential energy into kinetic energy. Since this approach to leadership is based on energy transformations in various forms, let us consider the possibility that **this proposition might be formulated as an analogue of Einstein's famous E=mc² mass-energy equivalence equation.** Burt Nanus and his colleague Stephen Dodds sketched a "whimsical" suggestion in their recent book, *Leaders Who Make a Difference,* that Einstein's equation might be used metaphorically as a handy tool for building "social capital." They were right. But how? Much remains open for disucssion.

This universal creativity equation demonstrates how energy, E, can be transformed into mass, m, through the constant velocity of light, c, when it is squared. The speed of light squared travels at 186,000 miles per second. When it is squared it reaches almost 35 billion miles per second! This speed is of such huge magnitude as to be virtually beyond comprehension. For our purpose in this book on voluntary leadership, I suggest we consider a specific application of Einstein's equation that expands it from the realm of nature in general to that of human nature in particular. I suggest that we use it as the inspiration for transposing the dynamics of energy transformation in material systems to a technology of leading human affairs especially on behalf of worthy causes.

In any leadership situation, a primary goal must be to create a certain critical mass that will make the difference between succeeding and falling short. What we want to do here, if we can, is to re-create the explosive potential of energy transformation in a matching equation for leadership. We must be cautious, however. First of all, the application of Einstein's equation has little or no *noticeable* impact on everyday affairs. Yet complexity science demonstrates that even the tiniest changes can ultimately burst into view as tremendous disturbances. Second, we must honor Martin Luther King Jr.'s observation that "Everybody can be great because everybody can serve. You don't have to have a college degree to serve.... You don't have to have Einstein's theory of relativity to serve.... You only need a heart full of grace. A soul generated by love." He was right. Yet, it would help a great deal in leading if we knew how Einstein's most famous insight could indeed be used, since I dare say it surely would

have pleased him, for the greatest good of the largest number over the longest period at the lowest cost.

Let's return to our leading properties, the civic energizers we are calling creative information, collaborative participation, visionary cause, concerted strategy, and connecting resources. Let's identify each as a super gene, a genetic combination—that has creative, participating, visionary, strategy, and resource capabilities—with autonomous self-energizing force. These five super genes make up the framework of our ODNA model. In the individual DNA, there are complementary relationships that include a base pair of movers, the A and T bases, corresponding in our model to the super genes of collaborative participation and concerted strategy, and a base pair of shakers, the G and C bases corresponding in our model to the super genes of visionary cause and connecting resources. In our model, the equivalent of mass would be the action of the movers, participants implementing strategy, the A and T bases together. The equivalent of the velocity of light squared in our model would be the momentum of the shakers, vision multiplied by resources squared, the G and C bases together.

Most important of all, the equivalent of energy would be the leadership impetus that is the leading force of the genetic code of leadership. The life stream of leadership is the creative super gene that gives rise to the genetic networks comprised of the A, G, T, and C bases. The creative super gene is the impetus that stimulates the dynamism of each of these biochemical networks—collaborative participation, visionary cause, concerted strategy, and connecting resources. The creative super gene is the kicker that activates each one of these to greater levels of intensity. The creative super gene is equivalent to the leadership impetus we are after.

We will state our equation for this leadership proposition as $I=am^2$ in which the leadership impetus of creative information is I, the action product of collaborators implementing strategy is a, and the momentum of the cause accelerated by its support is m^2. Leadership is the impetus that both creates action and is created from action propelled by momentum. Leadership is a certain combination of influences present in

the universe. Leadership occurs whenever these influences may be used in some kind of combination and to the degree that the combination is formulated in effective balance.

Leadership does not function in a vacuum. It occurs in situations arising out of contexts. It works well or poorly depending on the degree to which it is developing through the phases of action and momentum in its natural processes. Leadership requires followers, and only to the extent that it has them is it flowering into its full potential. As an autonomous self-energizing force, leadership requires that there is a receptive setting, a climate conducive to its growth, certain pre-existing conditions. I believe that leadership is, in essence, a builder of collaborative communities where people work together toward common goals. Is there a generic and universal organizational setting in which leadership can flourish? I believe that one is now emerging.

BEYOND-PROFIT ORGANIZATIONS

There is a new prototype organization that I see emerging across the three sectors of civic, private, and public enterprise. It shares characteristics of all three. In essence, it is a type of civic sector model writ large that is applicable to any public or private organization driven by a service motive. **I think of the new organization as the *beyond-profit organization*,** after a term used by professor Allen Levy of Chapman University. **I define it as simply a formally organized group of any sponsorship that is driven by the service it offers to customers, constituents, or clients. Such an organization is based on a civic model that defines success primarily in terms of service provided as the main stimulus of surplus produced.**

Putting service before surplus does not mean that an organization can or ever does ignore profit or politics or productivity, but that it sees service always as leading to return on investment however that may be defined by different organizations. This means that even in tough times, service still comes first. People are not squeezed, squashed, or slashed for the benefit of anyone else in such an organization. If there is gain to be

realized, and dependable service leads to real gain, it is done so honestly and honorably.

As I said, this is an emerging phenomenon, not nearly a predominating one. Obviously, a great deal needs to change in the attitudes of people before this phenomenon becomes ascendant. People will need to understand that valuable service meeting a demand really does produce a return that is greater than a quick killing. However, there hasn't yet been enough visibility given to this idea that would overcome the prevailing appetite of greed and immediate gratification. Nevertheless, the small but growing number of successes it has had holds out a real basis of expectation for a more sensible future. The philosophy of servant leadership championed by the Robert Greenleaf Center in Indianapolis is especially noteworthy, I believe, in these successes.

The generic nature of a beyond-profit organization coalesces around the idea that innovation and collaboration produce leading edge services delivered to target audiences ready to pay for them, and this generates a return on investment worthy of the enterprise. Innovation, collaboration, service, delivery, and reward correspond to our five energizing super genes: creative information, collaborative participation, visionary cause, concerted strategy, and connecting resources which together generate leadership impetus.

Now, we may return to our proposed leadership equation in which I=am^2. In order to produce the impetus of leadership, we must have action consisting of collaborative participants implementing a concerted strategy, and we must also have a visionary cause that attracts connecting resources. We must have them in right relationship to each other. Thus, **in a beyond-profit organization, in order to produce the impetus of innovation, we must have collaborators delivering performance, and we must also have them delivering it through services that produce surpluses.**

Notice that we are solving for the creative energy of innovation. Why does this make sense? Why aren't we solving for service? Because cutting edge service always depends on innovation. Never for a moment are we without change of some kind. **The paradox is that the status quo is always changing.** In any living system, there is an ongoing circulation of

energy radiating discontinuously, throbbing as in a heartbeat, that is the pulse of quantum processes. This produces change and uncertainty, even in systems that seem to be stable. Inside all living systems, change is constantly going on. In this dynamic world of ours, therefore, we are better off always thinking about doing things a little better each time, as if we are doing it for the first time. The learning organizations called for by Peter Senge in his path-breaking book, *The Fifth Discipline*, put a premium on constant innovation. So must we. But we must go further.

We must embed the impetus of leadership so deeply that it becomes part of our unconsciousness, habits of the heart that trigger a transforming process of what we're doing individually into the momentum of what our group is doing together: I=am^2. Oliver Wendell Holmes said "I wouldn't give a fig for the simplicity this side of complexity, but I would give my life for the simplicity the other side of complexity." The habits of the heart I am proposing here would have to come from the simplicity of a leadership idea that is produced at the other end of leadership complexity. They would need to function as a mindset with enough impetus to lead the actions of individual people into the momentum of a unified group.

Not-for-profit organizations are generally in a perpetual struggle for financial survival. For-profit corporations are relentlessly pressured to produce profits. Public agencies must pay constant attention to politics. In each case, the remedy increasingly lies in building a reputation for dependable, unswerving service. A beyond-profit organization is driven by a mission of high purpose and a vision of real significance. *It takes potential energy as an opportunity to be transformed into kinetic energy.* It appeals to thoughtful people who are looking for something more than the same old ego-inflating money, fame, and power. Nothing per se wrong with them; but in leadership they are by-products, not purposes.

The beyond-profit organization promises people an everyday environment that respects their humanity and celebrates their creativity. It does all this while simultaneously paying supportive attention to the bottom line and to the political atmosphere. It considers itself an economic community with a specific reason for being that justifies self-energized

loyalty on the part of its stakeholders. It is trustworthy. In these ways, **the beyond-profit organization allows money, fame, and power to emerge from a higher purpose rather than to substitute for the absence of one.**

In its not-for-profit form as a civic enterprise, the beyond-profit organization is the proper setting of the high performance 21st century leadership paradigm in which quantum civics works. It may be extrapolated by service organizations in business and government for use in meeting their obligations. It builds on an experimental design developed from years of experience in the field that is adaptable to specific circumstances. The beyond-profit organization is the ideal setting for putting the impetus of leadership into practice because it gives leadership a chance to emerge from the natural relationships of people at work. Powerful habits of the heart that are built into the culture of every beyond-profit corporation would celebrate Dr. Einstein's memory, with apologies to his insistence on certainty. Then it would go one step further, to $I=am^2$.

UNCERTAINTY AND OPPORTUNITY

In *The End of Certainty*, Nobel laureate Ilya Prigogine concluded that most recent discoveries of the inner workings of our universe lead us to "a new formulation of the laws of nature, one that is no longer built on certitudes, as is the case for deterministic laws, but rather on possibilities." These possibilities are the result of dynamic interactions pulsing through the universe which generate unpredictable outcomes but which tend to distribute themselves in demonstrable patterns over time and space.

The paradox of orderly instability springs from the amplified resonance of tiny quantum particles and their wave functions, as the great Henri Poincaré has shown, as in when we play a note on a musical instrument and hear the harmonics. This resonance plays a fundamental role in the way the physical universe works. Interacting fields can lead to resonance. The emission and absorption of light is due to resonance. Resonance is associated with communication, as in being on the "same wave

length" or "vibrating to the same frequencies." Resonance involves relationships out of which our futures are constructed.

But these futures cannot be predicted with certainty because the pulses or heartbeats of quantum interactions are discontinuous, that is, they come in lumps, jumps, and bumps, not in smooth, continuous and invariant trajectories. These discontinuous interactions, when repeated with sufficient frequency, produce patterns of results that can be observed and measured.

Herein lies opportunity. Seeing patterns in the unfolding of events leads to understanding that enables us to envision our futures. Knowledge of uncertainties demands creativity. Without creativity we could build neither understanding nor a future. In fact most of us use our creative energies all the time as we go about the everyday living and learning we do to survive and make our way. The practical issue is how purposefully to build up our energy reserves, our potential energy, so that we can call up energy when we need it. This is just as true for our organizations as it is for us.

The uncertainty principle comes to us from our inability to determine the position and momentum of an object simultaneously in the quantum nature of our world, and requires us to look carefully for patterns before reaching conclusions about what we should be doing. These patterns enable us to view the world as an orderly universe that contains open doors of opportunity worthy of our attention. Our thoughts then could more effectively be turned to future opportunities now unfolding before they pass us by.

WHY ARE WE HERE?

This is the essential question we must ask ourselves as we intentionally pursue a self-consciousness, an astute awareness, about where we are coming from. Why am I here in this space? Why are we all here in this place? What is it that seems to be on my mind? That is prompting me? That is agitating all of us? That is exciting about our coming together?

What is leading us is the creative energy that comes from within each one of us. We don't know how that happens exactly, but we do know that we respond to messages transmitted by our hearts and minds. These messages are interpretations of our perceptions and our feelings. We don't see with our eyes, but we do see through them. We actually see with our brains using their interpreters to sort things out. Our creative energies are released in response to the inner workings of our minds and our bodies.

It is very helpful to know where each of us in a group is coming from. That way we can respond more nearly to realities. This is why dialogue is so important in the leadership process. We need to communicate with each other, and that means of course that we need to listen as well as to talk. In this case, our listening must be tuned to how others are responding to the same question we are: Why am I here? Why are we all here?

In order to get better insight into our answers to the question, we will need to assess the creative information and energy that is present to begin with. I suggest we consider it in two ways, that which comes from the heart and that which emanates from the mind of each participant in the collaborating group as a whole. This way we can see what feelings and views are leading us into the process.

I suggest we evaluate the responses on a scale of one to ten, scoring from low to high, on strength of feeling and on firmness of view. Let us assume that an individual score of nine or ten represents very strong feelings or very firm views, a score of seven or eight represents strong feelings or firm views, a score of five or six represents mildly strong feelings or somewhat firm views, a score of three or four represents limited feelings or limited views, and scores of one or two represent little feeling or infirm views. Since strength of feeling and firmness of view are so directly related to the presence of energy available for action, I would emphasize the importance of building strong feelings and firm views before getting very far into the process. When you have strong feelings and firm views as a group, you are in a state of readiness for real and serious discussions about some kind of effective collaboration. Until then, you are basically just in the preliminary discussion stage, brainstorming ideas.

TWO COLLEGE PRESIDENTS
STEP ON DIFFERENT ACCELERATORS

Both Camden Gould and Jacqueline Hope realized that there was a great deal of work to be done to get their institutions moving again, headed in the right direction at an orderly pace. This is not easy, as both of them know. Camden had seen it before from the same position as president of his previous college. Jacqueline had seen it before, too, but from the number two position as dean of her previous college.

Camden figured that, because he needed all the information and energy he could get, he needed to concentrate on the key sources of leadership in the college's various functioning constituencies. He returned, one by one, to members of the presidential search committee who recommended his hiring and he asked them about what was on their minds. Its members were among the most trusted leaders of the college community at large. They carried a lot of weight. And they were naturally well disposed to help their new president get off to a good start. They told Camden they wanted to see a good future for the college and they wanted him to succeed. With help from them, Camden moved on to visit with individual leaders of the board of trustees, the faculty, the student body, the alumni, members of the local community, parents of current students, and along the way as the process unfolded, with members of the administrative staff he inherited from his predecessor.

In the process of these private consultations, Camden accepted each opportunity to speak out before groups who held special power and influence, such as the board and the faculty. But he was careful about making any specific promises or laying out any detailed plans for the future because he knew how dangerous it could be to get too far out ahead of the opinion-makers. And he did not go out of his way to make any more public appearances than necessary where he would be expected to deliver substantive speeches about the college's future. He was anxious to move forward, but with deliberate speed. He really wanted to know where people were coming from before he committed to any specific course of action.

Jacqueline, too, began her learning curve with numerous private consultations. She, too, started with those she had met in the presidential search process. They, of course, were very helpful in providing useful information and energy to help her get off to a good start. She met with trustees, faculty members, administrators, students, alumni, community members, and even members of the support staff who had had little if any contact with her predecessor. She spent quite a bit of time with business, educational, government, and civic leaders who saw the college from a distance, not close up like the then current leaders of the institution's constituent groups. She wanted to know what everyone thought about the college's situation and its future. And she spent a great deal of private time reflecting on her own thoughts about what she could best do to help.

During the presidential search process, she had picked up some clear indications of the institution's priorities. She made a special point to seek out not only key audiences as well as key individuals wherever she could find them, but to spell out her initial thoughts about how to approach these priorities. She spent more time talking to groups than Camden did and had more to say about the new priorities emerging in her mind about the college's future. But this was a riskier course because she was getting out in front of established opinion. She began to get some backlash as she moved ahead.

Camden, on the other hand, experienced smoother sailing as he became increasingly aware of the political currents swirling about in his constituencies. He was energetically tracking the information he was receiving. Jacqueline was also energetically pushing the solutions she was creating. Camden was assiduously touching all the power bases. Jacqueline was also relentlessly opening new sources of potential. Camden set up a steering committee of key players from the major constituencies to help formulate a plan for the future. Jacqueline encouraged each of her constituencies to create their own action teams to develop priorities while she channeled emerging ideas from all sources to the existing groups.

Camden's leadership process was slower but more orderly.

Jacqueline's leadership process was faster but less orderly. In both cases, new energy and creative ideas began flowing in greater abundance. It was actually a little strange, though. Camden was more assertive eventually but less so at first, and Jacqueline was just the opposite. Camden seemed to be more fixed on clarity of result, while Jacqueline seemed to be more fixed on consistency of process. It was a very interesting contrast of styles.

Initially, Camden's leadership rated a seven on heart and an eight on mind, and Jacqueline's leadership was the reverse, with ratings of eight on heart and seven on mind. Would Camden's more results-oriented approach or Jacqueline's more process-oriented approach, both assertively pursued, work out more productively?

TWO COLLEGE PRESIDENTS STEP ON DIFFERENT ACCELERATORS

Camden Gould	Jacqueline Hope
Started with internal leaders	Started with external officials
Discussed background thoughts	Proposed preliminary initiatives
Tracked new information	Pushed creative solutions
Touched power bases	Sought new potentials
Slower, more orderly leading process	Faster, less orderly leading process
Wanted clarity of result	Wanted consistency of process
Seven for heart; eight for mind	Eight for heart; seven for mind

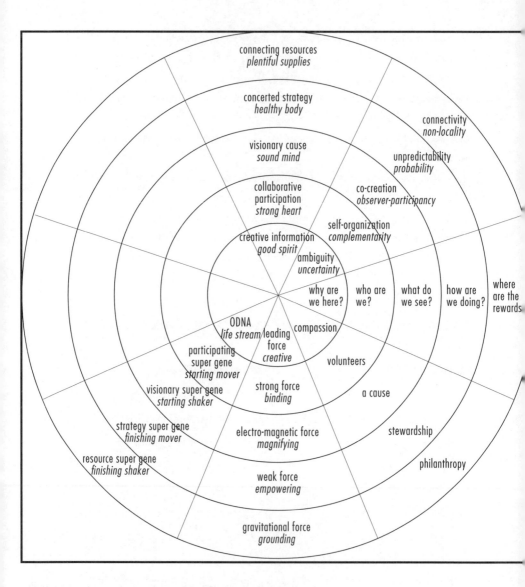

FIGURE 3: QUANTUM CIVICS PARADIGM C

Start reading from the north axis and read from the center toward the circumference, then proceed in like manner clockwise around the concentric circles to identify (1) the leading properties and civic values, (2) peculiar features and quantum principles, (3) key questions, (4) distinctive aspects of voluntary leadership, (5) the natural alignment of forces, and (6) the ODNA super genes and their special roles.

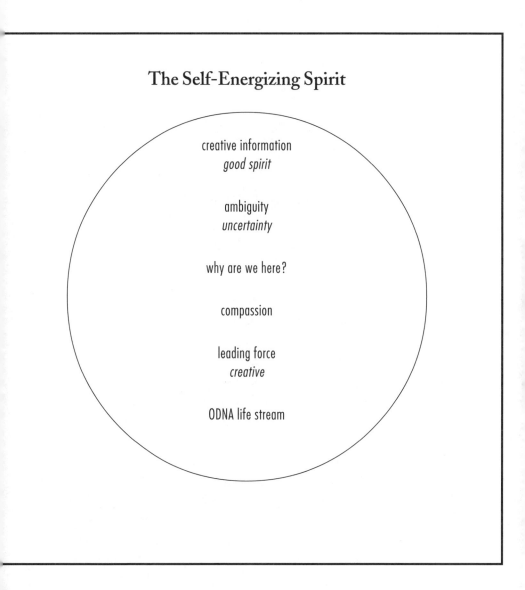

The Self-Energizing Spirit

creative information
good spirit

ambiguity
uncertainty

why are we here?

compassion

leading force
creative

ODNA life stream

FIGURE 4: THE CENTER OF THE CIRCLES

The creative information and energy of the ODNA life stream permeates the entirety of the concentric circles of the quantum civics paradigm of leadership as suggested above.

"My bounty is as boundless as the sea,
My love as deep; the more I give to thee,
The more I have, for both are infinite."
—*Shakespeare,* Romeo and Juliet

4. COLLABORATIVE PARTICIPATION:

Searching for Heart

In June 1997 one of my students, Gilberto Flores, was elected California state director (chair) of the League of United Latin American Citizens (LULAC), the largest and oldest civil rights organization for Latinos in the United States. He framed the platform for his candidacy and his campaign strategy as his class project that spring. His focus was leadership development. And his dream was that every Latin American in California should be empowered with knowledge about how leadership works at the community level. This is where real change affecting Latinos would come first and do the most good. After he was elected, he arranged for me to speak on a panel at the LULAC national convention that was held in Anaheim later in the month.

At Gil's suggestion, my theme was grassroots empowerment and my message, delivered in English and also translated into Spanish, was how to do leadership through use of the quantum civics paradigm. During the question and answer period afterward, when someone exclaimed how he had been wronged and was without help in his community, I was inspired by the man in the audience who stood up and declared "You have the power to do something about this yourself! Just get started, and let the rest of us know how we can help you." And he sat down to loud applause. This was exactly the point. Collaborative participation starts with a single voice speaking out.

Later in the summer, Gil asked me to come to Sacramento to speak with his new state board and then in the fall to San Juan Bautista to do a training session for board members so that they could begin a process of creating awareness of the enormous potential power Latinos have for grassroots self-empowerment *even if no one else does anything*. This is not the message that people are generally used to hearing. With the huge growth of the Latino population in California that is expected to continue indefinitely into the new millennium, this message of self-directed collaboration at the grassroots could make years of difference toward better communities for all. It is a message that every disadvantaged population can use not only for its own benefit, but also for that of the wider communities where they live and work.

COMPLEMENTARY RELATIONSHIPS

The interdependent world, of which we all are a part, so highly touted by global thinkers, is a world of connections. I can remember how my dad used to note the importance of connections, but I remember that his point did not hit home right away. I can remember thinking, "Are contacts *that* important?" I was worried about how to distinguish superficiality from substance. Dad was big on relationships, and I did not quite get the depth of his point that both in combination are the key. He was big on doing what was right, but he was also big on making the connections to allow that to happen. It took me a while before I understood that they go together.

In complementary relationships, we are tied together to make a whole even though we are thought to be opposites, polarities, contradictions. Two properties of the same reality are different. Their two-dimensionality creates a tension of opposites in which both sides appear to be struggling with each other, as if in a tug of war to see who has the greater strength. This is one way to look at complementarity. There is another way.

In complementary relationships, both sides are necessary to

complete the picture of reality. The whole is actually a duality, as in the tiniest quantum particle-wave energy unit of the universe. When you get down to the core, you guessed it, you find *both* Adam *and* Eve, both a female and a male, because we need both for the world to go round. Yes, complementarity involves interdependence. Complementarity calls for collaboration. In complementarity, there is genetic altruism.

Paradox rules at the roots of reality. The *selfish* interest of our genes is to protect their futures, and that means they must be *unselfish*. Without interactive relationships they could not survive. And survival is basic to all our instincts. At the genetic level, which drives life itself as we have seen, the instinct for survival translates into unselfishness, that is, the selfish pursuit of cooperation that serves the mutual survival of "interdependents." It is like the two strands of the DNA molecule of life. Each is the complement of the other. One is left-handed going up, and the other is right-handed going down. A perfect match-up. In this way, they connect with each other up and down the life-line of survival and reproductive success.

Without a reasonably complete understanding of what's going on, or as near to one as we can get under the rushed circumstances we so often seem to face, we risk going forward ill prepared. We may be on dangerous ground. We react in fear. Of course, we must constantly make decisions with incomplete information. We are busy. We are driven by schedules and deadlines. The pressure seems always to be there one way or another. What are we to do?

We pause, at least momentarily. We check out who is involved and who may not be, but should be. We look at what purpose can unite the group. We think about the alternate game plans that might get us where we want to go. We figure out what support we need to provide the necessary resources. And we figure out what information we need to share in order to keep everyone's eyes on the same unfolding picture.

In short, we take stock. First in our quantum inventory we find the uncertainty principle which tells us that the future is ambiguous and unpredictable, but that we can play creative roles in shaping it. Next we find the complementarity principle which tells us that apparent opposites are

really two sides of the same coin, and we need to understand both. Then we can look ahead and see the observer-participancy principle that holds us accountable for our response to situations, and we cannot avoid this responsibility. Following that we can discover the probability principle which suggests that all things are produced from potentials, and we need to commit to a course of action. Finally, we can see the non-locality principle which suggests that all reality in the universe is connected to everything else in a giant network of relationships, with the implication that volunteer champions and their collaborators must connect to means of replenishing their wherewithal.

Most fascinating about the complementarity principle is that, as intelligent beings, we humans may be seen as the children of Mother Nature and Father God, of the finite body and the infinite spirit. We are the consummation of our physical and non-physical worlds in the whole of the universe. Our hearts and minds are linked to it. So, we can see and understand natural phenomena. The dialogue between humankind and nature would not be possible if our hearts and minds were unable to perceive, interpret, and understand the sights and sounds which nature makes possible. We need to "get real," as the saying goes, and getting real is making peace with our nature, both our own and the world's. And we can do that, the complementarity principle indicates, to our very great advantage not only individually, but collectively as well.

Our energy level is far more important than we generally realize, both in ourselves and in our organizations. Our energy is creative, and this creativity comes from our natures as intelligent beings who are dynamically alive. This energy is literally full of information, actually creative in-formation. Creativity in process of formation is in-formation, information with a hyphen, as Margaret Wheatley has shown. The creative potential carried by this in-formation is extremely important to us, much more so than we normally think. It quite literally gives us the breath to breathe, the food for thought, and the energy to be strong. Like the invisible waves that carry television signals to the receivers in our sets at home to be transformed into talking pictures, it transmits light to darkness and sounds to silence.

WE ARE QUANTUM PERSONS

The heart of a leadership process is people working together. It begins with the consciousness of an individual who becomes excited by the occurrence of a thought. An idea germinating into a more complex process of thinking is all it takes for quantum excitation to rise toward ordinary everyday action. The action is instigated with an expansion of consciousness that spills over into conversation with someone else whose attention is stimulated enough to listen and respond. A connection is made and an interaction takes place that accelerates into wider conversation with others, reinforcing the initial thinking that precipitated the original conversation. Someone speaks up, stands up, and acts up. Others join in. A quantum process is under way. *The quantum process is the dynamic through which kinetic energy develops from potential energy.*

As Danah Zohar shows, the quantum process is initiated by quantum persons, that is, ordinary people driven by the extraordinary powers of their consciousness. Human consciousness has distinct characteristics akin to those of a quantum system. A quantum system, functioning deep inside the real world of everyday reality, is one that is dynamically charged by electrons and photons oscillating and interacting. In doing so, these infinitesimal particles extend the waves of their being across an infinity of invisible boundaries, into the orbits of other electrons and photons, looking for new orbits to explore and establish as their next homes. They cannot be found in a single place, but are everywhere at once, it seems. They are taking up temporary residence in many different places in the process of settling on a choice among prospective new locations.

This transitional state, common to the sub-microscopic quantum world, is what physicists call a "superposition," one that goes beyond a single place to many places. It is very important, both because it enables the quantum electron to check out many places at once, but also because it enables it to elude discovery in the process.

This is not unlike the process by which an ordinary person, actually a quantum person, goes about making difficult choices. Doing the right thing is not always an easy call, yet it is nonetheless important that a

good call be made among the various choices available. So, we look into the alternatives, size them up, and figure out which might work best. We are not necessarily sitting on the fence, undecided about what to do. Instead, we may be testing the waters and probing the depths, seeking to find the most navigable course of action.

The inner workings of each of us consists of electrons, atoms, and molecules moving about constantly while obeying the laws of basic reality that reach into our everyday world. We cannot escape their impact, however invisible *they* may be and however unaware of them *we* may be. In fact, as individual persons, we are the intermediaries between the unseen quantum world of the infinitesimal to our material world of the immense. It is our capacity for reflection, for self-conscious thought, through which this is possible. **The inner state may be one thing and the outer state another, but we intuitively sense that the two must be closely connected both in order for evolution to sustain human society and in order for the world to survive.**

Our self-conscious energy epitomizes life at the top of the chain of physical being, human life, organized society. This self-conscious energy emanates from the radiated energy of quantum processes, into condensed energy as matter, on into conscious energy reflected in the progressively complex responsiveness of plants and animals, and finally into human consciousness which is unique in that it is capable of both thoughtful evaluation and self-organization with others to build sophisticated instruments of work and communities of different kinds.

Collaborative participation arises out of human consciousness, and is the analogue of the strong force in nature that binds the atomic nucleus and drives self-conscious energy. Participation is initiated by this sub-microscopic nuclear force that explodes into material being at the macroscopic level. It translates through the electromagnetic force, and the weak nuclear force, gravitating toward the necessary resources to sustain itself. Creative information is the source of our energy, and *collaborative participation is the overt initiator of the quantum process that converts our potential energy into kinetic energy.*

People are the only self-conscious beings we know of in our

universe. **The individual person is the quantum, or indivisible nuclear unit, of creativity in any human organization. Each person, therefore, embodies as its quantum equivalent the force of highest magnitude in all of nature.** This is the strong force which binds the electrons and protons inside the nucleus of the atom and propels the atom into increasingly higher forms of organization clear up to self-consciousness in human organizations. This force is charged with power of the 41st magnitude, far more than any other. It corresponds to the *binding force* of the quantum civics paradigm.

The individual person, then, is at the heart of any organization. But what is an individual person? A singular independent being who works alone? Only partly. While every human is a unique set of genetic traits and cultural influences, humans hardly work alone effectively for very long. We all have lifelines to others, starting with our parents and extending to whatever families, friends, neighbors and associates we may have. Our lifelines are necessities, not luxuries. We depend on others for all kinds of assistance as we pursue our journeys. We cannot do without them. In fact, it really is hard to tell where the identity of a single person leaves off and the identity of his or her interpersonal relationships takes over.

Quantum intimacy, the very close association of two persons who are sharing a common pursuit, as Danah Zohar has explained, involves a working interdependency that makes soul mates out of associates. Intimates are on the same wavelength. Each knows how the other feels and thinks. Literally, the fields of their dreams overlap so well that they produce synergy, as author and corporate coach Chris Alexander stressed to each of my classes at Chapman. Chris, who was born and raised in southern Africa, liked to point out that synergy is something greater than what each of us would produce separately, something that is universal to human success. In quantum reality, this state of being is not only possible, but is the necessary way that living beings exchange information and share interactions to produce higher value.

Quantum reality is not about bouncing ideas off one another or passing things by other people or engaging others in serial monologues.

It is about sharing thoughts and responses, exploring suggestions and feedback, brainstorming, and, most of all, entering into intensive dialogue, as quantum physicist David Bohm long advocated, with others whose opinions are different, and therefore of interest. In quantum reality, deep inside the everyday real world with which we are most familiar, the energy fields of two or more people intersect and overlap, more or less. The more they do, the greater is the likelihood that one will learn from another and grow to respect the other, even to love the other. **Quantum reality is about the meeting and merging of individual energy fields into joint energy fields that enhance the strength of the participating individuals and produce synergy.**

Shared consciousness is the result of quantum intimacy. This carries the weight of an important set of assumptions not to be taken for granted. These quantum assumptions are that a person's consciousness is more or less based on having a healthy self-image, workable relationships with others, and a sensitively reasonable outlook on the world. Mutuality is more of a practical possibility and even a wonderful opportunity as these three assumptions become more real, and are framed in a coherent world view. Quantum reality offers a unique opportunity to put together a new view of the world that likely will magnetize the potential energies of those who commit to the adventure. The first step is to recognize that we are quantum persons who have the responsibility of making choices and are, in fact, free to make those choices.

VOLUNTEER RESPONSIBILITY AND FREEDOM

A quantum person chooses. Participation entails choice. People are participants as quantum persons. *Quantum persons are the activators of kinetic energy that develops from the potential energy people have by their natures.* Their energy fields necessarily interact with other energy fields at all times. The choices people make may or may not be conscious. In either case, decisions are made and action is taken accordingly.

Quantum consciousness always involves at least some degree of

quantum superposition that opens up multiple possibilities for happening. Consciousness ranges freely over the possibilities. As a choice is made, all other possibilities fade into the background, and energy is concentrated on the choice. When this happens in quantum reality, the various reaches of a particle's wave function, extending out over a given space, coalesce into a single quantum event. An event actually materializes as the result of its probability potential in relation to other alternatives. The probability is higher that an event will happen when there is least resistance to it, that is, where the least energy is required to make it happen.

But that does not assure that such an action will occur, only that it is more likely. Choice may be exercised to take a higher energy level option that may be more desirable. So, it is very important to work the probabilities. It is imperative that special effort be made to improve the chances that something desired will actually happen. This is where calculated thinking comes in. What effort needs to be made and where does it need to be made in order to increase the likelihood of something happening that is desired?

Again, responsibility enters. We can think of it as response-ability. Developing response-ability toward what is desired makes a lot of sense. The more ably we can respond to opportunity, the more we are assured of getting what we desire. What is nice about this is that we have the freedom to choose what we are going to do in response to the circumstances before us. We are given our circumstances, but not our responses. We get to choose those.

The more able we are to see ourselves as quantum persons and to develop our quantum capabilities, the greater will be the range of choices we are able to make. This is what is meant to be free. To have choices is to be free. But making choices is not enough. We need to make effective ones. How do we know which are the most effective ones? The question begs the answer. The most effective choices are those that enhance our capability for making choices. This is not to say which choices we will make when we have the opportunity to choose. Only to say that we have that opportunity. This is empowerment, power that is ready to be used at the discretion of the holder. This is the possibility of self-actualization, of

realizing one's dreams.

Taking responsibility for expanding choices and the freedom to execute them is a matter of building quantum connectivity. This means building relationships with all phenomena that may figure into a calculation of improving one's chances as well as the chances of others. To do this, we must build our awareness and knowledge of our environments. We must learn all we can about how to create new phenomena of our liking. This means learning how to put things together, which in turn means learning about the things we want to put together. As we build our knowledge, we build our mastery. As we build our mastery, we increase the likelihood that we will succeed. So, we need to make connections in order to understand, we need to understand in order to master, and we need to master in order to succeed in a self-sustaining way. All of this depends on exercising the freedom that comes with taking responsibility.

Responsible freedom is exercised by volunteering. The role of a volunteer is typically associated with service on behalf of a church, hospital or school organized as a not-for-profit organization. One of nearly every two American adults, more than eighty million people in the latest Independent Sector survey, volunteers an average of almost four hours per week for one or more of two million such organizations at last count. These volunteers are a huge complement to leadership in America all the way from grassroots to global levels of involvement. They, and their voluntary organizations, are a most distinctive feature of the American community in the world. American volunteers are ordinary citizens who have chosen to contribute their services and support to their communities through not-for-profit organizations which enjoy tax-exempt status under the federal income tax code in recognition of the service they provide that otherwise could be a burden of the government.

Volunteering is actually a much deeper concept than stepping forward to help a charitable organization. Volunteering is the act of freely choosing to become involved in anything. Volunteering means to follow a lead, whether it is of one's own making, of another's initiative, or a joint venture of two or more together. Volunteering is being persuaded to do something as a personal commitment to someone else as well as one's self.

Not-for-profits are generally well aware of how critical volunteer service and support are for realizing their missions of compassion. Without it, many of them would be out of business, and all of them would be shadows of what they are.

Only recently have businesses and government agencies begun to wake up to the roles that volunteering actually plays in their realms as well. This has occurred with growing recognition that the typical worker today is a knowledge worker who applies specialized information to critical tasks. The specialized knowledge-ability of such people is typically superior to the more generalized capabilities of those who supervise them. They are, in effect, partners or associates or colleagues of those to whom they report, not subordinates. As such, their outlook is less from the bottom up than it is from the outside in.

Knowledge professionals all have accepted a certain degree of responsibility in their chosen work. The question is how much more of what type of responsibility is a person willing to accept. The answer will be the result of persuasion, by some process involving the weighing of alternative claims on one's values. In any case, the person will end up voluntarily deciding on a level of effort that is comfortable in view of circumstances. This is always true in volunteering. **Prospective volunteers must choose. They will choose to make a greater effort or a different effort or to cut back, whether they are on the job or on their own time.**

All enterprises can learn from the experience of voluntary organizations about volunteering. Volunteers can walk out or walk in any time they wish. They can grumble quietly or complain loudly, whenever their sentiments suggest. They can lobby for their special interests as enthusiastic advocates or as unrelenting believers. They can join in, step up, and go for it as champions of the cause. As champions, they can lead a charge or help pave the way in a supporting role. This is what every organization needs not just at the top, but throughout the ranks.

In not-for-profit organizations, volunteer board members have a special responsibility that has implications for service delivery of any type by any organization. This responsibility is fiduciary in nature. Fiduciary means entrusted with holding and using property given by others who

have, for the purpose of helping others who have not. This trust has legal standing in voluntary organizations. It also has financial standing, but most of all it has moral standing in that the fiduciary is entrusted faithfully to follow the purpose for which the property has been given.

By inspiring confidence the fiduciary attracts the interest and support of others who may wish to contribute to the cause. Also, the fiduciary attracts clients who pay for services offered by the not-for-profit organization in which they have confidence. In this respect, such an organization functions in reality as a beyond-profit organization in that the service providers are doing just that, going beyond profit, as their prime motive.

In beyond-profit organizations, the providers are perceived by clients and customers to be in it for more than their own gain. They are perceived to be doing it to serve others regardless of how strong is the motive for personal gain. **In a beyond-profit organization, the purpose is to provide a living by living to provide. So, the volunteer fiduciary is one who sees himself or herself as helping to hold in trust the totality of a beyond-profit service organization dedicated to helping its stakeholders.**

So, how do we recruit such responsible volunteers? Especially talented ones who see the high purpose we see in the tasks we have set for ourselves. We begin by seeing them as collaborators, co-participants, who bring something valuable to the party. And we can begin also by persuading them that they are getting in on a cause that has the makings of a noble undertaking. What the cause needs now, we tell them, is whatever they have to give, their help in whatever form and fashion they can give it.

Another way to think of volunteers is as free agents. Free agents are people who choose to act independently for themselves and for others whom they represent. In the wake of corporate downsizing and government cutbacks, many previously employed professionals have found themselves out on the market selling themselves as independents. It helps to recognize that every employed person is a free agent in that he or she can walk any time that circumstances demand it. **Volunteers are free agents. Free agents are volunteers. Both are citizens exercising the rights**

and responsibilities of their citizenship.

The inimitable Peter Drucker has long pointed out how a sense of citizenship is the key. Citizens are people who take part in their communities. The idea of community itself depends on the exercise of citizenship, of citizens rising to occasions of necessity. **Not-for-profit organizations epitomize the values of community in their work on behalf of their missions of compassion. Citizens involved with these organizations epitomize the essence of civic responsibility.** Citizens in action as volunteers find meaning in their lives not accessible to them otherwise. They are able to give direction by what they do in ways that are unmistakably important. In this way, they discover meaning that would otherwise elude them.

If organizations respect their collaborators as citizens, not just warm bodies or deep pockets, they are more likely to tap into the deep wells of meaning that bolster the dignity of the quantum persons they are trying to reach. Let us remember that citizens are human before they are anything else. They react very much the way people are programmed by their genes, their culture, and their own experience to react. They exhibit their human nature. They demonstrate the association their human nature has with nature itself. They reflect the potential power as well as the certain limitations that human beings possess as self-conscious beings.

SELF-CONSCIOUS ENERGY

Effective leadership requires a high degree of awareness and self-consciousness among the parties involved. Joseph Provenzano explains that we must not take self-consciousness for granted. It arises from elemental quantum reality in which energy is radiated from the interactions of electrons and photons, through its condensation in all forms of matter, to consciousness as elementary responsiveness in plants and animals, to its unique status in human beings where it is conscious of itself. *This is the pathway traveled in the transformation of potential energy into kinetic*

energy. The self in self-consciousness can be described as a definable energy field that is identifiable in the mind's eye as *my* self, a particular individual. The consciousness that arises from this energy field bestows extraordinary power on the quantum person. At the same time, it places clear responsibility on that person for its use.

In the first place, there is the question of knowing one's own mind, of being in touch with what's going on in one's own energy field, so to speak. There are always a variety of thoughts circulating. Which are uppermost? There are shifts of mood and feeling. Which predominate? There are patterns of thoughts and feelings that seem to unfold over time. What is the nature of these changes? A character of mind emerges that can be described in terms of personality type. How together, coherent, is a particular personality? The first responsibility of a quantum person is to formulate a coherent state of mind that enables that person to live with himself or herself effectively. This is what gives a person a clear self-image, a conscious identity, a "self-differentiated being," to use Edwin Friedman's term.

Then, in the second place, there is the question of a person's relationship to others, to the energy fields of people one meets. This is the connection of that person's self to society. When one quantum person encounters another, as Danah Zohar elaborates in her book, *The Quantum Society*, the two selves meet, and an impact is felt, depending upon how much of an overlap occurs in their energy fields. The openness of a person to others has much to do with the quality of the encounter, that is, with the overlapping of the energy fields. A quantum person has a responsibility to maintain and nurture good relationships with others. This enables that person to develop a self-differentiated presence, a clear social image consistent with a self-identity to which other people wish to relate.

There is also the question of a person's relationship to the world, more specifically to the physical universe. Actually, most people most of the time have very little sense of being connected to the physical world beyond the coincidental, such as when they bump up against something. We should, no kidding, pause for a moment and think about our rela-

tionship to the earth, the sun, and the stars. Is there much that we sense? Is our awareness more a sense of harmony or indifference or alienation? As quantum persons we have a responsibility to build a compatible relationship between our physical selves and our physical environment.

This relationship is what enables our human nature to function effectively in relation to Mother Nature. This is the ground of what enables us to have hope for a future beyond the material immediacy of today. And this, in turn, leads us to the possibility of "consilience," which is the possibility of a unified explanation for our existence in the universe that is discussed by Edward O. Wilson in his exceptional book of that title. Since most of us are not philosophers or maybe not even philosophical, we do not have grand schemes that satisfactorily explain all the phenomena we confront in our daily lives. We are ordinary people who, day-to-day, are simply trying to make sense of our worlds. This leads us constantly to be figuring things out or checking things out in order to be working things out. We often make unconscious assumptions about what is happening in our worlds when, in fact, we would be better off if we were more keenly aware of what is actually going on around us.

The possibility of consilience is a grand idea for leadership in that it takes the view that the facts and theories of our world, however disconnected they may seem to be, do hang together across the separate realities we experience. **In Wilson's words, consilience holds out the proposition that, despite the differences in various states of reality, "the world is orderly and can be explained by a small number of natural laws."** We can find it in a few universal laws that underlie every branch of knowledge and the tree of life itself. In consilience, everything is ultimately connected to everything else in the deepest ground of our own nature and in nature itself. Out of all the disorder in the world, there is basic order in the universe. This is a much-disputed, but very exciting thought, because it suggests a ground of unity in all our diversity, and moves us closer to being a world at peace.

Perhaps as fascinating a thought as that of consilience is the "arrow of time." As Ilya Prigogine has demonstrated, **there is a direction to the change that takes place over the unfolding of events out of unity into**

diversity and back again, over and over, ever unfolding. This arrow of time points toward the increasing complexity and consciousness in the universe that Pierre Teilard de Chardin observed. Driven by an arrow of time, evolution continues its journey through history and on into the future beyond. Open systems, not closed to exchanges with outside influences, have an observable tendency to stimulate greater possibilities of life.

In organizational life, these forms are seen, for example, in a few big companies that have developed greater capacities of human consciousness and, therefore, of human sensitivity. These "living companies," as Arie de Geus calls them, are those that focus on all their stakeholders rather than just their shareholders. They demonstrate a higher level of survival capacity than those that merely focus on the bottom line. One of these is the Cummins Engine Company that is headquartered in Columbus, Indiana and does business selling diesel engines across the world. Visitors there are treated to a remarkable display of company support over many years for the community and its quality of life. The company and the city are monuments to the civic-minded leadership of the Irwin, Sweeney, and Miller families in collaboration with corporate and community leaders.

Living companies have a life force comparable to the DNA in living beings. This is their organizational DNA, or ODNA. And they have learned how to pay attention to it. We have identified five super genes in our powerful ODNA combination. We have seen how the creative super gene functions as our life stream. Now, we turn to the participating super gene.

THE PARTICIPATING SUPER GENE

Adenine, the proposed correlate of collaborative participation in our ODNA structure, is one of the four chemical compounds in our genetic alphabet, AGTC, from which every living creature grows. In each human being the DNA is unique. But all human beings are unique among all

other living beings, which also have a DNA, because we have the capacity of intelligence, reflection, self-consciousness. Both types of uniqueness, those that determine our individual differences as humans as well as our collective differences from other species, are determined by the precise combination of genes strung out across the DNA strands in the billions of tiny cells in each one of us. Our human DNA is also remarkably similar to the DNA of other living beings. What we will focus on here, however, are the similarities we share with other human beings. These genetic similarities are spelled with the four letters AGTC, the basic components of the DNA life molecule. They are our chemistry, the basic chemical compounds of life itself in all living beings.

While we have now discovered the human genome, we do not yet know exactly how our genetic programs produce living beings, let alone exactly what sequence of chemical reactions is responsible for the evolution of a living being. Now, we are learning a great deal rapidly and have grounds for informed speculation that will help us to understand how human processes, in our case leadership processes, function most effectively. This is very important to us because, as I have proposed, there are grounds in experience for believing that the ODNA structure can help us breathe new life into struggling organizations of all shapes, sizes, and types.

The starting point of our leadership process is the quantum person who is the initiator of change that requires the concerted efforts of people in groups. When we are looking for the power source behind these dynamics we can trace our search to the DNA bridge between the micro quantum world and the macro material world of everyday life. Upon arrival there, we find that the bridge has four starting points from which to choose. It turns out, I believe, that one of them will best facilitate both the action and the momentum we need to build leadership impetus. The four alternatives are, of course, the four chemical bases of life that comprise the DNA—adenine and guanine, thymine and cytosine. Each one of these is part of a biochemical network that helps generate the future of living systems.

Let's not forget the basic role of protoplasm, the life-giving fluid of

each cell that is our creative energy and that contains the leadership impetus to get us across the bridge. It is the carrier of life, the creative super gene. The creative energy arising from the protoplasmic life stream is present every step of the way as we cross the bridge. It is the catalyst for each of the four phases through which the leadership process moves.

Form and substance start somewhere. In the leadership process it begins to take shape in collaborative participation. Among our movers and shakers who are also our starters and finishers, collaborative participation is our starting mover, our participating super gene.

Collaborative participation, like leadership itself, does not exist in a vacuum. There is always a context of relationships. Our super genes must interact in order to generate the dynamics of reproduction and growth. In our ODNA structure, the participating super gene interacts with the visionary super gene we are correlating with guanine, the strategy super gene we are correlating with thymine, and the resources super gene we are correlating with cytosine. We'll discuss the others later. Right now we want to focus on adenine, the big A base of the participating super gene, because it appears to be the most likely starting point of our process. We have learned that matter flows through the dynamics of kinetic energy, that is, energy in motion. We are looking for the spark that ignites the leadership process. In adenine, we find the characteristics of flexibility and size that we think can best set things in motion. Not that initiatives cannot come from any of the other chemical bases. Only that decisive movement seems unlikely to occur until the big flexible one, the A factor, gets going. This I propose as our starting mover, our participating super gene.

The leadership process, then, may originate anywhere in the chemistry of life, but it needs a sequence of influence to be implemented. Adenine has the size, the stature, and the standing to move matter from a position of strength. Adenine also has the flexibility, and therefore the potential for excitability, even hyper-sensitivity, to fire the process into a state of readiness. So, the goal is to get to adenine. One way or another, sooner or later, we need the big A to join in and lead the way. This could happen because A initiates or because A acquiesces. Either way, A moves.

A is, in a real sense, the gatekeeper, though not at all an immovable or arbitrary one. What it takes for A to move is a flow of energy that is strong enough to excite A to action. The big A looks like our initiator, the starting mover in the ODNA structure of our leadership process.

The network of collaborative participation is the equivalent of the big A in our leadership process. It must have the clout to attract attention and interest, as well as ultimately, involvement and investment. It must be able to get the ball rolling with such momentum that it is able to sustain the ride to fruition. So, the question now becomes what constitutes sufficient size and excitability to be the big A?

It boils down to building a critical mass of desire into an idea whose time has come. Renowned sociology professor Earl Babbie of Chapman affirmed the thought of Victor Hugo to each of my classes there by calling an idea whose time has come "perhaps the most powerful force on earth." In my mind, it is akin to the strong nuclear force of our quantum micro world, what we are calling the *binding force* of our quantum civics paradigm. As Earl said in one of his many books, *You Can Make a Difference*, "Whatever else it may take to cause an idea whose time has come, one thing seems clear: it cannot happen without individual initiative and responsibility. Somewhere in the history of any idea's time coming, we will find at least one individual taking a stand; usually we find more than one." And he concludes that **an idea's time comes when a large enough number (a 'critical mass') of individuals are willing to take personal responsibility for the whole thing…and act in a manner appropriate to that responsibility."** This is what collaborative participation can do. This is the role of volunteer champions. They are the new heroes of our future together.

When we think of influential people as movers and shakers, we can think of the big A types as movers, people who get things moving in the direction in which they ought to be going. These are people who care enough not only to start the talk, but also to begin walking the talk. Quantum persons are potential movers increasingly as they actualize the inner dynamics of their thoughts into the social dynamics of action.

When we think of these same people also as starters and finishers,

we can think of our big A types also as starters, people who like to initiate, create, participate in building and developing, and are willing, perhaps even eager to be out in front, to go first. Adventurers. Risk-takers. Essential for leading change in a world of unceasing and increasing change.

WHO ARE WE?

Collaborative participation asks a summary question: "Who are we?" By asking this question, we are seeking to learn what we need to know about our collaborators in order to make a judgment of their potential, and decisions about how to improve that potential. The answer to this question has two sides. **One side of the story has to do with the influence of the collaborators, and the other side of the story has to do with the degree of their involvement in the process.** Both sides combine to produce a total output of energy as they interact to yield a result.

To illustrate, let us posit a scale of one to five on each side of the equation, scoring from low to high, making possible a combined score ranging from two to ten. Let us assume that a score of five on either side of the equation represents great influence or involvement, that a score of four represents high influence or involvement, that a score of three represents a fair degree of influence or involvement, that a score of two represents some limited amount of influence or involvement, and that a score of one represents little or no influence or involvement.

A person of great influence would rate a five on this scale. If that same person had only some limited involvement in a given project, that person would rate a two. The total of the two scores of that person would be seven of a possible ten. Now, turn this around. A person of only some limited influence would rate a two on this scale. If that same person had a great involvement in that project, that person would rate a five. The total of the second person's two scores would also be seven of a possible ten, the same as the person of great influence. Who is going to do more good as a productive collaborator for the project at the moment the ratings are made? We will be pursuing the answer to this question as we continue with our story.

TWO COLLEGE PRESIDENTS
RECRUIT COLLABORATORS

Camden and Jacqueline are now several months into their new presiden-
cies. The energy levels of their two institutions have clearly begun to pick
up. There is new voltage in the air. As we watch them, we see that they
are taking somewhat different tacks.

Camden is going for the top people in every arena in which he
must compete. He is going for the high profile stars wherever he can
reach them. He is seeking out opinion leaders wherever he can find
them. He is currying their friendship and their favor whenever he can.
He has a high profile of his own as an experienced president from anoth-
er respected institution, and this has given him a high level of credibility.
The top people he has sought out are responding affirmatively for the
most part, but the question for Camden is how strongly can he count on
them when he needs them.

Jacqueline, too, is seeking out top people, but with a caveat. She
does not enjoy the high profile credibility that Camden carries, since her
previous role as a dean did not accustom her to being in the public eye.
Most of all, she has decided to begin by seeking people who are al-
ready committed to the college or who seem to have a certain built-in
interest. She is betting on commitment over clout as she pursues early
support. What she is looking for are people who will make significant
efforts to help her off to a running start.

Camden's approach to his task has led him to pinpoint key lead-
ers who, as it turned out, tended to operate as "leading men" or "lead-
ing ladies." They had well-deserved reputations either for operating
alone or for getting a small band of loyalists together who had been
down the road with them before. They tended to act as members of an
elite club. Up-and-comers generally did not have much chance to be in-
cluded unless somehow they became one of the family.

Jacqueline looked for different types. Most of all, she wanted team
players. And she found a few very good people in senior positions, but
no VIPs like Camden had found. Initially, she missed out on the top lead-

ers. She thought it would be more important to develop a team consciousness from the beginning. There is no question that the team players had a mutually sustaining effect.

Camden found that his top people did indeed make a difference by the attention they were able to command from many others. They could get more calls returned promptly and more invitations accepted. But sometimes the support was a mile wide and an inch deep. The trick was to net some really committed big ones with the broad net he was casting. He was able to do that.

Jacqueline realized that her people did not have the pulling power that the very top people had. Most of her people were committed team players without decisive influence. Yet they seemed to work harder and take more responsibility. Those they recruited were generally people she could count on. Her task was to find her strength in numbers to make up for what she lacked in big names. Her hope was that she could eventually attract some top people who became impressed by the demonstrable commitment of her lower profile people. This would take time.

Camden's top people more often than not saw the opportunity to assist him at his institution as a marketing opportunity, one way or another. They tended to see what they were doing for him as an extension of their business strategy. They had agendas of their own that produced mixed motives.

The people associated with Jacqueline were not quite like that. They tended to see the opportunity to help her and her institution as a service or even as a cause of high purpose. Their commitments tended, therefore, to be deeper and a bit more intensive. Whatever agendas they had of their own were less likely to compete with the institutional agenda.

In essence, Camden's initial collaborators were generally fives on the scale of influence, but only threes on the scale of involvement. Jacqueline's early collaborators, on the other hand, were generally twos on the scale of influence and fours on the scale of involvement. As a result, Cameron's score of eight reflected a faster start and Jacqueline's score

of six reflected a slower start on the scale of collaborative participation. What strength would these two different starts lead to in the end? We will see as we continue our story.

TWO COLLEGE PRESIDENTS RECRUIT COLLABORATORS

Camden Gould	Jacqueline Hope
Approached top opinion leaders	Approached civic team players
Recruited elite leaders (the shakers)	Recruited supporting players (the movers)
Received transient support	Received greater commitment
Brought mixed motives	Brought concentrated attention
Five for influence; three for involvement	Two for influence; four for involvement

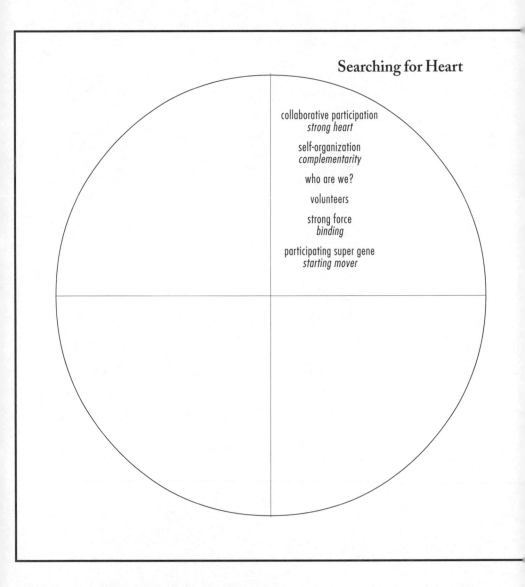

FIGURE 5: CIRCLE OF ODNA, QUADRANT I

This first quadrant of ODNA is the sibling of the second quadrant (page 152), the mate of the third quadrant (page 180), and a collaborating relation of the fourth quadrant (page 210). Quadrant interactions are shown on page 224.

"Where there is no vision the people perish."
—*The Holy Bible KJV, Proverbs 29:18*

5. VISIONARY CAUSE:

In Our Mind's Eye

In early 1998, I was invited by the Salvation Army's Western United States Territory headquartered in Rancho Palos Verdes, California, to assist them in developing a new vision to guide their College for Officer Training. Territorial financial development director, Bob Gregg, a graduate student of ours at Chapman and formerly of Boys Town in Nebraska, challenged me to facilitate a three-fold set of all-day vision retreats modeled after those done for the voluntary leadership program at Chapman by outstanding author, consultant, and facilitator, Burt Nanus. It was a fascinating experience.

The Salvation Army in many ways is one of the leading causes in the world, including in gift income. It is organized like a church, dedicated to serving the poor and neglected, and is comprised of "Christian soldiers" whose demeanor and dedication is beyond any I'd seen before. I was stunned by the quiet heroism I observed among these servants of God, as they are proud to be known, who devote their lives to serving those in need. But this is not the point of the story.

The point is that the College for Officer Training or CFOT (as it is known) of the USA Western Territory, decided that it needed to reconsider its vision of the future in light of threatening signs of officer deficits in numbers and preparation. Salvation Army field officers are expected to deal competently with an extraordinary array of daily challenges that would intimidate the ordinary manager of a business or government agency. And they are expected to do so sacrificially, by devoting their lives

to it. The officers are required to submit to an unwavering discipline of spirituality and dedicated effort that would daunt all but the most stalwart. They are, in my opinion, a breed apart, to be admired and held in awe.

Why, then, should such a group wish to reconsider the vision it has of how it trains its officers? After all, it is one of the most supported causes in all the world, and appears to be growing. There is another side to it, as we might have expected. The CFOT at Rancho Palos Verdes believed that it had to do better, much better, in order to provide the trained officers of the future the ability just to keep pace with the rising tide of social services the Salvation Army is providing to needy clients across the western United States.

The issue was not whether it needs to change, but how. What vision of the future would build on the great traditions of the past while allowing important adjustments for the future? It is a common question. The uncommon thing about it was that a critical part of this huge organization of Christian soldiers would consider how to revamp its disciplined training to remain in fighting trim. The eighteen men and women, ranging in age from teens to seniors, who made it through the three separate days of our vision retreat, were extraordinarily devoted to their mission. This is what set them apart from most of those I've seen before. The wonder to me was their military-like dedication to social service. Their arms race, I thought, was a different kind of arms race, one which literally and figuratively put its arms *around* those they are aiming at, with compassion.

Even such a leading cause in the world has to change the present in order to serve the future. Every cause I can imagine should learn a lesson from the Salvation Army's USA Western Territory. Do not stay put, relax, get smug, or be stubborn. Your success will turn into your failure if you do. As it turned out, we came right down to the wire on our third and last day in the attempt to leave the retreat with a consensus statement of vision for CFOT that could be taken to territorial headquarters for action.

Everyone at the retreat sessions had been asked to leave the uni-

form at home and dress casually. No one, not the ranking officer in charge nor anyone else, was to dominate the discussion. Whatever direction that might be taken would emerge from discussion within the group. Actually this was to be more of a dialogue, self-organized dialogue. And it was. Faced with an impending deadline, and looking at the options on the whiteboard before us, a suggestion was made that captured the spirit of the participants who, by now, had become true collaborators in this task, and consensus was reached with an exciting proposal in hand. I have been excited to learn since then that the new vision was accepted and has blossomed beyond the expectations of that day.

OBSERVERS ARE ALWAYS PARTICIPANTS

The fascinating thing about being an interested observer, especially a passionately interested one, is the empowerment that takes place as a result. Initiative is more often taken than it is given. As initiative is exercised by interested observers who are increasingly passionate about their interest, their capacity to effect change grows, and grows exponentially when acted out in concert with like-minded others.

The quantum law of observer-participancy indicates that all observers always are also participants whose actions have an impact on outcomes. They decide what they wish to see and how they want to look at it. This is very important for our consideration of visionary cause. Collaborating participants are making choices that influence others. And they must take responsibility for these choices. Most importantly, these choices are helping to create the future and the future will reflect the responsibility of the choices that are made. Inactivity is also a choice and also has an influence on outcomes shaping the future. *The future is always the product of a process that creates a level of kinetic energy from a level of potential energy.*

Observer-participancy is a harsh taskmaster. It is relentless, unforgiving. One must choose what one is to observe. One must decide what to pay attention to. The alternative? Fuzziness. Confusion. Disorienta-

tion. Alienation. That's the downside. The upside is empowerment. You decide and you create. The observer as conscious participant helps to create the future as a collaborator with whatever the circumstances are and whoever is part of it. **By taking responsibility for participation, the quantum observer chooses that which will be the subject of concentration, and the future unfolds from that point. All other factors disappear into the background. The vision of the observer becomes the magnifying force of that observer's participation.**

Phenomena being observed have a way of showing the observer what he or she is looking for. For example, the famous Two-Slit Experiment, performed thousands of times by physicists over many years, demonstrates the qualities of particles if viewed going through a single slit and demonstrates the qualities of waves if traveling through two slits. The decision by the observer is crucial: to look for particles one examines movement through a single slit or to look for waves one examines movement through two slits. The observer participates in the action by deciding what to look for and therefore how to measure results. The decision of the observer transmitted to that which is being observed intervenes on behalf of what the observer is looking for. The observer truly becomes a participant who co-creates the future by deciding what to look for.

If you don't like what you expect the future to be, then get involved and change it. To say that "the best way to predict the future is to make it" is an old saw because it contains an essential truth. Whatever one decides about the future, one is helping to make happen by doing something about it, or by not doing anything about it. **A net producer of resources adds to the total. A net consumer of resources subtracts from the total. Both affect the total. Both impact the future.**

THE NECESSITY AND POWER OF CHOICE

The individual self, deeply rooted in nature and deeply involved with others, is the source of all transformation. The quantum person is the creative bridge between the world that is inherited and the world of the

future. As participants in the action of whatever is going on, quantum persons can, for example, measure either the position or the momentum of a phenomenon at any point in time, but never both at the same time. This is the principle of uncertainty, or quantum indeterminacy, which we looked at earlier.

We can never know all there is to know about something, however close we may think we have come. This is true for all seemingly opposite or polar extremities that we may experience. They seem to be everywhere. Our everyday pursuits and observations seem to have built-in dualities, just like our mother energy source, the quantum, that particle-wave duality we have been considering. Someone or something can be this or that, it seems, one or another that appears to be at the opposite end of a given scale or mathematical equation. These differences are evidently irreconcilable. But are they really?

Leadership demands that there be a direction. How do we make a judgment before we set off on a journey of any kind, in thought or action? In the dynamics of quantum systems, and therefore in our human consciousness, different possible realities are tried out or imagined virtually all at the same time, to sense what would be the most desirable future in a given situation. These simultaneously imagined multiple realities or super-positions as we have noted, enable the observer-participant to mentally interact with these potentialities before making a decision about what to do.

Such super-positioning enables the active participant to reach a more useful decision. When this process is spread among others, it produces a dialogue that leads to mutual focus. The "I" now becomes "we." What are we looking for? How do we evaluate what we find? In every instance, sooner or later, we engage in super-positioning to pay attention to one thing more than other things. When we do, all else tends to fade into the background. Reality narrows to what we see. It excludes what we don't see.

This leads us back to the fundamental point we saw earlier. We can only clearly see one side of a coin at a time. While we are taking the measure of one side, the other side is out of sight, but is not gone. It simply

does not exist in the eyes of the quantum observer-participant who is, at the moment, fixing attention on the one side. It may be outside the field of vision, but it is not removed as a potential for coming into view when the coin is flipped and turns up heads rather than tails.

Our requirement is to get a focus on what we are interested in until we can see it clearly. If we are interested in the position of an object, then we cannot measure its momentum at the same time. We have, at the moment, chosen position rather than momentum. This does not mean that momentum is halted when we take a snapshot of position. It just means we cannot see it and, therefore, cannot judge it at that instant in time. And when we measure momentum, this does not mean that there is no position. It means that we cannot tell exactly what it is when our attention is focused on calculating momentum.

We live in a world of polarities or opposites, seeming contradictions. They are in a continuing state of motion and change, seen or unseen, but always remain in similar relationship to each other. When we look at something and see it clearly, we are not looking at its opposite and, therefore, are uncertain about its status at that moment in time. But **we must be mindful of Richard Farson's playful but poignant observation in his scintillating book on *Management of the Absurd* that "the opposite of the truth is also true."**

This illustration of a two-sided coin mirrors the universal duality in all things, generated by the reality of quantum systems everywhere. Strangely, because the opposite of any given truth is also true, there is always another side to what is reported, what is seen, what is presented. We often forget that as we think about whatever it is that is on our minds, when we watch the evening news, when we form impressions of people, when we envisage alternatives from which we must choose. Are we getting the right impression? Are we hearing the straight story? Are we making choices based on good information?

It helps to be mindful that we can't be absolutely certain about such things, so we need to hold an element of doubt in reserve to help us cope effectively with changes that sometimes are surprising. It is necessary, of course, to hold beliefs about many things of great variety and type

in order to make decisions that have to be made, even when there may be little or no specific information to go on. **We simply need to be careful about framing our beliefs as absolutes that never change. Typically, our beliefs unfold as new dimensions of a subject are introduced to us. Our understanding becomes richer. It may even change appreciably.** This does not mean that we should not cherish our values or hold dear our friends and loved ones. Of course we should. It means, rather, that our values and our relationships evolve over time and are never precisely the same as they were or will be. That is wonderful, when you think about it, isn't it? What an exciting world we live in!

FUTURE PULL

George Land and Beth Jarman have developed a compelling approach to the importance of vision, surprising to most. They take us back to the growth of living systems stimulated by DNA that contain the genetic codes of their possible futures. The DNA is inscribed in the nucleus of every cell so that every part of the body plays a role in developing the future of a particular system. The future of any living system, therefore, is circumscribed by the DNA of that system.

The DNA pulls the future into being from the seed planted at conception. It is, in effect, a magnetized image that draws the future out of the present. For us, as people, this means we live with a micro-vision of an unfolding future that prompts us to develop in certain ways and act accordingly. Contrary to our common conception, we are not pushed into the future by our past, not driven by our histories, but pulled into the future by our DNA attractors and our culture-laden imaginations.

This is a point of potentially astounding proportions. It not only contradicts our assumptions that we are limited by what we are, it tells us instead that we are really limited by what we will. Our visions play a far more powerful role than we realize. **Our visions are the prime indicators of where we are heading and what we are doing. Our visions are mental pictures we have of ourselves that transmit every moment to every one**

of 50 trillion cells in our bodies, not just to the 15 billion of them in our brains. The body is full of the mind. Its neurotransmitters communicate the messages of the mind to every muscle in the body moment by moment. Visions are powerful guides. The clearer they are and the more resolutely they are held, the more potent they become in the thoughts we have and the actions we take. The future really is in our mind's eye.

Now that we know about vision's accessible potential, we can more effectively imagine the futures we want. Just imagine, we might dream, what it would be like if. We need to know with Shakespeare's Prospero in *The Tempest* that "we are such stuff as dreams are made on." But dreams are not just sleep-induced images of reality. They can be conscious images of the future with great power. We need to dream about what we would like to be, and then make plans and preparations to live those dreams. But we need to get a strong focus on the vision of our dreams if we are to make future pull work.

To do this most effectively in our beyond-profit organizations, we must build the shared vision of our co-leaders. Prospective co-leaders include all those who identify themselves with our organizations. Think of them all, whatever their roles may be, as volunteers. Each one chooses to get involved, more or less, with the vision and to become one of its champions. **Our volunteer champions one and all are our co-leaders. Nothing else matters more about them than that they are collaborating participants who are working together with others in the name of a shared purpose.** This is the essence of civic culture. Executive director Irene Martinez of the Delhi Center in Santa Ana, California, put it very simply: "Vision is the heartbeat." It's what people believe in. This is what she demonstrated in my classes at Chapman, what she taught her leading volunteers, and what these volunteers showed Delhi's new immigrant Latino clients in community clinics and workshops.

Prospective volunteers need to develop clear pictures in their mind's eye of what the organization is striving to do and to be. They need to have opportunities to interact with the vision, to enter the organizational mind as deeply as possible, to encounter the soul of the cause it represents. They need to become intimately familiar with the vision's im-

plications and meanings. They need opportunities to participate in shaping the vision, to transpose it for others, and to extend its messages as far and wide as possible.

The challenge of building shared vision among de facto volunteers, that is, all those who must be persuaded to buy into the vision, is to clarify its contours so compellingly that they stand out in relation to other visions which are competing for attention. Vision volume is turned to high pitch in today's multi-message society. Information overload is rampant almost everywhere almost all the time. Visions need to sport sharp images to be noticed and remembered among people who are very busy living their lives in these times of perceptively faster pace and greater pressure. Vision is at the high end of leadership.

FOCUS IN THE FACE OF CHANGE

In the quantum world realities that the discoveries of 20th century science have unfolded, we have learned that an observer in any situation becomes an active participant at a moment of choice. This is what the principle of observer-participancy means. A thought occurs to an observer and a decision is made to act. At this instant of participation or action, our observer's field of vision narrows to a single focus. All else, at least momentarily, fades away. The choice pulls one part of the picture into the observer's view and leaves the rest of it in the background. Our observer turns one side of the coin toward the camera and the other side away, hidden from the eye.

When the leadership process is initiated, and choices are narrowed as direction becomes increasingly clear, we confront the dilemma of polar opposites. **Leadership always involves change, and change always encounters conflict. Conflict, in turn, presents choices in stark terms, often as polar opposites that somehow must be reconciled.** We can go one way or the other. We can make adjustments as we go. But once committed, we cannot change our fundamental direction without serious risk.

From the start, we must develop the clearest possible focus in the

face of the inevitable change as events unfold. That focus, not rigid but firm, needs to be unwavering even as we plunge forward into uncharted territory toward a result that is very important to us but whose ultimate form is unknowable.

Whatever feelings of excitement and adventure our challenge may stimulate within us, change allows comfort only as it is accompanied by the conviction that the end we have in view is clearly necessary to achieve. Then, as we press ahead in such a situation, our attention span zeroes in on the task at hand and we put aside other priorities that must wait.

The intense concentration of our attentiveness screens out distractions and allows us to focus our energies on what is most urgent. We have decided what we want to do. Now we must deal with how we are going to elevate our vision of the task to such a position of strength that it becomes a powerful magnetic force.

THE CAUSE

Our task is oriented toward achieving a mission that defines who we are. The mission is the basic purpose that describes what we see ourselves doing. The mission is our ongoing function that reminds us constantly of our rationale for being. It represents the core business we're in. It lives in an overriding present.

Our vison is something more. As Burt Nanus describes it in his excellent book on *Visionary Leadership:* "There is no more powerful engine driving an organization toward excellence and long-range success than an attractive, worthwhile, and achievable vision of the future, widely shared." Vision, too, lives in the present. And it is based on the mission. But it is primarily future-oriented. It vividly describes, even colorfully portrays, anticipated success that enlivens the mission as it builds on its foundation.

The vision adds excitement to the mission by incorporating an extra level of achievement that surpasses realization of the mission. Vision

steps up the heartbeat, increases the pulse. It says we're not only going to do this, we're going to do this in some extraordinary fashion that can be distinctly imagined in the mind's eye.

Compelling vision is the leadership counterpart to the control factor in management. Visions are the boundaries that frame the change of organizational direction. Controls are the boundaries that frame the direction of organizational change. The vision needs to give direction to the controls and the controls need to enable change mandated by the vision.

Yet, there is a level beyond vision to which we should aspire. And that is the level of a cause. A cause is a feeling so strong that it is deeply heartfelt. A cause involves a moral high ground that literally stirs the emotions. A cause lifts up a seemingly impossible vision and, in so doing, rivets the attention of those who are caught up in its inspiration. A cause seems to compel commitment by the high-minded anticipation it holds. A cause is grand, a noble endeavor worthy of the highest respect. Those who are advancing a cause are admired for their commitment to something greater than self.

People pursue missions. People are excited by visions. People sacrifice for causes. *In the leadership process, there is an increasing progression from potential energy to kinetic energy in the movement of focus from the basic mission to the exciting vision and then to the noble cause.* **This is the fire that burns in collaborating participants.**

A visionary cause shines in the mind's eye as one that is both exciting and noble. The wheels that set it in motion are a set of values, that is, those qualities held in highest esteem which are most prized and appreciated. Values create an evolutionary frame of reference for the process of leadership. They define what is most important, what has the greatest worth, in light of the end we have in view. Values ultimately define an organization just as they do an individual. Values are demonstrated in the transition from vision to action.

In the quantum civics paradigm of leadership, the defining values are civic values, those qualities which foster quantum leadership in matters pertaining to the rights and responsibilities of citizenship, values we

have come to associate with causes. *In quantum civics, our values are those which are essential for developing potential energy into kinetic energy for our communities.*

The first quantum civics value is creative information. It is a self-energizing spirit, the life-giving oxygen that enables organizations to breathe deeply and to be dynamically alive in pursuit of their directions. It is the product of their efforts that demonstrates how well they are *transforming their potential energy into kinetic energy.*

The second value in the sequence of quantum civics is collaborative participation. It is the heart, the moral ground upon which an emerging group of stakeholders who want change begin forging a proposal that would not only produce what they want, but also help stakeholders who are happy with the status quo, a win-win situation. This is where the process of leading change starts.

The third value in the quantum sequence of leadership is a visionary cause. This is the collective mind of collaborating participants who infuse their shared vision into a cause with which other citizens, non-stakeholders, can identify. **The situation now shifts to win-win-win. The triple win draws in the consideration of community impact.** The triple win says that you and I, as parties to a given leadership process, have not done our jobs until we have factored in members of the wider community who ultimately will be influenced by what we do and will respond to what they think we are doing as they become increasingly aware of what is going on. This introduces a "new leadership ethic" which is concerned with producing the greatest good for the largest number over the longest period of time at the lowest cost or with the least effort.

The fourth quantum civics leadership value in the sequence is concerted strategy. Here is the organized body where we shift our focus to implementation. **The new leadership ethic becomes a triple win strategy of "moral pragmatism" in which our attention is concentrated on what works for the whole body of people involved.** We engage strategic thinking to anticipate the array of potentials that may affect our situation. We strive for competitive excellence necessary to be all that we can be in light of others who are pursuing similar goals. We embrace ethical values to

ensure we stick to a pathway most likely to produce the triple win we are seeking.

The fifth value of the quantum civics leadership sequence is connecting resources. This value calls forth all the human, material, and financial energy available to pursue our mission, enhance our vision, and further our cause. When we begin working together, we ask where these resources will come from and we begin reaching out for them. We keep in mind that the resources we seek to keep us going are resources that must serve the integrated agenda of priorities emerging from our efforts. This is a special challenge because we want to stay on course at the same time as we do not want to fly off on a wild goose chase.

THE TRIPLE WIN

Our attitude going into a leadership situation is critical. Instead of thinking about what is in store for us in narrow terms, we do better to think broadly about what the future may hold in store for everyone who might be impacted, everyone we can imagine having a stake in our decision-making. Instead of looking at the situation only from our own viewpoint, we also look at it from the prospective viewpoints of others we will likely affect and who will respond to what they think we are doing.

We consider more than scoring a win for ourselves. We consider more, even, than also scoring a win for other parties to our leadership negotiations with a direct interest in the situation. **We think about triple wins in which both parties win and other stakeholders, who are not direct parties to the negotiation, win as well.** We refuse to be parties to deals that satisfy us and our deal-making partners but that harm the public in the process. Win-win is not enough. We are only interested in win-win-win agreements. Our choice of such a broad focus sets a wider circumference around the actions we take and the values we apply.

The new leadership ethic called for in this more comprehensive perspective relies on collaboration and consent among the parties engaging in change. **The new leadership ethic seeks the greatest good for the**

largest number over the longest period at the lowest cost for all who are touched by the change. It rests on the premise that this outlook will yield the best return for all concerned. It recognizes that interactions and relationships are the heartbeat of the universe, indeed, that having the right relationships is everything. It puts primary emphasis on improving the quality and dependability of our relationship to everything in our environment. It embodies our resonance with our universe.

The new leadership ethic must increasingly prevail in order to reinforce the growing complexity and interdependence of our quantum world. It must do so with increasing power in order to support our unceasing need to succeed through *real* real-world solutions, remembering that the real world is actually a quantum world within and around all things material, animate and inanimate. Real world solutions, therefore, must take account of the quantum system dynamics at work everywhere in order that we may exercise full responsibility for the participation and vision its values indicate we must follow.

The new leadership ethic enables us to reach out to others with new eyes in mind. We can imagine our work-mates as collaborators, fellow members of a quantum community who share an evolving history together, who become increasingly close, who develop a deeply caring attitude toward one another. Such quantum community members are more than members of a civic group whose mutual interests and involvement can be superficial. Now they have bonded with each other. There is a magnetic force that holds them together. They are naturally aligned, on the same wavelength, inclined to do things together.

Members of a quantum community are emotionally involved with one another. Feelings can frequently run to fever pitch. The possibilities of quantum community open the pursuit of common interests to a whole new level of engagement. The depth of participation reaches down much farther than it would otherwise. The level of commitment holds much more firmly. The quantum community carries an emotional attachment strong enough for members to make genuine sacrifices to help other members.

THE VISIONARY SUPER GENE

In the previous chapter, we looked at adenine as the purine correlate of collaborative participation, starting mover in our leadership paradigm. Now we turn to guanine, the other purine compound of DNA, which has the size and connections to be envisaged as the starting shaker. Big G, as I will refer to it, appears to be the correlate of our principle of visionary cause because it is a combination of influence and steadiness. It points a big arrow in a particular direction without a lot of wavering. It is like a big cool base in the chemistry of life that has the size and stability to concentrate the attention of collaborating participants on the cause they have in common. Big G is one of the two big chemical bases, along with the big A correlate of collaborating participants, and is also one of the two better connected, more stable chemical bases, along with the small C base of connecting resources we will return to later.

Big G seems to be the perfect energizer for leading transmission of the *magnifying force*, operating at the 39th power of magnitude, second only to the binding force which drives the natural order of all things at the 41st power of magnitude. With amplification from big G, the light waves of our *magnifying force* have, through the lens of our quantum civics leadership paradigm, an illuminating quality that enables participants to see ahead to their common ground. The *magnifying force* is analogous to the observer-participancy principle in quantum physics and the principle of visionary cause in quantum civics. At this stage, conscious energy increasingly becomes focused and self conscious, extending the thoughts of participants into the shared vision of collaborators.

As a shared vision emerges with the surge of a visionary cause, it moves the action process into the essential second phase of leadership in which momentum begins to build. When vision is truly shared it becomes the bond of leadership which sustains the process as long as the bond is held. Increasingly now, the energy shared by participants becomes quantized, that is, distinctly dynamic, as it develops in multiples of itself. The more strongly it is shared, the greater becomes the quantum multiple, and the higher becomes the degree of magnification.

If for example the quantum civics paradigm were a baseball diamond, collaborators would be standing on second base, where big G lies, from which they would be able to see both ways to the first and third base corners with their peripheral vision as well as to home plate straight ahead. At any pause in the action of play, they are able to look all around in a 360-degree circle. Their vantage point in the midst of the action allows them to see the entire field of vision, where every player is and what is going on. This is what vision enables when one is standing, thinking and seeing from a position in the midst of the action.

With its larger size, big G carries greater weight. It helps to magnify change in the direction of a phenomenon's potential significance. With its greater connection, it has a stabilizing effect. As a stabilizer, it helps to generate focus. The big G looks like an incubator, the starting shaker of our ODNA. It produces light, and light leads to life. When the contents of consciousness become increasingly complex and self-conscious, Big G helps them hang together, acquire definition, and form a clearer picture. Such consciousness links thought processes to quantum processes.

Quantum processes are excited by the heat generated when one chemical substance interacts with another. The stimulus of this new concentration *actualizes potential energy into kinetic energy,* thus pumping new energy into action. As this occurs, quantum coherence emerges through the evolutionary catalyst of DNA. Following the arrow of time, a self-organizing process points toward the integration of matter in the direction of increasing complexity and consciousness in our capacity for self-reflection and self-realization.

At the same time, a moral center becomes distinguishable as the arrow of evolutionary time points toward a recognizable set of interrelationships that have meaning. A big picture takes shape that has a story of its own. Depending on its impact upon human life, the picture portrays an integration of the tangible and the intangible with value attached. Collaborating participants discover shared values attached to the shared vision.

The vision augments into a cause, even into a noble cause, as these values are more deeply interwoven into their belief systems and stimulate

increasingly heartfelt action. For each collaborator, there are discoveries that give more reason to care about the outcome. Each discovery empowers further action. More intensive action, in turn, enhances feelings of value and the chances of further discovery. A quantized or dynamically activated moral imperative is a more obvious presence than a presence without excited movement.

A quantum baseball player at second base will be thinking about how to get to third base and then to home plate. The brain's quantum system is working to integrate the diverse elements that comprise the palpably more vivid picture that will show the way. Big G is preparing to move full force ahead. It is generating a self-organizing system soon to emerge that is limited only by the potentials inherent in the unfolding pattern of events.

The self-organizing capacity of our quantum systems is now producing an awareness of growing coherence that has deeper levels of meaning to us. Collaborating participants are finding themselves involved in creating a new world of being out of the pre-existing world with which they have been most familiar. Their dialogue is evolving from what was, through what is, into what might be. Now taking shape in the real world is a new structure in the making. The configuration of matter is assuming newly created form.

THE VOLUNTEER CHAMPION

The embodiment of the new world being created is the volunteer champion who believes deeply that he or she is pursuing not only a mission, but also a cause that has a noble vision strong enough to keep the creative energy flowing. This volunteer champion is none other than the collaborating participant so purposeful as to be driven by a sense of compassion, that is, a passion directed to the well-being of others. Not every collaborating participant becomes a volunteer champion. Some continue in supportive roles of less intense activity.

The leaders among the collaborating participants do emerge as

volunteer champions. It is these volunteer champions upon whom we count for the more decisive initiatives and on whom we need to focus first. We must be sure that the working conditions we foster, in what Mark Youngblood calls our "quantum organizations," create a climate conducive to the emergence of volunteer champions.

Regardless of their official roles in an organization, volunteer champions do what they think needs doing in relation to a particular mission, even if it means venturing into territory not specifically assigned to them. They look for collaborators in strange territory. They take risks. They feel they must get something done. In this initiating role, their incentives are not so much material payment of meeting a challenge, as the psychic reward, the spiritual peace, or the social accountability. Such material reward as may come later in the sense of a return on investment is actually secondary in this manner of thinking. **A volunteer champion is compelling precisely for being perceived in pursuit of something extraordinary, a sacred mission.**

A volunteer champion is more than an advocate, more than one who promotes a certain change. A champion is one who is unrelenting in the belief that the cause is the right one. Therefore, a champion can show how the cause can advance the human race in its effects on the material world we will be living in, how the cause, on net, works for the greater good of the largest number over the longest period in the most economic way.

The volunteer champion thus embodies the new leadership ethic in full form as a living, breathing presence on fire with commitment to make happen whatever the cause represents. The volunteer champion in pursuit of a noble cause is ready to make sacrificial commitments of time, talent, and treasure toward the vision of a better world made possible by the anticipated effects of the cause. Voluntary service and support take new form in voluntary organizations that, whatever their purpose, go beyond profit in service to humankind in some set of specific ways.

Volunteer champions are the true leaders of beyond-profit organizations. Their creative energy is virtually unstoppable. They will not quit. The very ground of their being is rooted in what they are doing. The

self-energizing principle they share with others of like mind leads them on. That principle becomes more and more clear as the collaborating champions go forward. Their synergy begins to work miracles of accomplishment not heretofore possible. As it does, the moral imperative of what they are doing becomes increasingly powerful. They are becoming a practicing community of champions.

Volunteer champions seem to be increasingly in synch with their worlds. Synchronicity seems to occur in ways not imagined, as Joe Jaworski elaborates in his wonderful book of that title. There appears to be a growing alignment with what is happening in the universe of their experience. The situation suddenly feels right. Expectations are rising. Momentum can be felt. Spirits are elevating. An air of inevitability begins to emerge. Champions are walking the talk. We can see it in what they are saying and what they are doing.

WHAT DO WE SEE?

At this juncture in the leadership process, then, we can ask a third summary question, this time about the visionary cause that is in our mind's eye: "What do we see?" We want to know what the message is and how widely it is shared. The question, therefore, refers to what the collaborating participants led by their volunteer champions are seeing and what prospective stakeholders, who are not yet involved but who have a degree of interest in what is in the offing, think they are seeing. What is in fact going to be in the offing will be profoundly affected by the interaction of all the parties to the vision, that is, those who have a stake in the outcome from specifically identifiable perspectives.

The answer to the question "What are we seeing?" is really about the message at the heart of the mission, its vision of the future, and the greater cause it serves. **We take the measure of our visionary cause, then, by asking the volunteer champions, the leadership team, to tell us what they have in mind, then by examining their comments for similarities and differences to determine how great is the degree of clarity about the**

focus felt by the key players in the unfolding drama. As an illustration, these evaluations may be tabulated on the same one-to-five scale, scoring from low to high, as we used earlier to assess the involvement of our collaborating participants. The high scores will signify greater clarity of the message and the lower scores less clarity.

Next, we test what has been said by the leadership team with the remaining stakeholders, collaborators also participating in the enterprise as well as outsiders not yet involved who are presumed to have a prospective interest of some significance in the outcome. The entirety of the relevant population segments, those who are impacted by the initiative of the champions and their collaborators, are surveyed for their views. The evaluation scores are tabulated on the same one-to-five, low-high scale as those of the leadership team. **Stakeholder evaluation scores are then compared for consistency with the main message emanating from the leadership team.**

In this way, we again have a two-sided measure, with two subtotals added for a combined score from a low of two to a high of ten. Now, we assume that a score of five on either subtotal would indicate great clarity or great consistency, that a score of four would indicate a high degree of clarity or high degree of consistency, that a score of three would indicate a fair degree of clarity or consistency, that a score of two would indicate a limited degree of clarity or consistency, and that a score of one would indicate little clarity or consistency.

A group of volunteer champions who have great clarity of vision would rate a five on this scale. If that group had only limited consistency between the ranks of its champions and the ranks of its potential collaborators, that total group would rate a score of two. The combined score of that total group in this case would be seven of a possible ten. Here the message is clear but the people are not together.

On the other hand, in another group of volunteer champions there is only limited clarity about the message, thus scoring a two for clarity on this scale. If that same group had great consistency between the ranks of its champions and the ranks of its potential collaborators, that total group would rate a score of five. The combined score of this second total group

would also be seven of a possible ten, the same score as the group with great clarity but little consistency with its prospective stakeholders. In this second group the message is not clear, not yet anyway, but the people are together, presumably trying to figure it out. Again, the question is: Which situation, the first or the second, is going to do more good for the cause at the moment the ratings were made? Again, we will be coming back to the answer to that question as our story continues.

TWO PRESIDENTS
ENVISION THEIR FUTURES

Camden came aboard his new presidential assignment sensing that he would need to push as firmly as he could wherever he saw an opportunity. He was a very good talker and usually managed to make himself clear whenever he had the chance. If you asked him, he would tell you that, once he has presented his thoughts, gotten feedback, and made up his mind which direction to take, he expects people to follow his lead. His experience as a chief executive had prepared him to be decisive and direct. These qualities were decided assets for efficient decision-making.

Jacqueline was different. She took her new promotion with a strong commitment to fostering a process of dialogue, or mutual learning. She believed that such a process, if kept on course, would produce a shared vision with the iron-like pull of a strong magnet. She was not a great talker, but she was a careful listener. However, she somehow managed to get across her feelings while getting a good hold of the feelings of others. This had a lot to do with her reputation for being a good communicator. She was most concerned that, by her presence, people felt empowered to affirm their feelings.

Camden's sense of mission was palpable. His energy was rather well structured accordingly. He knew what he was there to do and he began searching immediately for help in articulating a vision of the future that would realize the mission in the most exemplary way possible. One of the early moves he made was to replace a tired public relations director with a high energy successor who had lots of bright ideas about how to promote Camden's sense of direction. They spent much time together creating themes and headlines they thought would excite people about the cause they believed the college represented.

Again, Jacqueline saw things a little differently. Her dedication to a visionary mission from the beginning was set in the context of the greater cause it served. She made no bones about it. The cause was intrinsic to all that she would do. Her feelings about this were never in

doubt. She constantly found ways to make the pitch for it in every conversation. To her, the cause was the thing into which the vision and the mission must fit. It was the organizing principle from which all the rest would be derived. This had the advantage of giving her more flexibility in defining her mission and the vision that would give rise to it. But its downside was that, at least initially, it provided less direction, and her associates would wish for more even as they knew where she was coming from.

Camden's values were classic by any account. One might say they were as solid as rock, bedrock. One could count on them. Time tested, dependable, bottom line. It was a case of knowing the rules and sticking to them faithfully, start to finish. This meant being predictable, safe, risk averse, but extremely hardworking and savvy. Camden was not going to miss a beat.

Jacqueline's values were creative, by contrast. Not that they were not deeply held, nor consistently demonstrated. It was tensile strength rather than material strength, evident in the tension between competitive forces. These values produced a less predictable, more vulnerable, and riskier path in a process that was no less hardworking and professional. Jacqueline would lose no opportunity to bring people into the vortex of action.

To Camden, teaching in the liberal arts tradition was paramount. This meant adherence to the established academic disciplines, fields of study such as biology, history, and philosophy, that were familiar to generations of college graduates. He wanted his professors to have solid academic reputations and he wanted them to have time to keep their research and publication current. As far as he was concerned, faculty should have the last word on curriculum, just as the trustees need to have the last word on budgets. The curriculum had to cover at least the basic concepts and skills required for students to master any academic concentration offered by the college and whatever specialization within each that might be most highly desirable. These decisions would be made by the faculty with whatever encouragement he could give them, and he would seek whatever financial support he could from trustees and others, such as foundations and friends, to help pay for them. This would be

an admirable path to take from the perspective of maintaining rigorous academic standards as they are practiced by the most highly competitive institutions.

For Jacqueline, who had her eye on enrollment growth, both qualitatively and quantitatively, a different path was required. She, too, wanted to build a fine academic reputation. But she didn't think she would do so primarily by strengthening existing academic fields unless, of course, enrollment demand might suggest otherwise. Instead of looking at the liberal arts as a defined set of courses to be taken, she saw her liberal arts curriculum as a flexible set of learning opportunities to be experienced. The liberal arts, she thought, would be better approached as liberal learning. This would put the prime focus on what students learn. The teaching of courses by professors would be seen as the means by which the windows to student learning are opened, not as ends in themselves. This would open the curriculum up to changes of course offerings necessary to attract career-minded students who were looking for marketable skills along with a quality academic reputation. This would be important for generating the enrollment growth she believed was top priority for the college. She would have to concede, she thought, any presumption of matching the high academic reputations of the most competitive institutions. But she would gain the capacity for greater academic service that she saw as her main goal.

While Camden was strengthening his departments of biology, history, and philosophy, and had plans to do the same for several other well-established departments in chemistry, economics, and literature, Jacqueline was investing her resources differently. She was busy urging her faculty to rethink and redesign major curricular components so that her college could introduce business management, computer science, and graphic design. She also planned initiatives in international trade, Latino studies, and urban affairs. She saw her academic departments not as free-standing entities, but as resources for interdepartmental program delivery to her students. Camden began building and promoting academic reputation. Jacqueline began building and promoting learning products.

In essence, Camden's vision was very clear among his co-leaders, a five on the scale, but its consistency with the visions of prospective collaborators was much less so, a two on the scale. The clarity of Jacqueline's vision and those of her co-leaders was getting better and better, and it was more and more consistent with the visions of her prospective collaborators. She scored four on both sides of the scale. On the visionary cause scale, then, she outperformed Camden eight to seven. What strength would this advantage translate into for Jacqueline's purposes in relation to Camden's? The story is becoming more complicated as we will see.

TWO PRESIDENTS ENVISION THEIR FUTURES

Camden Gould	Jacqueline Hope
Good talker	Careful listener
Decisive and direct	Pursued dialogue
Efficient decision-maker	Empowered people
Palpable sense of mission	Reflected a greater cause
Classic values	Creative values
Liberal arts disciplines	Liberal learning initiatives
Promoted academic reputation	Promoted learning programs
Five for clarity; two for consistency	Four for clarity; four for consistency

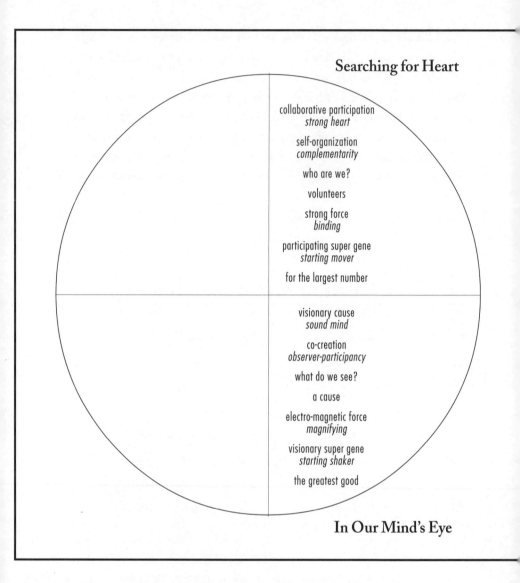

FIGURE 6: CIRCLE OF ODNA, QUADRANTS I AND II

The first and second quadrants of ODNA are siblings. The second is the mate of the fourth and, as already noted, the first is the mate of the third. (See pages 180, 210, and 224.)

"To be or not to be: that is the question:
Whether 'tis nobler in the mind to suffer
The slings and arrows of outrageous fortune,
Or to take arms against a sea of troubles,
And by opposing end them."
—*Shakespeare,* Hamlet

6. CONCERTED STRATEGY:

Possibilities of the Body

When I was asked to assist California's Orange County Social Services Agency (SSA) in late 1996, it had been hit hard with big budget cuts in the aftermath of the County's historic bankruptcy filing. The County Board of Supervisors was asking for new business plans from each of the county agencies. SSA had decided that its best response strategy would be a new vision for the agency that would enable it to bridge the terrible gap between its severely reduced budget and its significantly changed responsibilities under the new federal welfare legislation.

Somehow SSA would need to leave behind its mission of alleviating poverty in order to concentrate on empowering families and individuals to rise from dependency to self-sufficiency. This would be a huge task that would, as I saw it, mean rewiring the hearts and minds of agency officials so that they could help agency clients to rewire their own. It would amount to going from hand-outs to hand-ups. Responsible for administering $1 billion of federal, state, and county welfare funds to 228,000 clients on a $188 million budget under a new set of government mandates, the agency had concluded that it faced an impenetrable glass wall between its mission and its capability to help the people it was mandated to serve.

The only way SSA could remove the invisible but nonetheless real obstacle was to rethink the nature of the problem they would be accountable for solving, that is, to get people off welfare. No longer could the agency see the problem as an insuperable dilemma outside its control, if they ever actually had been inclined to think that way. They had to begin thinking about alternative possibilities that might be turned into real solutions. And this is what they did.

Agency director Larry Leaman concluded that the necessity of preparing a new business plan for the County CEO and the Board of Supervisors was also an opportunity. He saw a special chance to use the time spent on operational planning as time which could be invested in reengineering agency strategy by first reengineering their vision in order to produce different impacts from an entire organization of some three thousand employees. The new strategy would realign all departments and units in concert with the new requirements. An exciting new plan of action was developed in response to his insight.

The agency's top management team came together in four all-day off-sites or vision retreats that I facilitated in which they would reconnect their work to the new world of welfare mandated by action of Congress and the President. Because that world was undergoing dramatic change, their work would have to change radically to stay connected. In between off-sites, a six-person subgroup consolidated the observations and analyses that surfaced at the off-sites into succinct statements of vision, mission, values and a "BHAG" or "big hairy audacious goal" that would galvanize their organizational mind in dramatically more effective ways.

The top management team would, then, consider a new vision and what the potential strategic impacts of it would be. If successful, as the top team envisaged, SSA would be the regional catalyst for optimizing the number of healthy, functioning, and self-sufficient people in Orange County and for promoting this issue as foremost among all public policy priorities. A visionary goal, to say the least.

Leaman and his SSA team realized full well that it could not hope to succeed using the old ways. Thus, part of its new strategy would have to be newly instituted collaborative practices for leveraging its limited re-

sources for greater impact. Interdepartmental, inter-agency, and community collaborations would be joining the day-to-day administration by departmental units already in place.

New task-based project leadership teams would be set up and would consist of various unit managers recruited for their specific skills. The new sets of connections would be expected to get closer to client needs and have much more impact than would have otherwise been possible. As the new business plan neared completion, there was new confidence that SSA would be on the road to a productive future.

It worked. SSA immediately ran into distracting issues that diverted attention in the press. But it managed to be early in response to the County CEO's request with a planning document that was well received. SSA was given a green light to go forward, and now, several years later, has further revised its vision of the future to be more specific about how it can help the County get where it wants to go.

TURNING POSSIBILITIES INTO PROBABILITIES

Leadership liberates new possibilities, and now, having developed our vision, we are in a position to liberate our possibilities. We have seen a real challenge that has moved us. We have begun collecting and sharing all the information we can find about it. We have drawn together a group of collaborators who have gotten involved and are taking responsibility. We have identified our mission, focused on our vision of the future, and begun framing our vision into a cause. Some of our collaborators have emerged as volunteer champions, and others have continued in valued supporting roles. We have come a long way. And we realize that we still have a long way to go.

It is apparent to us, now, that most projects and organizations fail to reach the goals they set out to achieve because they do not manage to see their possibilities clearly enough to turn them into probabilities. So they do not realize the potential inherent in the ideas with which they started. It is difficult enough to create a visionary cause. It is more

difficult still to translate the initiating potentials into real programs and resources that enact the vision.

Our work so far has been at the front end of the leadership process, the start of action planning and momentum building. We are now at the threshold of selecting the possibilities most available to us, and choosing the priorities to which we will commit our greatest energies. We are at the strategic phase of *converting our potential energy into kinetic energy.*

The new leadership ethic we have embraced has become increasingly pervasive throughout our group as a common attitude and outlook. We are focused on the greatest good for the largest number over the longest period at the lowest cost. We see this not only as our vision, but also as the basis of our strategy.

But, we realize now, this new ethic requires a translation into practical thinking that will make things happen accordingly. It needs a strategy to implement the vision, a strategy that arises as a set of concerted activities that flows naturally out of the vision.

At its most powerful, in my mind, strategy is associated primarily with what I am calling the *empowering force* of nature. Technically, this force goes by the misleading name of weak nuclear force, that is, weak in comparison to the most powerful strong nuclear force. This force is the third most powerful of nature's four fundamental forces, operating at the 28th power of magnitude. It is responsible for breaking down the elements of the vision into its natural components that give substance to its structure.

This *empowering force* is decisive in transforming vision into the action that makes things happen in concrete ways. In essence, the *empowering force* finds the open spaces where action has the greatest potential for success. It is able somehow to see beyond apparent barriers down a pathway to achievement. Strategy is derived from a careful assessment of possibilities that have varying degrees of probability potential. In essence, strategy is about getting hold of the *empowering force* and following its lead.

THE PROBABILITY PRINCIPLE

Leadership is about converting possibilities into actualities, *potential energy into kinetic energy.* As a process, leadership seeks to identify the best possibilities, that is, the highest probabilities from all the rest. **It is important to realize that all phenomena in the universe are demonstrations of successful tendencies to exist. This is what the probability principle tells us is at work in all of nature, very much including human nature.** In fact, the probability principle now permeates the foundations of science as an ever-present law of the universe.

What appears so often to be utter chaos that is leading to ultimate disorder and disaster now appears more like a rearrangement of structure on its way to a higher degree of order in relationship to its environment. Science has found recurring patterns in the natural systems of life that demonstrate a continual cycle of growing and dying, creating and decaying, waxing and waning, ebbing and flowing of all phenomena. We live in an orderly universe. Mother Nature has been in the business of change since time began.

What scientists have discovered is that the tiny sub-atomic particle-wave energy resonance that inhabits the quantum universe demonstrates, in its constant motion and interaction, certain tendencies to exist. These show up in the production of large populations that are statistically significant aggregates of various electrons. The interactions of different, positive and negative electrons will always produce the same effect, for example the repulsion of those with the same electromagnetic charge and the attraction of those with opposite charges. Attraction results in the absorption of one by another and the consequent radiation of energy. Chain reactions can occur in nature or can be stimulated by technological means and, as in a volcano or nuclear bomb, enormous explosions of energy can be released.

In controlled conditions, radiation can be stimulated with predictable results once the electromagnetic field is known. The significance of this is the overriding importance of relationships. Quantum waves are literally in motion everywhere in the space within us and around us.

Their dynamic interactions produce a variety of effects depending on their mass and their velocity. Any relevant quantum energy field needs to be constantly monitored to assess what is happening.

At any given point in time, a quantum leap could occur as an electron catapults into higher or lower orbit. This happens when an aggregate of tendencies-to-exist converge to produce a super-charge powerful enough to send one of them into a new orbit while momentarily setting aside all the others. A quantum leap makes a sharp break from the past, jumping to another order of magnitude without leaving a trace of the path, and becomes a single actuality forged from a multiplicity of potentialities. This is transformational, such as when a caterpillar morphs into a butterfly or when a tadpole evolves into a frog or when a teenager becomes an adult.

Now, the requirement of our quantum process is to see the possibilities that are there in any given field of interacting energies. In any such energy system, there are a variety of potentialities, some greater than others. Which ones show promise, which ones show peril, and which seem neutral? It is not just the odds at play. It is the particular moment that shows up in the statistics of change.

Assessment of intensity becomes critical. Getting the feeling is essential. If the pulse is strong or faint, the dynamics are likely or unlikely. The point here is to ascertain which ones these are and spot them for careful scrutiny by trained eyes. Interactions are at the heart of quantum dynamics and how they are working is reflected in what is really going on in a particular situation.

Volunteer champions and other collaborating participants play decisive roles in the analysis that leads to strategic decisions. These strategic decisions must take account of all the possibilities and select the best among them. This involves much thought and discussion, and takes quality time. And time is always a problem with busy people pushed to their limits with other priorities that must be accommodated. So spending quality time with collaborators needs to be regularly planned.

Making time for anything means giving it priority status. Respect for volunteer collaborators and champions must be a given, and must

come naturally from the outlook of the new leadership ethic. Mutual feelings of quantum intimacy, of outreach to community members, even of love for one another must be nurtured.

At this point, we should be feeling a significant commitment from our collaborators, and especially from our champions among them. This is overridingly important for sustaining a magnitude of effort necessary to keep things going when times are tough. Commitment can be developed in proportion to the extent to which volunteers are really involved and deeply believe in what they are doing. So, we need to work persistently to build understanding that leads to heartfelt belief and informed opinion.

MORAL PRAGMATISM

In order to translate a visionary cause into the practical thinking demanded by the new leadership ethic, a simple but profound change of mindset is required. The new mindset must be rooted in doing what works for people. Not just what works for those in charge. But what works for the stakeholders impacted by strategic decisions. This is "moral pragmatism," what works for people. Not just what works immediately and gratifyingly for an individual or single group of individuals, but for the aggregate of individuals ultimately involved in a situation.

This is what the great William James had in mind, I believe, when he said: "On pragmatic principles we cannot reject any hypothesis if consequences useful to life flow from it. Universal conceptions, as things to take account of, may be as real for pragmatism as particular sensations are. They have indeed no meaning and no reality if they have no use. But if they have any use they have that amount of meaning. And the meaning will be true if the use squares well with life's other uses."

Pragmatism has got to work through and for people or it is not going to work. We are quick to recognize pragmatism as a philosophy aimed at the pursuit of what works. We have not been so quick to realize that pragmatism does not really work when people are exploited. Exploi-

tation generates contempt, and contempt leads to alienation and retaliation. Exploitation is no part of a pragmatic leadership solution.

There are three parts that I see in a strategy of moral pragmatism: strategic thinking, competitive enterprise, and ethical values. All three together develop a synergy that produces intensive energy, more likely in their presence than in their absence to make a difference. Three-dimensional moral pragmatism is the tricycle of a noble cause, that is, the set of wheels that makes it go and keeps it balanced.

Strategic thinking engages participants in a process that comprehensively anticipates obstacles, conflict, and resistance, and devises plans to deal with them. Like a radar or brain scanner, it sweeps the horizon for signals of activity that capture attention. It weighs the possibilities and prepares for those that appear to be most important. It assesses whether conflicts should be averted, alleviated or addressed head on. It identifies openings that are not covered by the work of others.

As Edward Luttwak of the Center for Strategic & International Studies points out in his book, *Strategy: the Logic of War and Peace*, strategic thinking employs paradoxical logic to frame imaginative and even unlikely solutions. In paradoxical thinking, opposites produce counterintuitive effects, as in too much of a good thing is a bad thing. Apparent contradictions prove not to be real ones. Actions produce effects that are opposite to what is expected of them. Paradox shows its surprising face in situations of conflict where opposing forces meet in confrontation. Paradoxical thinking is clever and savvy because it is, most of all, deeply insightful beyond what common sense leads one to believe.

Competitive enterprise is the quality of effort that goes into creating opportunities and achievements that are superior to those of alternative choices. Competition, though, does not need to come from an opponent with whom we are in some way competing. I learned this, like so many others have, as a kid in school, going for good grades in class, and in track, going for fast times in races. It may come from a benchmark of excellence you set for yourself to do the best you can. Or it can be a standard of perfection that pits your steadily improving performance against the ideal of being the best ever. Whatever the form, competitiveness is

invariably part of the equation because people always could be doing something else with their efforts.

Moral pragmatism is the decision tool with which the new leadership ethic is implemented in human affairs. Its watchwords are: "What works for each person is what works best for all of them." Moral pragmatism depends on careful assessments of who your people really are.

Ethical values always lead one to look out for others. They acknowledge that we are fundamentally dependent on others to make our way in the world. Even more, ethical values recognize that caring for others not only gets things done in the present. They represent a wise investment in the future. Ethical values emphasize service.

One never knows where help is going to be needed next. One always must be mindful of the role that chance and luck play in the unpredictable interactions of people and things. Yes, we may think, "There but for the grace of God go I." Or, next time around, that could be me. We realize that we can always use all the help we can get. We also sense that we are more likely to get it when we need it if we have a stockpile of good will that is built on the foundation of our services to others.

In the definition of voluntary leadership that I am proposing, we can see how the three parts work. Moral pragmatism is driven by the impetus of strategic thinking to the action of competitive enterprise with the momentum of ethical values into a leading force. Impetus leads to action propelled by the square of momentum. The equation is $I=am^2$.

When I was in charge of the North American office of Shakespeare's Globe, an international project to build a replica of the original theater near its former site on the Thames in London (now open), I had the opportunity to see the great actor, Dustin Hoffman, play Shylock in the *Merchant of Venice* in London and then again, shortly after, in New York. Our North American office was hosting an opening night party in New York to benefit the Globe, for which I was responsible. Dustin had agreed to come and headline the occasion. It gave me the chance to ask him about the more enthusiastic audience response I thought he got in his New York performance compared to his performance in London. I will never forget his immediate response. "These are my people," he said.

It was a simple matter of fact comment that has stuck with me. The London audiences and the critics praised his performance, but the New Yorkers took to him more positively as one of their own. His relationship with the audience made the difference.

We need to ask ourselves who are our constituents, our audience, if you will. Who really are the stakeholders with an investment in our actions? Whoever they are, they will be most responsive to what we do. They will frame the sphere of influence in which we must express our own version of the new leadership ethic, whether we are acting in a dramatic performance or acting in a corporate role. Both are acting in organizational settings. The enhancement of participants, whether they are actors or audiences, is all important. When I got to thinking about it I realized that, in an effective performance, a good actor is really leading his audience. Dustin Hoffman has a well earned reputation for doing that very well.

But, a well-kept secret of leadership, perhaps because it often hits too close to home, is that leadership needs a receptive audience, a responsive constituency, a ready clientele, in order to work. As successful as Dustin was blending in with the English cast, the London audience nevertheless responded to him as an outsider who was not actually one of them.

SYNCHRONICITY

A concerted strategy is designed to facilitate the alignment of forces and factors at play in the implementation of a vision. Concerted strategies bring together distinct elements into a single intermeshing constellation of activities. When strategies actually come together, they have somehow overcome their separateness to display a complementarity of traits that fit comfortably together, indeed, are mutually reinforcing and necessary for the success of the whole.

For example, the human body contains an array of dynamic parts that work smoothly together, when healthy, to produce an organic whole

LEADING BY HEART

in the form of a person. An organizational body of any kind is essentially the same, an array of dynamic parts that function systematically to produce certain results in the form of products and services. The most successful working bodies are those which work most productively and efficiently at the same time. Concerted strategies are the means by which organizational bodies realize their visions. Healthy growth strategies are the means by which human bodies work most successfully for their own development.

I believe that synchronicity is the cousin of concerted strategy in that it draws together disparate parts into a concerted whole. In essence, synchronicity is the meaningful coincidence of intermeshing phenomena that cannot be explained by ordinary circumstances. Synchronicity is the improbable meeting of different events to produce an unexpected result. Synchronicity is the emergence of compatibility seemingly out of nowhere. Natural causes, as we understand them, do not seem to explain synchronicity. Even the law of probability, insofar as we can see it working, does not appear to do so. In synchronicity, we are talking about real phenomena somehow generated by unseen realities we are not yet able to measure.

The signal of synchronicity is magnetism. Perception propels electromagnetic fields toward that which is observed, and in the process, influences the direction in which the process traverses. Attractive fields draw attention, interest, and engagement. The stronger the magnetic attraction of a given field, the greater is its pulling power. A volunteer champion whose perception reflects magnetism will draw corresponding support. The magnetism of a volunteer champion, charisma, is produced by the flow of intensity in perception and belief.

Charisma is the result of the intensity in the creative energy flow that produces perception and belief. Charisma attracts. It does so in a variety of ways. It is the presence of magnetic energy that compels a following. Charisma is not hype, such as high powered promotion. Charisma is simply the magnetic power of an authentic presence that has great magnetism as its electromagnetic field radiates energy and exerts a gravitational pull of irresistible force. This authentic magnetism may be

projected by a single individual. More importantly, it may be projected by a group of synchronistic collaborators.

Synchronicity emerges from the interactions of collaborators in unpredictable ways by arising from the center of gravity in a dialogue among them. It is this center of gravity which needs to arise spontaneously in the interactions of people who meet to share their concerns and ultimately to share visionary cause. Synchronicity is the sudden emergence of a gravitational heartbeat with a frequency that resonates between two or more persons. The coincidental events that occur have genuine significance of memorable impact.

When spirit, heart, mind, and body align with each other, synchronicity is most likely to burst forth. These reinforcing properties, in the right combination, are most likely to produce the effects we desire, indeed, the explosive effects we most probably will find to be rewarding. This alignment is the foundation of a concerted strategy.

QUANTUM LEAPS

Remember how we noted that quantum waves, those invisibly pulsing fields of energy, are quite literally in motion everywhere in the space within us and around us? We observed that their dynamic interactions produce a variety of effects depending on their mass and their velocity. We saw that the relationships between the quantum waves and their allied energy fields is overridingly important. **When an aggregate of wave potential converges into a critical mass of energy, then a quantum leap may propel that new potential into a different orbit of greater or lesser complexity.** So, equipped with this knowledge, how do we increase the likelihood that we may produce the new realities we seek?

We need to recall that the interactions of our tiny friends, the electrons, are always going to generate electrical charges. Electrons with the same electromagnetic charge will repulse each other. Electrons with a different charge will be attracted to each other. Attraction involves one absorbing another and results in the radiation of energy. Chain reactions

of energy radiation produce explosive effects. This is what we should be looking for in our pursuit of energy productivity. Mutual attraction that excites. People get excited by what they are attracted to. When that is shared with another person, the excitement increases. When groups of persons share an attraction, excitement multiplies. When large numbers of people do, the impact of excitement grows exponentially. Think, for example, of a crowd at an event in a stadium, arena, concert hall, theater, or house of worship. In such cases, we can see illustrations of how the flow of energy can surge into a group of otherwise unrelated people and create a power base of those who are mutually attracted to an absorbing idea or event.

Quantum leaps occur as we discover what is mutually attractive and explore how we may create it into something we share that adds value and meaning to our lives. In quantum dynamics, we are looking at shared responsibility, building vision, committing to strategies, and making connections with the greatest impact potential all the while scanning our radar for events on our sensory horizons that alert us to new possibilities. This process leads to the initiation of power surges with electrical currents strong enough to turn on organizational lights and open organizational doors. How?

A potent technique is to create dialogues in which people are brought together for the purpose of evolving solutions from the sharing of information, the analyzing of data, and the formulating of recommendations for response and change. A rich diversity of view is especially important within the context of some sort of shared purpose. We want to be sure the impacts we are looking for make sense for all those who will be involved. We will need, therefore, to consider all the perspectives we can that may be relevant to a particular issue and its ultimate resolution. To be as well informed as possible means to be as inclusive as we can be under the circumstances. How do we secure inclusiveness without being merely populist or politically correct? How do we do the right thing by taking into account both popular thinking and timeless wisdom?

We really need to think about diversity in different terms than

those of our tribal customs. To make wise choices we surely must consult our intuition, but we must also be well informed by other knowledgeable people. We must have taken clear pictures of the entire situation from every angle we are able to see within the time available. We must recognize the complementary variables at work in the often puzzling pictures we see and we must ask ourselves what are the relationships going on that most need to be recognized and harmonized. In this light, diversity of perspective is an asset to be cherished, not a quota with which we must comply. The differences we bring to a situation are potentially precious so long as we maintain them in relationship to other points of view.

FEAR AND LOVE

The Reverend Stan Smith leads the First Christian Church (Disciples of Christ) in Orange, California, the nearby congregation of Chapman's founding denomination. In a recent message, he suggested that one could encounter a stranger in one of two ways, with fear or with love. When fear predominates a premium would be put on negative thoughts. In this case, we would distance ourselves from the object of that fear as well as we could. On the other hand, when love predominates a premium would be put on positive thoughts. In this case, we would be open to the possibilities that might arise from the object of that love.

I have seen a description of fear as an acronym depicting it as "false evidence appearing real" or FEAR in James Mapes' *Quantum Leap Thinking*, which is okay in nonthreatening circumstances. It seems to me that another alternative would be to "live out vital energy" or LOVE, which helps to open new opportunities. These memory joggers highlight the differences between our polarities of thought. The importance of this is that varieties of fear and love really do make an enormous difference in the outlook of an observer-participant involved with a given situation. **As Stan said, one either engages another in a friendly or an unfriendly way. Just think of the difference in attitude. And then consider the difference in the behavior that follows.**

This takes us back to the particle wave dualities we now know emanate from the quantum reality that is constantly with us. How distinct they are. In so many situations we might imagine, we could lament the cards we have been dealt. On the other hand, we could accept them and, as we say, "go from there." For example, we can think of ourselves as flowers in a garden. We are planted in whatever flower bed we find ourselves. We can only blossom where we are. Wherever we are, we are always there. We must grow where we are with whatever nourishment we have. We will become whatever we can with whatever we have. This seems to be self-evident.

We are stuck with our birthmarks as well as our birthrights. They are what we are given. They are our gifts. If we see them as our blessings, and focus on those, then we can work with them as assets, whether greater or smaller. If not, then obviously this sets us back. Actualizing the possibilities begins with seeing the gifts we are given, then capitalizing on them. The necessity is to be open to seeing the possibilities. This is a real challenge, because we are so caught up most of the time with the trepidation life serves up almost relentlessly, it sometimes seems. Attitude really is the launch pad, into positive space or negative space, into constructive opportunity or destructive victim-hood. Having an attitude of fear or love really does make an enormous difference in the unusual encounters we may often face, as Stan Smith said.

Equipped with an attitude of going forward from here to some place beyond is more helpful as a context for action than an attitude which merely looks backward from here to some place before. This, we should be thinking, is where we start, not where we end. Now that we appreciate where we actually are, we can proceed with confidence on at least that ground.

Looking forward also, however, raises the question about where we are standing. Amid the swirl of forces descending upon us, it is logical to be thinking about "where we are coming from," and difficult to determine the answer, though we must. Then we are more able to choose effectively with a real point of reference. If someone asked what we are up to, what would we say? If we are asked what we are after, how clear would

we be? If we are asked where we are going, could we say with assurance? Do we have a good sense of bearing, of where we are as well as where we are headed?

This is important. We do need to be in touch with ourselves, the inner core of our beings, with both what we want and why we want it. Voluntary action begins with choice, and, whatever prompts it, that choice does come from within. This takes us back to uncertainty and creativity, to complementarity and comprehension, to participation and choice, and leads us to probability and the commitment that helps make it happen. The quantum process of which all this is a part can accelerate the action we desire if we are aware of what is going on in our own minds as well as in our strategic environment. Awareness is critical, and difficult. Often we aren't careful enough. We don't stop, look, and listen sufficiently. So, we sometimes miss out and maybe even get burned.

But we've got to commit in order to get something done. Even at the risk of being sunk if we commit to the wrong thing. What is the right thing? This is the age-old question. So often, it is not even asked. Even when it is asked, it is often answered expediently. How to ask it with the power of sincerity? How to risk our decisions wisely?

Let's think first about our mission. This is the purpose we serve as an organization. More expansively, it becomes the cause we serve as a voluntary association of people who could be doing other things. What is it that we are really in this for, we should ask. Why should we break our necks, so to speak, for the task? We are face to face with the question about why we are here. Actually, why are we here? Money? Not good enough. Power? Not good enough. Fame? Not good enough. What then? Meaning. Significance. Yes, and we need to come up with good answers if we are really going to find meaning and significance, and not just immediate gratification. This is a tough thing to do. We must do it anyway.

What should really be driving us is something more than the material, something more than palpable gain that can disappear, be taken away, reducing us to empty replicas of what we were. Whatever it is, it must be something that cannot be taken from us, something that is part of the untouchable soul within us that is our ultimate identity. For exam-

ple, we might have a desire to help others, a yearning for a just society, a delight in beautiful art, a sensitivity toward healing the sick, an inclination for teaching children.

This is what we can best communicate to those we wish to involve in our enterprises because it is what we can be genuinely enthusiastic and joyful about doing. That is what radiates, what puts a stamp of presence on what we say and do. It is what communicates more effectively than anything else.

Volunteers are attracted to causes they get excited about and organizations associated with them that have credibility. It comes down to people attracting people to causes they believe in. True believers, not slick sales people, are most effective. That's why, in the beyond-profit world where we rely so heavily on volunteer champions, people who could be elsewhere but who choose to be doing what they are. So, our supreme test is whether or not we are attracting the volunteers we want. And especially volunteers we want to have on our boards of trustees. For better or worse, these are the volunteers who will set the pace for our voluntary organizations. Who are they, why are they here, and what are they doing?

TRUSTEES ARE OUR STEWARDS

There are many effective books and manuals describing how to recruit, prepare, and nurture trustees. Read them. And do them. My favorite title is Art Frantzreb's book called *Not on This Board You Don't,* the most pointedly passionate I have seen among many others without a whole lot of passion for this greatest of all voluntary leadership challenges, the challenge of stewardship.

It should go without saying that we must not expect the usual appeals to jumpstart our futures. Something deeper is at stake. A cause. A cause so compelling that it moves people to action. Plus a champion of the cause who engages us in concerted action with others. Time-consuming and energy-absorbing action. Action that requires a stretch.

Action that necessitates a choice. In fact, action that redirects already committed plans to more compelling purpose. This is what we are looking and striving for, a commitment to stewardship that can reach back to a deeply meaningful origin.

The trustees we are looking for—both to serve and to support our cause—are those who are in it for more than a ride. Rather they are aboard because they want to make the journey for its own sake. Beware the ones who are not. They are absorbed with their own agendas. Identify them early, invite them to be in or out, and let them go if they are uncomfortable with the commitment. They will undermine a cause if they stay to sing a different song once the curtain goes up.

When we seek the leaders of activities, we must be sure to select those who promise to actively exemplify what we stand for rather than just passively support what we would settle for. It is very easy to be sucked into the illusions of empty promises. I have seen it and it is ugly to watch what it does. **It is easy to be corrupted if we are not sure what we seek. Personal agendas will prevail where group agendas do not.**

I remember well the owner of a bank with branches across the region in which the university I was serving was located and which he served as a member of the board. He explained to me in some detail over the course of several fascinating meetings in his office that he was a very wealthy person worth what would be more than $500 million in today's dollars. He could not, however, make any significant commitment to our institution (or any other) because there were too many complications that got in the way, he said. You can bet that we tried to help him work through his difficulties. But to no avail. He died a few years later leaving no particular bequests to any charitable organization that we knew of. What a shame for him. What a regret for us, and for the other charities with which he had been associated, and for his heirs who were not able to savor what would have been the joyous aftermath of his benevolence, and above all for those potential recipients of institutional largesse his giving would have made possible.

On the other hand, I remember the woman whose fortune was made as her husband's partner in a very successful international business.

After he died, she took his seat on the university board where he served and carried on a practice of giving a substantial share of her assets to the university and to other charitable causes in the areas in which they lived and made their money. She did what she did with love and personal attention while she was alive. Five million dollars I am familiar with, and many millions more of which I am not. People associated with the causes she supported knew her as a pillar of what they stood for. She cared so much, whatever it was she actually gave. She lived to share in the joy of her giving. And her beneficence lives on in a foundation that carries her torch into the future.

Too many trustees fall somewhere in between these two cases. They may or may not be donors of funds, or expertise, or just plain old time on task. Yes, they are there, as Claude Rosenberg's detailed research shows in his book, *Wealthy and Wise*. But that is about it; they are just disappointingly, sadly and inactively there. What a loss to both the volunteer and the cause. This is where voluntary organizations have their greatest opportunity to leap forward. **Many volunteers, maybe most volunteers, are treated by the organizations they serve as sponges to be squeezed rather than as the beautiful precious incredibly valuable diamonds to be polished that most of them are, no matter what they are worth.**

This is hard to imagine, admittedly, by veteran nonprofit leaders, professional and volunteer alike. If we and they could just imagine a volunteer, any volunteer, as a priceless asset to be cared for and nurtured, the story would be a very different one. What if each trustee is treated as a gift beyond measure to your program or project? What if the goal is to train each one to be one of your board's co-leaders? What a change that would probably be. What a chance that would open up to realizing the possibilities we have.

When I was at the Center for Strategic & International Studies in Washington, D.C., I attended every seminar I could on military strategy (a subject previously outside any experience I had known) that was led by Edward Luttwak. He would invite top strategic thinkers from around the country, and vigorously debate them on key points of national security. I remember him repeatedly explaining in these public meetings and private sessions afterward how most people don't understand what strategy actually is and how it really works.

Strategy, he argued, really has to do with conflict. Strategy deals with anticipating conflict, then attacking the source or alleviating it or avoiding it. Always, we must not forget that strategy is made necessary by conflict in some measure, from active hostility to passive resistance. If we think accordingly, we need to concentrate on how we deal with obstacles, even the most extraordinary ones. If we ignore them, they will have their way with us.

What interested me most was what Luttwak had to say about paradoxical logic. This was new to me as a systematic way of thinking, and I became fascinated by it. What I learned is that the usual common sense, linear way of thinking could no longer, if it ever did, account for all the requirements of problem solving that we face. **We would need to understand that too much winning could end up losing, or that too much of a good thing could be bad thing.** Extremes could literally reverse their roles while challenging us to reconcile their differences. Wow! I had to learn about nonlinear, paradoxical, counterintuitive thinking and how to use it. The military has learned this over the battles of recorded history. And, industry has been learning about it as fast as it can. Competitors in virtually any situation understand it or risk certain danger.

In paradoxical logic, we are dealing with opposites. However, these opposites are apparent, not real, contradictions. They are actually "complementary variables," that is, variables that fit together to make a complete picture or perfect whole. These opposites or complementary variables are not irreconcilable, not inharmonious, not absolute enemies.

Rather, these complementary variables are actually partners who play importantly different roles that are essential in the chain of being, the web of the universe, the network of life. Paradox is counterintuitive in that it is not what your intuition is used to dealing with. It is hidden from ordinary view, yet always there, ready to be called upon in situations of conflict when the usual reasoning gets us nowhere. Paradoxical logic can, therefore, work wonders that are seemingly magical, maybe even miraculous.

For example, think of the statement, "opposites attract." That seems incredible at first. But if we see that opposites are only *apparent* contradictions, we can see that opposites are really complementary variables, like male and female, that are distinctly different aspects of our common humanity. We need them both to sustain life itself. The two extremes of such polar opposites fit together in a perfectly natural way. Night and day. Hot and cold. Wet and dry. Once we internalize, that is, make reflexive the logic of paradox, we are much more able to respond to the challenges we so frequently encounter.

Seen in this way, strategic action can become *a self-sustaining superconductor of organizational efforts to develop potential energy into kinetic energy.* Seeing this is a very big advantage for organizational leaders who become adept at releasing such possibilities. The greater are the complexities of organizational life, the more important it is that leadership respond strategically to conflict situations, whether they are passive or active in nature, by working reflexively through the paradoxes they face to the performance levels of their aspirations.

THE STRATEGY SUPER GENE

In our ODNA gene code, the strategy super gene is the component that I propose is most closely aligned with the chemical base thymine, the T base, and the relationships it has with the A, C and G bases. As the strategy super gene of ODNA, I look at the T base as the *finishing mover* in the integrated circuit of our leading memory chip. Remember that the T

base is one of the two smaller and less complex bases along with the C base. It is also one of two that have fewer bonded connections like the A base with which it is actually paired in a 1:1 working relationship. The big A base represents collaborative participation and the small T base represents concerted strategy in our leadership paradigm. These two together constitute the action factor in our equation of leadership impetus, $I=am^2$.

The strategy super gene also corresponds with the *empowering force* of nature in our leadership paradigm, the force which physicists refer to as the weak nuclear force because it is far less powerful at the 28th power of magnitude than is the strong nuclear force at the 41st power. The importance of this point to us is that strategy, aligned with the *empowering force*, is concerned with getting through the web of resistance put up by any set of problems, situations conflicting with our desire to sail smoothly toward our goals. This is exactly what the *empowering force* facilitates.

Remember the power sequence of the four forces of nature. First is the strong nuclear force, the *binding force* in our paradigm, that is the glue holding together the protons in the nuclei of atoms. Second is the electromagnetic force, the *magnifying force* in our paradigm, that bundles atoms together as molecules. Third is the weak nuclear force, the *empowering force* in our paradigm, that mediates the decay of radioactive material and that has kept the earth warm for billions of years. This third force is the process by which unstable atoms emit large amounts of energy from tiny chunks of radium. Fourth is the gravitational force, the universal attraction of all particles of matter for one another, or *grounding force* in our paradigm which, in turn, holds the stars and the planets, including us, together.

In this line-up of natural forces the *empowering force* generates heat, and heat is an essential of life. The energy of heat builds as temperature rises. As temperature rises the processes of action increase and still more energy is radiated. Strategy is all about "the conduct and consequences of human relations," according to Luttwak, in situations where conflict is imminent. In order to work, however, strategy needs to be

highly aware of the fluctuating climate in which it must function.

As the *finishing mover*, **the strategy super gene multiplies the steps taken by collaborating participants and converts them to concerted action by an assemblage of people forming a group.** It reflects the intentions of the participants and embodies their stated visions in the implementation. Participants can start the action process, but they need strategic action to finish it in the sense of giving it life. Strategy is (with participation) one of the movers that is involved in the action. But the movers need help from the shakers (vision and resources) to sustain the process, and boost its momentum.

HOW ARE WE DOING?

Developing concerted strategy that converges, blends harmoniously into mutually reinforcing components, requires that we consistently ask ourselves the question, "How are we doing?" We need to see exactly how we are doing in relation to our vision of the future in order to know just how well we are actually doing. So, we need to measure two things: impact and innovation. **We need to measure impact in order to understand results, not just activities. We need to measure innovation in order to understand why we produced these results, not just why we undertook these activities.**

Impact is not activity, whether intended or coincidental. It is common to mistake what one is merely spending time on as what one is actually accomplishing. When we ask about how we are doing, we really want to know what we are accomplishing by investing our time in a certain way. When I am speaking with a group, I am doing so in order to convey a message, let us say, proposing a new thought for producing a result we want. The speaking describes what I am doing and the result describes how I am doing. We are after results in leadership. Our activities are means to those ends, not the ends themselves.

Innovation is not just change of any kind. This, too, is a notion commonly mistaken, especially among those who are uncomfortable

with change. Innovation is change in the direction of improvement, not just change for the sake of change. The value of innovation is its adaptability to, as well as anticipation of, the ongoing change that is constantly a part of life in this world. If we are not innovating in one or more parts of the production process for whatever it is we are producing, then we are falling behind the waves of change. We want to ride the crest of these waves in order to ride farther and faster and enjoy more fun in the process.

Impact covers both quality and quantity. Innovation covers both change and improvement. To measure them, we constantly audit our practices, and we learn how we are doing. This requires that we set out on a fact-finding mission to compile information about what is going on. The results we find all represent some type and degree of change in the population we measure. If we are teaching school, we want to know what the students are really learning, so we administer tests designed to show that. We also want to know why they are learning what they are learning, so we examine the teachers and the learners as well as the test results for clues leading to the most likely connections between inputs and outputs.

Again, we score our situations on scales of one to five, low to high. Great impact rates a five as does a great amount of innovation. Scores of four indicate high impact and a high amount of innovation. A score of three indicates fair impact and a fair amount of innovation. A score of two indicates limited impact and a limited amount of innovation. A score of one indicates little impact and little innovation.

A strategy that is producing a great impact of five with a limited innovation of two may be going extremely well for the moment, but not sustainable for very long. A strategy that is producing a limited impact of two with great innovation under way may be struggling at the moment, but ready to take off into a more productive future. The same score of seven out of a possible ten on the combined impact-innovation scale of strategy portray very different pictures for these two approaches. We cannot be certain how to interpret each of these scores without more information. We also need to know how well each situation is connecting to its resources in order to judge where it is in its particular life cycle. For that assessment, we will need to continue on with our story.

TWO PRESIDENTS
PLOT STRATEGIES

Camden spent most of his time working with his faculty on academic strategy. Whenever he could, he tried to pull his board members and other stakeholders who might be able to contribute valuable perspectives into the ongoing discussions. He also made contact with officials at several foundations he thought would have an interest in seed money grants for promising new approaches. Eventually, his hard work with faculty colleagues paid off with a revised core curriculum and three new academic majors that received the blessings of his board. One of the foundations provided a sizeable grant to help implement the new program. The college also got some well-deserved publicity in several academic publications.

Jacqueline, again, took a different course. She decided, after consultation and following her own instincts, that the strategy best suited to her institution of higher learning and its marketplace of aspiring learners would be a strategy linking the learning society she saw when she looked outside and the learning community she saw when she looked inside. This would not be an easy strategy to execute because the parties were not used to working together. She worked with her constituency teams to put together a new curriculum of competency-based learning and assessments. She got them to consult closely with outside people from industry and the professions. The heart of the program would be a new bimester or two-month-two-course calendar scheduled four times a year replacing the semester or four-month-four-course calendar scheduled twice a year. This was intended to give faculty and students more flexibility to accommodate different learning needs. The new bimester also provided a marketing advantage, but required a challenging transition for faculty and students who would need to develop new teaching and learning skills. She was able to secure special funds from several grants to support the change and that helped.

Camden's college experienced superior faculty morale that never had been higher. The curriculum probably never had been more rigor-

ous. The academic reputation bloomed to unprecedented levels. However, the graduation rate dipped as students found the going tougher, and faculty were unwilling to compromise their academic standards. The enhanced image of the college took longer to sink in among prospective students than it did the academic world and student enrollment did not rise quite as rapidly as the graduation rate dropped. The pressure on annual fund raising to increase had never been greater and was producing some strain on the college's development team, but so far it was managing to keep pace.

At Jacqueline's college, student morale was never higher as the focus on their learning needs took hold and began making a real difference. The graduation rate began climbing. The change of image in the collegiate marketplace began to have an impact. The change from an emphasis on teaching to an emphasis on learning was catching the interest of some opinion leaders. Student recruitment began to improve. Fund raising picked up.

In academic circles, the light of Camden's college was a beacon. The change to a truly challenging core curriculum was considered enlightened and courageous. Many other institutions had tried and failed. The new majors were icing on the cake. These were forward-looking, though not path-breaking. Altogether, the college bolstered its reputation as an institution of quality. Camden was hailed as an academic leader of consequence.

In the same circles, Jacqueline was admired for her insights and her courage. Yet there was a good deal of skepticism about whether her college's strategy would succeed. A minority of the more innovative academics began to get excited by the impact its changes seemed to be having. Some favorable publicity began to appear. But would it be able to sustain its breakthrough in the face of the august teaching traditions built on teacher lecturing and student listening in formal education virtually everywhere?

In essence, Camden's innovations were sound and scored a four on the scale as did their impact which was also strong and rated a four. Jacqueline's innovations were more daring and rated a five, but their

impact so far made it less certain and rated a two. Camden's eight to six advantage gave him more impetus if he and his colleagues could convert it to actualities. Would Camden's college be able to build its current advantage into greater resources? Jacqueline had less impetus but plenty of potential if she and her colleagues persisted. How would this play out at her college?

TWO PRESIDENTS PLOT STRATEGIES

Camden Gould	Jacqueline Hope
Teaching strategy	Learning strategy
Revised core curriculum	Competency-based curriculum
Superior faculty morale	Student morale great
Academic reputation bloomed	Academic image changed
Graduation rate dipped	Graduation rate began climbing
Enrollment increases slipped	Student recruitment improved
Fund raising pressure strained	Fund raising picked up
Four for innovation; four for impact	Five for innovation; two for impact

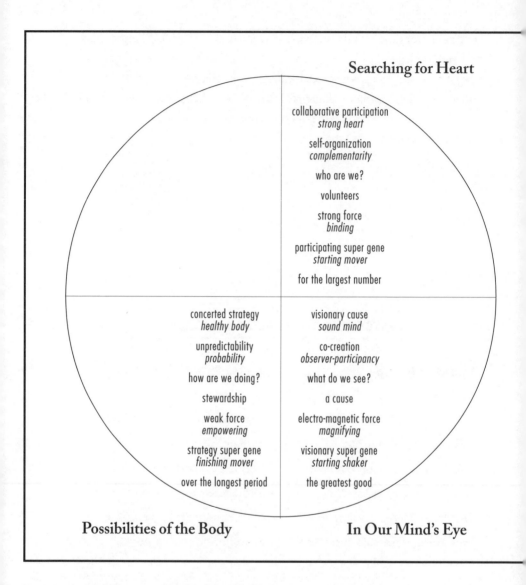

FIGURE 7: CIRCLE OF ODNA, QUADRANTS I, II, AND III

The directional impetus of these three quadrants leads to the missing fourth quadrant (pa210) and to the interactions of all quadrants (page 224).

"Today our world society is more aware of our humanitarian interdependence than perhaps at any time in our history. Even with frequent and sustained local confrontations to the contrary, humanity's goal is human rights for all humankind. This goal is philanthropy applied, demonstrated, and provable."
—Arthur C. Frantzreb

7. CONNECTING RESOURCES:

Supplied to Soar

Gogh van Orange, an arts and music festival in its Orange, California debut, was a kick. It was 1995. Bobbie was invited to be co-chair with Scott Parker, the generously friendly proprietor of the oldest business establishment downtown, Watson's Drug Store, also well known for its fifties atmosphere, its delicious food, and later as the setting for a scene in the Tom Hanks movie *That Thing You Do*. Scott was incoming chair of the City of Orange Chamber of Commerce, which was looking for a fundraiser but wanted to develop a special event that would rally the community. Bobbie was invited because of her reputation as an arts person that had followed her from Annapolis, Tampa, and Hamilton, New York where we had lived. Scott and I knew each other from membership on the chamber board. Bobbie asked me to help with corporate sponsorships.

After talks with Scott and others, it was clear that we should go see Bob Martini, then CEO of Bergen Brunswig, the biggest company in town, and a leader in the global pharmaceutical industry. He and Scott knew each other because he liked the homemade pies he could pick up weekly at Scott's store. We went to see Bob, made our pitch, and found

him to be the supportive neighbor we thought he would be. Bergen Brunswig became the lead sponsor of the festival and we were off and running.

The unusual thing about it, though, was that the company really did not want anything special made of their sponsorship. They wanted to do it, Bob said, because it helped the community, not because it promoted the company, so we did no special publicity to promote the company. What he emphasized was that the festival could be an event which would make the community a better place, and that of course would make the company a more attractive place for people to be. Besides, he liked Scott and trusted him. The festival drew Anaheim neighbor Tex Benecke and his famous "Glenn Miller Band" plus forty thousand people in its first year. We all were thrilled.

Compared to some other opportunities I've been privileged to be part of, this one was not a big headliner. But it was a wonderful reminder of an old lesson. We connect with the resources that are close to us if we take the time to search them out and ask for them. Small-town city, as Orange likes to say, but big-time lesson.

MAKING QUANTUM CONNECTIONS

Leadership makes connections and succeeds, or forget it. There is no leadership of organizations without connection to resources, the wherewithal of success. Making connections makes sense when considering resources. When we want to get something done, we've got to be wired for results. This includes being plugged in, ready to go, arrangements made, preparations in place, trusted people in charge, resources in the pipeline, awaiting a turn-on to stimulate a power surge. What does this entail?

We normally think about people, of course, when thinking about making connections. So, we must be sure not to forget the prior connection of thoughts and feelings which, when shared, enable us to connect with like-minded people. In order to establish a baseline, let us begin our

connecting phase by doing a little thinking about thinking to connect smaller thoughts and larger wavelengths more effectively.

We do our thinking with our brains, of course. They are the organic machines with which we generate intelligent thoughts, insights, and reflections. Our brains, as it turns out, are driven by our hearts and minds. How effectively we are able to do this depends on our capacity to transmit the feelings of our hearts as creative information through our brains and central nervous systems to the rest of our bodies. Our capacity seems to be, according to Zohar and others, the degree to which we have developed a network of neural connections that allows us to transmit messages between brain tissues with different functions. It also seems to be, according to Paul Pearsall and others, the degree to which we have receptive minds in which our hearts, brains, and nervous systems can work together.

Take our memories, for example. They retain information inscribed in our hearts and minds at birth, which we inherit not only from mom and dad, but also from our ancestors all the way back to the earliest times. At the same time, our memories retain information from our personal experiences back as far as they go in our lives. A memory is a coherent energy field held together with electromagnetic force from the high impact of memorable moments and genetic impulse. **Can we imagine a memory field embedded in a non-material computer-like microchip in our brains? Or, a quantum-like memory chip embedded in a rewired neural network? What we might call a leader chip?**

Action starts with thoughts, feelings, and spirit. They are framed in the mind. The mind is encased in the body, and body parts work together. This is true in a human being, of course, and I believe it is also true in any network, association or organized system, which is a kind of being all its own. Thoughts, feelings, spirit, and action are organic. That is, they are made up of systematically interrelated connections within self-conscious living beings. They work together. Generally, the closer they are, the better they work. The more effectively they are linked, the more powerfully they function.

The emphasis is on the connections, the interacting relationships

that energize the whole body. Quantum connections? Let's go back to our discussion of the micro-world realities of invisible quanta, the elemental indivisible units of energy in our universe, that inhabit every open space inside and outside of us. These quanta are pulsating waves of action that increase in complexity and intensity as they continue interacting with other energy waves to form greater masses of energy.

Each change of state to a more complex organism entails a more complex orbit of electrons revolving about a nucleus. Each of these changes involves a transformation, however small or large. **Each new level of activity is reached by a quantum leap in which there is a clear and decisive change that produces a greater capacity for action.**

Quantum leap connections produce considerably more than those that merely rearrange things already present. In quantum leaps, we are undergoing dramatic changes such as those of going from propeller-driven to jet aircraft, from coal-fired to diesel locomotives, from vacuum tube to transistorized computers, from muscle-stimulated might to mind-stimulated motion.

Change has now so apparently become part of our daily lives that we are learning how important continuous learning is to stay alive and invigorated. Otherwise, we could not keep up. Quickening the pace, however, does not mean running out of breath, unless we are not in condition. Being in condition means being up to speed, that is, able to maintain a certain pace, abreast of relevant change. Keeping pace involves mental conditioning, preparing the mind, conditioning our neurotransmitters. This enables us to think well enough to be on top of what is happening in the worlds we are living in.

Because the pace of change is quickening, it is essential for us to condition our minds so that their responsive and creative reactions to stimuli are *both* spontaneous to the highest possible degree *and* appropriate at the deepest possible level of understanding. What this means is that we need to cultivate our intuition. We need to become intuitively sensitive, able to sense what is actually happening even if it is invisible at the moment. We need to become anticipatory thinkers, capable of deriving the real meaning of various phenomena that may not be immediately

obvious to the untrained eye or the uncultivated mind. We need to be able to make timely judgments without being able to express in so many words why we have done so, and go forward spontaneously and resolutely on the basis of these judgments.

Continuous learning is, therefore, critical to making quantum connections. It produces the capability for increasing interact-ability. This, in turn, presents us with more opportunities for the right combinations to coalesce. In situations of growing complexity, it is important to remember the law of large numbers in which probabilities are realized. Thus, we strive for the "positive spirals" of energy that Bill Gates likes to talk about and that we need to develop in order for the desired critical mass to materialize.

NON-LOCALITY

Non-locality is a foreign term to our practical everyday world. But it has significant and, so far as I know, largely unexplored implications for leadership. In a momentous theorem published in 1964, physicist John Bell showed in principle that bonded quantum entities (such as electrons), regardless of the distance between the objects involved, are connected by influences that take place instantaneously. In a corroborating series of experiments in the early 1980s, Alain Aspect demonstrated that such non-locality, or action at a distance, rules a real world that exists apart from our observations of it. The controversy over interpretation of the findings continues to this day.

The point is that we must seek out potential connections that will most likely lead to significant improvement in performance. We should think of them as prospectively long-term engagements in which linkages are formed with close colleagues and good friends who can pursue more productive relationships. In this process, the quantum physics principle of non-locality, and our associated quantum civics principle of connecting resources, comes into play.

We are invited to see, accordingly, that **everything more or less is**

connected to everything else at the deepest, most profound levels in which the universe functions. Non-locality places central importance on connectivity and connectivity provides access to resources, between people and ideas as well as people and things. This principle says, in effect, that an electrical connection must exist before an electrical current can flow. A switch must be turned on before a space can light up.

Just as quantum mechanics led to high technology and an information revolution of global proportions, it is now leading to a leadership and organizational revolution with profound human implications. There is a long way to go, but a start has been made from which there is no turning back. There is a great deal to overcome: traditions of long standing, customs that are taken for granted, strong mindsets which are habitually used, and a powerful if subconscious fear of loss at stake in their removal. Yet we must overcome our fear of new knowledge that human inquiry uncovers. We must do so in order to deal with the great paradox of leading more powerfully by doing so more gently.

BIONIC SYSTEMS

High technology leads to bionic systems. Not to the stuff of science fiction as we usually think, but to the realities of organic systems. High technology refers to highly specialized and complex systems, usually thought of in terms of hardware, that are designed to handle specific technical problems. In order to take responsibility for guiding high tech instrumentalities, we increasingly are in need of organizational modes that are based on the mind-power of people working together, social capital, trust, the most valuable resource we share.

In order to obtain readier access to our human capabilities, I suggest we turn to bionics, the science of designing systems modeled after living organisms. Organizations are, after all, complex human systems holding together material support systems to accomplish our goals. Organizational systems must generate energy and vitality to be productive. Whatever else they may demonstrate, these systems must reflect the

needs of an organizational body. They must be, in essence, living systems that breathe life into organizational formats. They must be like the software that is necessary to run the hardware successfully. They must foster bionic organizations that work beyond profit for service with a surplus.

We cannot afford to make the mistake of thinking that our organizations can escape the impact of high technology. That is not possible. The world always has turned on the force of current technology and the use leadership has made of it. It is doing so now, as we speak. On this point, **the prime challenge we face is our own imagination.**

In science fiction, the terms "bionic man" or "bionic woman" refer to people with extraordinary, superhuman powers. Compared to the fading industrial age hierarchical norms that got us where we are on the world stage, bionic systems must produce greater outputs with greater resource limits demanded by the new realities of the information age. **We are expected to do what we think is impossible.** We are pressed by our circumstances to use our imaginations far more actively than we usually have. We must learn to think creatively as a matter of habit rather than as a matter of exception. We must let go of things that impede realization of our highest goals and most deeply held values. We must learn, paradoxically, to envision changes of strategy in order not to be forced to change our loftiest visions because our strategies did not work.

Quantum theory, quantum physics, and quantum mechanics have engendered new ways of thinking about realities that always were there but never before seen. They have led to the development of new technologies that made possible rocket science and nuclear bombs, laptop computers and laser beam surgery, microchips and multi-national corporations. They have enabled electronic communication to perform astounding feats not dreamed of until recently.

Now quantum thinking is being applied to human organization. It is reinforcing old inclinations about the need to foster creativity and make connections, while giving them whole new meaning. **Creativity and connections are not luxury supplements to the good life. They are the good life itself.** Creativity and connectivity are not only desirable, they are essential. The old idea of quality products is not just a healthy

choice, but a staple of organizational life. The old saying about the customer always being right has re-emerged. **The customer now is the real boss, even though most of us don't act like we know that yet.**

The challenge for organization is to increase productivity more than incrementally or gradually, but significantly and rapidly. In no other way can it stay abreast of the demands of change. Digging deep into the well of human capability, we find the spring of under-tapped human mind-power where the inner self may be called forth to meet the outer world. Here we find the infinite resources that may be tapped by organizational leadership. Here is where we meet the dynamics of highly spirited action. Here is where we may embrace a meeting of the minds that generates new energy for thought and action. Here is where synergy can electrify as connections are developed.

As dynamic relationships emerge between individuals acting together in groups, new possibilities arise and new solutions may be sorted out. Purpose and people come to the fore and processes are forged to facilitate their creative interactions. It becomes possible, through dialogue, to break down barriers that are obstacles to communication and accomplishment. It becomes easier to keep the end in view, or mutually to evolve a new one not yet in view, and becomes less likely that ideologies will get in the way of urgent tasks that need doing. More gets done because mutual trust replaces distrust and unproductive time is freed for use in productive work. Plus, the interplay of diverse perspectives sparks lively exchanges that, in turn, elicit greater understanding. Knowledge really is power, and in far more effective and unexpected ways than we had probably imagined.

The point is that the organizational spirit, heart, and mind all affect the organizational body and the supplies with which the body is stocked to soar into the future. What is nearest and dearest is a product of the organizational belief system that, in turn, is a value-driven vision of the organizational culture. It is, therefore, pre-eminently important to nurture the type of collective culture that nurtures what is most desired. Organizational culture does make a difference. And organizational culture works best when it is seen as a bionic system.

QUANTA-SYNTHESIS

Leadership always produces new synthesis. The synthesis we probably first learned about in school was photosynthesis, the biological union of chemical compounds in plant cells stimulated by the presence of light from the sun. The new mixture enables the plant cells to produce organic substances that transform their radiant energy into potent new chemical forms. In doing so, it creates new plant life from which animals and people find nourishment.

Similar to this biological process are organizational processes that lead to what I believe is a *quanta-synthesis*, a synthesis of human energy formed in the presence of common vision and produced in quantum leaps as synchronicity. Quanta-synthesis involves organic change developing into new organizational life. It produces vital qualities of interaction made possible by new sets of connections.

Quanta-synthesis engages a more complex and conscious web of connections charged with energy not previously available. It draws more people more effectively into working relationships. It has a focus that is clearly held in common. It shares knowledge that is meaningful to all. It involves a commitment to the whole that drives the group as a team and then as a community of practice. It opens new avenues of communication and action not heretofore available. As a process, it confers new power upon those who are engaged. It is an autonomous self-energizing process, and has all the thrust of empowerment.

Self-energizing autonomy is like self-government or self-determination. It creates its own relationships and processes. Not that it ignores the bigger picture or larger context in which it finds itself. It cannot do that without endangering separation from the supportive universe of which it is a part. But this is the common fear of managers and supervisors who worry about losing control. **In the presence of a shared vision, the paradox is that, by empowering autonomous self-energized teams, greater power is generated for the whole.** You might say that, as in rocket science, there must be a letting go and a powering up before there can be a lifting off.

New synthesis is an everyday thing in all forms of life as quantum change keeps going and going. Quanta-synthesis recognizes the life-giving resources that are accessible in the quantum world to associations of individuals whose organizations are losing momentum or simply to those who are not satisfied with things as they are. **In quanta-synthesis there are five sets of critical connections.**

First is the connection with the self or the inner core, the creative energy of being which identifies one's purpose in life as an individual or as an organization. Here is where the spirit lives. Here is where the foundation lies. Here is where bedrock principle is found. Here is hard-core belief. Here is the bright light of illumination. Here is the power potential of intelligent energy emotionally bound and ready for supercharge. Most of us, and most organizations as well, most of the time, are not in touch with this ultimate inner source of strength and vitality that is accessible through introspection.

Second is connection with a group of active collaborators coming together with an emerging vision that has an image of a future pulling it forward, out of the known and into the unknown. Here is where our dreams are taking us. Here is where our thoughts are leading us. Here is the path upon which we will walk the way ahead. Here is a future waiting to be created and which we can shape by our actions. Here is hope in progress or fear in regress. It's what we make of it. Again, most of us in most of our organized groups most of the time have little appreciation for what power we have in our minds to envision what we desire.

Third is the connection with good friends who are potential collaborators with us in a visionary cause. These are the people we trust and count on. These are the ones with whom we share an attitude and mindset, common knowledge and commitment. These are those we would walk a mile for and who would do the same for us. We are on the same wavelength. We share core values. We have similar interests. We want the same things in life, at least in certain important ways. Are we in close touch with these friends? Are we sure we know who they are? Are we helping them with any part of their lives? Are they helping us with ours?

Fourth are connections to interesting acquaintances we have

begun to engage, who may be prospective collaborators. We need to bring them into the dialogue. We need to draw as close to them as we can to share our thinking and hear about theirs. We need to tell stories and trade knowledge of experiences we value. We need to talk about the future, speculate about the choices, and discuss the possibilities. We need to enlarge our circles, turning outward to the new as we turn inward to the trusted.

Fifth are the connections that can develop in a participatory process through which we seek to wire our vision with the resource potential of other friendly people. In such a process we want to see a leadership opportunity in which we enable those we serve to become those who serve as well. We want to transform our suppliers into our partners. We want to see our associates as our co-leaders. We want everyone with whom we come into contact to become a friend of our cause. Each person with whom we work in whatever capacity should be a prospective volunteer for the high calling that means so much to us. The process we choose to follow will be a very valuable tool for helping to shape our success.

If we think of the journey in pursuit of our vision as part of our goal, if we think of our journey as a means to the end we have in view, if we consider the road as integral to our destiny and our destiny as an evolving destination, then we will keep our minds on the moment even as we have our eyes on the horizon. This way, we never separate the pursuit from the purpose or the way along from the way beyond. We see it all, everything together, interconnected, as one.

Quanta-synthesis in our organizations will give them new strength and resiliency for the long-term future. It will enable them to strike a better balance between the need for creative use of precious resources and the need for careful monitoring of these same resources. It will put a premium on exemplary leadership, as Warren Bennis has described it, in which leaders and followers are co-leaders, and often trade roles depending on who has what expertise on what subject when it is needed. It will anticipate leadership being applied at every level and in every segment of the organization. And it will see follower-ship in the same way. **No one is too great or too small to play either role as leader or**

follower, to share either responsibility, or to receive recognition accordingly.

The need for knowledge, as I see it, will press administrative units, once established to control the effective production of inputs, to convert into pools of expertise which are selectively tapped for work on project team outputs. Working units that consist of functionally related professionals will re-conceive themselves, with Gifford Pinchot, as "intrapreneurial" providers for an organization's project teams. Or, they will be split up into self-energizing, multi-specialist teams. In either case, rigid hierarchies will deflate and will be replaced by flexible networks. **The hierarchies themselves will not disappear. Instead, they will more flexibly support the leading edge work done by project teams.**

As it coalesces, quanta-synthesis will morph into a synchronicity of events that results from ongoing quantum dynamical processes. These processes produce quantum leaps in performance as each phase of growth in complexity and consciousness reaches maturity and transforms into a new level of energy and action. Each phase will have greater potential for building on the other while leading on to a greater convergence of activities. The reinforcing nature of collective activities is of great importance to realization of the vision, and cannot be taken for granted. The pathway from potentiality to actuality is laced with obstacles, and requires a very perceptive feel to be successfully negotiated.

How would volunteer champions and their collaborators have the best chance to magnify their possibilities? Let's take a look at what I'm calling "strategic philanthropy" and "strategic accountability" for some answers. In strategic philanthropy we'll be looking at why people give significantly of their time, talent, and treasure. In strategic accountability we'll be looking at how recipient organizations and institutions must be prepared to account for their use. I believe that beyond-profit organizations of the future across the public, private, and civic sectors will benefit from looking at their resources as gifts invested by those who are responsible for making the decisions to do so.

STRATEGIC PHILANTHROPY

Philanthropy is a word not often associated with leadership except where big gifts to charity are reported. But philanthropy is more important than that. The word philanthropy comes to us from the ancient Greeks. It means love of humankind, in essence. It is generally used for acts of benevolence in the form of charitable gifts. But it also includes voluntary contributions of service to charitable causes. In the year 2000, in fact, gifts of voluntary service in America were estimated to be more than gifts of money, $239 billion to $211 billion. Either way, philanthropic service or philanthropic support, a donor gives something of value that helps others in need.

Philanthropy, in actuality, is a form of investment in the well-being of other people. The return on investment in philanthropy for the donor-investor is the knowledge that he or she has done something worthwhile for others and the feeling of joyfulness that arises from knowing that. Gifts cannot be explained simply as acts of charity. They are also made as calculated action for purposes considered worthy by donors.

All philanthropy, therefore, begins with a connection of some kind to a cause. In some way, a donor is moved by the touch of a volunteer, and chooses to do something more or less benevolent which has the effect of helping others who represent a hopeful opportunity. As this occurs, a three-dimensional situation arises involving a cause, a volunteer who is associated with it, and a donor who experiences them both. The cause must be appealing. The volunteer must be considered a friend or legitimate agent of some kind. The donor's experience must be meaningful. Usually, however, it isn't quite that simple. The philanthropic situation is complicated by a variety of encounters with the cause, a variety of contacts with people associated with the cause, and a host of engagements at different events run by an organization on behalf of the cause. These associations, when successful overall, leave some sort of positive feeling.

Philanthropy searches for a desirable return, like investing, where it will do the most good, get the best results, in light of the donor-investor's priorities. **The bottom line for a donor is more like a beautiful hori-**

zon with a range of related colors than it is like a clear straight line. It has space both above and below that delineates one realm from another, that is, let us say the dark from the light. But the line does not appear as an absolute, rather more like a changing blend of differences. The dark consists of unacceptable factors, let us say, and the light of acceptable factors. There is no single line separating totally clear differences, but a multiplicity of lines with different gradations of color quality.

How these gradations are interpreted on a horizon of priorities depends on the donor's vision and values, those matters closest to the heart. The donor, therefore, will be affected a great deal by the people associated with the cause, who they are, what they do, and how they make one feel. We're not talking here about anyone making hasty decisions, not usually anyway, but rather about people building long-term relationships that promise substantial reward over time for the parties involved.

Strategic philanthropy goes beyond the ordinary. **Strategic philanthropy is that which plays a life-changing role both for the donor and the recipient.** Such philanthropy leads to other philanthropic responses that build upon it. Strategic philanthropy plays a decisive role at the frontiers of leadership for the recipient's work on behalf of its cause.

Philanthropy isn't necessarily generated by what first meets the eye or what initially crosses the mind or what generally passes as the official line. The real inspiration for strategic philanthropy is a combination of factors that often is hidden. Philanthropy is a private matter involving highly personal motives when it is strategic. Even when it may later be described in public testimonials, that is only part of the story. The magic comes in really touching the heart of a prospective donor whose friendship is actively sought. That is not usually done on stage. It is done in personal conversation which may arise after quite some time spent leading up to it that involves, again, a variety of exposures of the prospective donor to the prospective recipient.

Strategic philanthropy is given *from* power *to* potential, from strength to opportunity. It is philanthropy that is not something small or frivolous, but deeply meaningful to both parties. I will never forget the gentleman in Tampa, a leader in that community, who was looking for a

way he could help get a major campaign going for the university, which he served as board chair, but who claimed he did not know anything about fund raising.

He had good advice from Art Frantzreb, who was serving as the university's consultant in philanthropy, to organize an unprecedented $25 million anniversary campaign for financial support. Art said what the university most needed was an unconditional gift of $5 million to give it the urgent lift required to begin taking the big steps planned for its future. But, since there appeared to be no one around who could do that, maybe a group of ten donors could combine gifts averaging $500,000 and make such a goal a reality.

Art's thought came after a series of interviews with leading volunteers convinced him that something dramatic was needed and that, despite an inglorious philanthropic history in the greater Tampa community up to that time, the philanthropic potential was evidently there. The situation challenged this gentleman, who began by asking himself if he would be first, as Art had wondered. Best place to start. The answer was "yes." But that was only the start. The man was partially disabled, and it wasn't easy for him to get around, though he kept up a rigorous daily schedule of work and personal activities. He decided to make time for a special effort to see what he could do. He called on nine other people he thought could match what he was planning to do and asked each one to do the same.

Three said "no," and six said "yes." Four of the six matched his commitment of $500,000. The other two pledged $200,000 combined. He had succeeded in raising $2.7 million, more than half what he had set out to do. He could go no further, he felt. He was no expert at things like this. He literally had done it all himself, and there was no one else to whom he could turn. In his mind, there was a shortfall, and no one else to blame.

Or to take the credit! To everyone else the $2.7 million looked more like a fabulous windfall, and was a tremendous boost for the university. He was joyful at the reaction. Each of the five $500,000 gift commitments was almost twice as big as the largest single gift ever before made

in Tampa. This was on the eve of the university's 50th anniversary in 1981. (Today those gifts would be worth well over $2 million each and all seven gifts would probably be worth more than twice the $5 million originally sought.) In the end, the seven gifts were made anonymously as a joint gift of $2.7 million from what the donors called a "Committee of Confidence" with (unfortunately) no special publicity.

The following year, when the annual report of national philanthropy was published, this $2.7 million gift was reported as the 30th largest gift made to any of more than 3,000 colleges and universities by any donor for any purpose *in the United States* in the previous year. It was also the first *joint* gift of its magnitude ever announced, as far as anyone knew! This man could not walk without braces, but he could talk with the charm and charisma of a person of great faith, one who believed deeply, and so strongly that his quiet words and his warm heart were irresistible to those who cared.

This was an example of strategic philanthropy at its best. The power of its magnitude at the time was awesome. But the power of its purpose was, too. The donors did not give the funds without restriction. They asked that they be used entirely to leverage current operations in the first of their five-year investment strategy, but less and less so through the period with increasing amounts going into endowment until all the funds in the final year were designated for the investment portfolio. This was strategic thinking of unusual wisdom. The university got an immediate shot in the arm that launched it into a new orbit of academic excellence. Then it received a significant new infusion of long-term capital to endow a continuing margin of excellence.

Several years later, Tampa's mayor Bob Martinez, soon-to-be governor of Florida and later head of the U.S. Drug Enforcement Agency under the first President Bush, earmarked public funds to match those of the General Telephone Company of Florida for the rehabilitation of the city-owned park at the university's entrance and to erect a permanent remembrance honoring the seven anonymous donors. A magnificent abstract sculpture by Verne Shafer of Wisconsin, celebrated the donors as seven "Sticks of Fire," the old Indian term for the lightning so common

in the area. It stands to this day as a tribute to the "Spirit of Tampa" which one extraordinary leader and six co-leading friends made possible with a lightning strike gift never to be forgotten.

The seven anonymous donors were actually strategic investors who gave of their resources so that something important might happen in their city. **Their return on investment was not a particular financial return to them. It was an unfolding civic return that could provide strategic leverage for their city through its university.** In both philanthropy and finance, resources are transferred from one party who is looking forward to a return, to the custody of another party who is accepting responsibility for a return.

STRATEGIC ACCOUNTABILITY

We might say that the final connection is accountability, though we all know it is also the lead connection to the next round of organized activity. Insofar as we can pinpoint one last thing, it has to be accounting for what we have accomplished. Not that accountability always comes at the end of a process, because it actually is required all along the way of a process, but that it comes *after* what it purports to measure, and in that sense is final.

We should think in terms of *strategic* accounting. By strategic we should think of that which is most important in the scheme of an organization's operations all together, not just in its finances. It works most effectively to begin this thinking right from the beginning of our work. We should think ahead as we consider our collaborators, our vision and strategy, and our sources of support, indeed all of our stakeholders. We must consider who these people are in the broadest reasonable sense so as not to leave out anyone who is likely to be affected significantly by our work.

In strategic accountability, it is essential to address the fundamental issues a beyond-profit organization faces. Why are we here, in other words, what is motivating our presence? Who is involved as providers? What are their visions of the future, and how consistent are they with

officially stated intentions? How are they doing in relation to their plans, in financial and other terms? Where are the rewards being reflected?

These questions go back to the beginning and cover the five properties of our quantum civics paradigm of leadership—creative energy, collaborative participation, visionary cause, concerted strategy, and connecting resources. We often forget to ask these questions. We must not be satisfied with superficial answers we don't really understand. We must not wait to check up until something goes wrong.

Chief executives and staff associates carry operating responsibility for paying attention to these questions. Volunteer board members carry ultimate responsibility for the answers to these questions. That is because board members are trustees who are the fiduciaries, or official stewards of their organizations. **Being fiduciaries means they are required by law to take good care of the organization's resources and see that they are used for the purpose to which the organization has committed itself.**

Fiduciaries hold other people's money in their trust. They have legal responsibility for it. But it is not enough just to look after the money and to be sure it is not being misused. Important and basic as that is, it is only the beginning of accountability. Though we cannot get very far past the starting line without accounting for funds, we must remember that the end of accountability is how well we served our reason for being, our purpose in existing as a public benefit organization, in terms that ultimately the public understands and accepts.

To know well how effectively we are serving our purpose, we need a lot more than the insights of those in positions of legal control. They could be mistaken for any number of reasons, not least of which are the limitations necessarily imposed by their time constraints and their particular experience. Every organization needs to establish a set of benchmarks in reference to which its operations may be authoritatively guided not only by collaborators but also by other stakeholders. We will want to be sure we have a broad spectrum of opinion on the benchmarks we select so that we may effectively assess and accept the progress we are making. And we will want to be sure that we have reliable instruments to audit the progress itself.

Even voluntary organizations that do a good job of protecting their financial resources in the immediate sense, often do a poor job of paying attention to how well these resources are used to accomplish the organization's purpose. **Stewardship of resources is more than about assuring solvency. It is mostly about being a guardian of purpose.** As challenging as staying financially whole often is, the really tough part is pursuing organizational purpose in the face of persistently distracting circumstances. This is the prime reason it is important to set the signposts of organizational measurement comprehensively in advance.

One major reason this frequently is not well done is the difficulty of agreeing on measurement indicators. The selection of these not infrequently becomes an emotionally charged issue. A strongly shared common will to pursue the best that can be found will go a long way in the right direction. In one way or another, everything gets measured or assessed by those who are affected by the outcomes. How that occurs should be the starting point for working on accountability.

Even where organizations are taking care of funds and focusing effectively on their purposes, they must also consider the impact they are having on all their stakeholders. For example, how well are they treating their staff members? What about their neighbors? Not to mention the clients they are sworn to serve?

Often, organizations exploit those stakeholders who hold little power. In tough times, the frustrations of alienated, resentful stakeholders can turn into rage, and lead to ugliness, sometimes in a very public way. I have witnessed this and experienced it first hand, both in private and public situations. I have seen individuals and institutions hurt badly and unnecessarily. And I am reminded of the ethical admonition to "first, do no harm." To avoid harm and to produce good will, we must try very hard to think of everyone who might be affected by what we do. Then we need to make a point to put ourselves in their place. How would we feel and what would we do if we were in their place? That should be our guide.

More important than the public relations issue, though, is the moral obligation to take *good* care of everyone, *especially* those who are

powerless to fight for themselves. In looking out for their well-being the stakeholder is treated like a friend, and friends take care of their own. Conscientious accountability of this sort is common sense good business practice no matter what purpose your organization is serving.

Lastly, it means a great deal to report progress toward planned goals in timely and candid ways. Participants in the planning process should be privy to the status of operating achievement in relation to benchmarks they had helped to set. They should be treated as full partners in the enterprise. And they should be expected to share the news with their associates on an immediate basis so that it is learned directly rather than from outside sources.

Accountability is accentuated with a sense of ownership, regardless of financial arrangements. A sense of ownership increases with a feeling of responsibility. And a feeling of responsibility increases with the presence of knowledge. If we keep our associates away from timely information about important goings-on, we not only risk the loss of their best informed efforts, we also risk their resentment for being treated as tools of ownership. How would you feel?

One of my valued colleagues in the voluntary leadership classes at Chapman was Patrick Guzman, principal of Guzman & Gray certified public accountants in Long Beach, California, who specializes in non-profit organizations. He has developed an accountability model for our quantum civics paradigm of leadership and the beyond-profit organization that he describes in *The Nonprofit Handbook: Fund Raising* (Third Edition, edited by Jim Greenfield. He calls it the LIFE model. As part of that, Pat has also created its anti-thesis, the DEAD model. Without attempting to characterize how Patrick actually uses this idea in assisting his clients, I want to outline what I think is the significance that his LIFE/DEAD model has for the quantum civics paradigm of leadership.

The LIFE/DEAD accountability model is a mirror image of the quantum civics leadership paradigm. That is, through it we see our reflection in a leadership looking glass. Why do we look into the mirror? Of course, because we are checking our appearance to decide how to get it ready for what's next. Pat sees his LIFE/DEAD model in the same

way, as a tool for reflecting how an organization shapes up according to the principles of quantum civics.

In the Guzman LIFE/DEAD model, the **first concern is the presence of "leading participants," the "L" in LIFE.** This is the first responsibility and corresponds to collaborative participation in quantum civics. Remember that the beyond-profit organization sees itself fundamentally as a service organization, regardless of the specific purpose it may have. The first requirement of being an effective service organization is to assemble collaborators who are taking responsibility for getting done whatever needs to be done and who are excited about what they are doing. Succeeding generations of leading participants are the first essential to long-term success in any venture. The volunteer champions who emerge from the collaborative efforts are the persistent force throughout the leadership process and its successive life cycles. Volunteer champions lead the way for collaborative participants who are framing a visionary cause, then implementing a concerted strategy with connecting resources.

On the other hand, in the absence of collaboration, darkness falls where the parties to participation insist on having their own individual ways. **"Darkness of outlook,"** as seen in the dark faces of participants and the dark shadows of their strained relationships, **is the "D" on the opposite side of success which leads to being DEAD.** Often, it is difficult for aspiring beyond-profit organizations to secure the spirit of collaboration necessary for progress to be made, especially when agendas become contentious. After all, the individualism that so well characterizes much of American culture in all walks of life does not always accommodate collaboration easily. It takes an adjustment of attitude to switch gears. The point here is that this adjustment is absolutely necessary up front in order for the leadership process to function at the level of effectiveness required in civic matters. Failure to achieve an adjustment from individualism to collaboration will lead to disastrous results no matter how well plans may have been made.

The second concern in the LIFE/DEAD model is to achieve "integrity of vision," the "I" in the Guzman model. This is the opposite of

imposed compliance. With integrity of vision, we are looking for consistency and wholeness of character that is self-generated. We are looking for signs of shared purpose that we can equate with a visionary cause. We look for how well the direction of organizational efforts coalesces throughout the actual activities in the organization's ranks. Integrity that illuminates is the result of a visionary cause embraced by the collaborating participants of a beyond-profit organization, and is embodied in the exemplary efforts of its volunteer champions. The volunteer champions exemplify commitment to the cause that is so strong it cannot be missed, or denied. In an organization with a vision of integrity, truthfulness is a hallmark of its culture.

On the other hand, in the absence of visionary integrity there is an "ethical void," the "E" on the DEAD side of the Guzman model. Ethical voids are not uncommon even in apparently successful beyond-profit organizations that may have plentiful possessions but cluttered spirits. It is very easy to become waylaid from ends to means in any organized group, and not any less so in service organizations of the type we are describing here. In schools and colleges, for example, there are countless instances of an overdone preoccupation with teaching that obscures instead of assists the goal of learning, where what is taught is considered more important than what actually is learned. This tends to produce the effect of an ethical void, no matter how well intentioned are the principals, and this in turn eventually leads to financial stress points between costs and prices, because it results in so much energy invested to compensate for the performance gaps. Inevitably, the absence of strongly shared vision leads to ethical voids caused by ends-means inversions. And these, in turn, have adverse financial consequences.

The third concern of the LIFE/DEAD accountability model is "favorable results," that is, how the strategic plan of the organization is working overall, what changes are taking place in the organizational environment as a result of it, and where the greatest headway is being or likely to be made. Favorable results are the "F" on the LIFE side of the model, and are the accountability equivalent of concerted strategy in that they frame the operating picture that catches what actually is happening

in the life of the organization at any given moment. We don't wait until the book is closed to look at how cost-benefit ratios are shaping up, we start looking at them as soon as we begin operating. Strategic accountability looks at the flow of key factors on how effectively the organization is going about its business. Therefore, accountants doing strategic analysis are also looking at the leading programs and practices of an organization to see how well they support its purpose.

On the other hand, an organization in trouble has a hand-to-mouth mentality that reflects "adverse consequences," the "A" on the DEAD side of the model. We are not unfamiliar with this feeling because we see it so often, in small organizations especially, and in start-up organizations mostly. It is a state of mind as well as a material fact. It often leads to poor-mouthing and that in turn leads to begging, a sure sign that death is near. In this case, tin cups do not runneth over.

The fourth concern of the LIFE/DEAD model of strategic accountability brings us to the "E" in LIFE that stands for "evaluation of productivity." This emphasizes how well resources are acquired and allocated to the purpose and program of the organization. The acquiring and the allocating together add up to a degree of resourcefulness, which equates to the principle of connecting resources in the quantum civics paradigm. According to this principle, excellent performance is the prerequisite for attracting support based on careful evaluation. For an organization to achieve lasting results through the persistent efforts of volunteer champions and their collaborators, they must adhere to a continuing focus on evaluating the actual performance against the stated intent of the organization. This standard must apply first and foremost to implementation of purpose, including program applications and financial controls together. The evaluation must be thorough enough to stand up to professional and public scrutiny.

The second "D" on the DEAD side of the model is for the "disastrous results" that follow from lack of attention to excellence in performance, running from program to finance. Casual attitudes have no place in the setting of standards. This is not to say that informality and fun do not play productive, and even critical, roles in generating creative energy

for the enterprise. They do. What has no place is an attitude of carelessness that breeds neglect. The process of leadership involves a creative discipline that demands attention and care. The process of accountability demands no less. Disastrous results can be avoided by an attitude of responsibility that pervades the mind set of a united group.

THE RESOURCE SUPER GENE

The movers and the shakers need each other as much as do the starters and finishers. The resource super gene is the final ingredient in the success of each life cycle in the quantum leadership process. It is the *finishing shaker* in the process. Remember that our leadership paradigm envisages resources as the equivalent of cytosine, the C base that functions along with the A, G, and T bases of DNA. Remember also that the C base relationship with resources includes its interactions with the other bases which, in turn, we have identified as being correlated with participation, vision, and strategy successively. These energizers of the quantum paradigm, powered by the leadership impetus of the creative energy super gene, are embedded along an integrated circuit in our quantum leader chip containing the core memory of the leadership process that we can see in our mind's eye.

The *grounding force* in our paradigm is equivalent to the gravitational force in nature. It is the only one of the four forces of nature that has not yet been explained by quantum field theory, the most sophisticated explanation we have of how the universe works. A number of astute physicists are at work on a "unified theory" or "theory of everything" that would bring all four forces together in a simple explanation of universal symmetry. In the meantime, many surmise, as I do, that this force somehow participates in quantum effects. We could not keep our feet on the ground otherwise, and since we are quantum persons in a quantum world how could there not be quantum gravity? The only trouble is we haven't yet been able to explain it!

It is fascinating to recall, as reported earlier, that this *grounding*

force operates at the 1st power of magnitude, far weaker than the others which are operating at the 28th, 39th, and 41st powers of magnitude. How can this be, if resources are really most closely correlated with this force? Money, after all, is more important than anything, right? Wrong.

As Art Frantzreb likes to say, "Money is the root of all excellence." Roots grow from seeds which contain all four DNA bases that together pull beautiful trees up from their roots into long life. Roots are just that. They are not the rest of the tree. The roots exist for the tree, not the tree for the roots. Roots represent resources in a basic sense in that they absorb nutrients from the soil in which they are growing. In an analogous way, the resources of our paradigm absorb creative energy from the growing seed of participation, vision, and strategy. Then they go on to use this creative energy as leadership impetus for building the leadership process into a dynamic living system.

As the resource super gene or *finishing shaker*, our paradigm envisages resources as the final connection we need to have in order to make the entire circuit work. The C base is the same size as, but better connected than, its T base sibling, epitomized by strategy. It is smaller than, but tightly connected to, its base-pair partner, the G base, epitomized by vision. **Resources are illuminated by vision and they are activated by strategy. Then, they stimulate the initiating participants to move on to the next level of activity in the leadership process.**

WHERE ARE THE REWARDS?

In making connections, we constantly must be asking ourselves the question "Where are the rewards?" **We must ask ourselves quite literally about where we see specific revenues as well as generally about where we see return on investment in the provision of services, the marketing of these services, and good will in the larger community.** It is no contradiction to keep our eye on the bottom line to first make sure we are paying our way as we go about putting service before surplus in the beyond-profit organization.

The beyond-profit organization obviously cannot serve at the sacrifice of its survival or it ceases to serve at all. What it must not do is to put surplus before survival as the primary intent of the organization. The surplus is always a means rather than the end. Good service smartly delivered to a well-targeted market will produce a sound return for investors. If investors are looking to make a killing for themselves, they are in the wrong place. The beyond-profit organization is in it for the long haul and so are their investors.

This is what Richard Carlson likes to call a "worry-free, wealth-building strategy" in that it looks at what really matters. It is also the basis of what Arie de Geus means when he observes that "Like all organisms, the living company exists primarily for its own survival and improvement: to fulfill its potential and to become as great as it can be." Thus, the beyond-profit organization puts service to all stakeholders, as distinct from just shareholders, at the top of its priority list. **To be beyond-profit is not to impugn profit but to put it in its place at the bottom of the line after all the others in order to assure there will continue to be a top of the line before all the others.**

Again, in establishing a basis for measurement, we will score our situations on scales of one to five, low to high. Great net revenue flow rates a five as do great ratings of general investment return. Scores of four indicate high revenue earnings and a high composite rate of return on investment. Scores of three indicate fair revenue earnings and a fair composite rate of investment return. Scores of two indicate limited revenues tilting out of balance and limited investment returns encountering trouble. Scores of one indicate little revenues clearly coming up short of balance and little investment return showing deeply troublesome signs overall.

Again, to illustrate contrasting values, resources that are producing a great net revenue flow scoring five with but a limited composite return on investment scoring two may be doing extremely well short-term, but at real risk long-term. On the other hand, resources that are producing a limited revenue flow valued at two with a great composite investment return under way are barely making it short-term, but heading for a suc-

cessful future down the road if they can get through the current struggle. The same score of seven out of a possible ten on the combined revenue-return overall scale of resources portrays a very different picture, as in our earlier illustrations. Without a better understanding of the comparative strategic situations it is difficult to prejudge the two different life cycles. Our story will need to unfold further before we are in a position to get a clear picture of the two situations.

PRESIDENTS CONNECT
WITH POTENTIAL RESOURCES

For both Camden and Jacqueline times are getting more and more interesting. They both appear to be doing well. But the challenges they face are becoming increasingly complex. It is clear that, as they reach this resource-oriented phase of their work, they are finding that the choices and commitments already in place are having a huge impact on their resource possibilities.

For example, Camden was welcomed by donors with outstanding track records over the years. Jacqueline, on the other hand, was finding support from first-time donors who were most interested in new approaches for the future. Camden's supporters more often represented old wealth, established sources with prestigious names and elite standing. Jacqueline's supporters included more of the younger professionals, first generation entrepreneurs, new wealth.

Constituency members of the college headed by Camden were often low key in life style even when they were occasionally in the news. They tended to like things the way they were and enjoyed the privacy of their business and social lives. Camden's board, not surprisingly, opted when the time came for a capital fund raising plan, for new endowment and building projects clearly within their means that had a conservative goal rather safely within reach. They went for it and made it. It was nice, but was essentially an above-average achievement, less than they might have done had they raised their sights.

Constituency members of the college Jacqueline headed seemed to have a more adventurous attitude, and didn't mind being in the public eye if they thought it might do some good. They were more likely to be dissatisfied with whatever the current state of affairs was, and seemed to be continuously pressing for innovation and change. When the time came to face the capital campaign issue, Jacqueline's board took an expansive view and went for a stretch goal, far bigger than anything attempted before by their institution. They made it, too.

There seemed to be room for both contrasting approaches to insti-

tutional success. At least in the short run. The first half dozen or so years were productive ones for both presidencies. The presidents' contracts had been renewed once and were up again. As their campaigns concluded, a new issue began to emerge. What about their capacity for renewing their resources? Was the stress of capital campaigning so great as to exhaust the potential for greater resource development in the future? Or, did it uncover new potential along the way that could be cultivated for future leadership?

In essence, Camden did all right on revenue flow with a clear campaign victory, scoring a three, and a rate of return also scoring a three, for a total of six. Jacqueline had done better on revenue flow by exceeding a stretch goal in her campaign along with a reasonable rate of return on investment, yielding a five and a three for an eight. What did all this add up to? It will become more clear as we shall see.

TWO PRESIDENTS CONNECT WITH POTENTIAL RESOURCES

Camden Gould	Jacqueline Hope
Established donors; old wealth	First time donors; new wealth
Conservative campaign goal	Stretch campaign goal
Above average achievement	Superior achievement
Three for revenue; three for return	Five for revenue; three for return

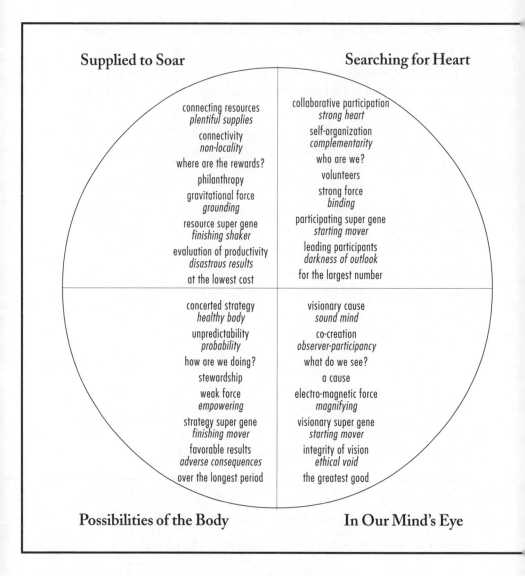

Supplied to Soar

connecting resources
plentiful supplies

connectivity
non-locality

where are the rewards?

philanthropy

gravitational force
grounding

resource super gene
finishing shaker

evaluation of productivity
disastrous results

at the lowest cost

Searching for Heart

collaborative participation
strong heart

self-organization
complementarity

who are we?

volunteers

strong force
binding

participating super gene
starting mover

leading participants
darkness of outlook

for the largest number

concerted strategy
healthy body

unpredictability
probability

how are we doing?

stewardship

weak force
empowering

strategy super gene
finishing mover

favorable results
adverse consequences

over the longest period

visionary cause
sound mind

co-creation
observer-participancy

what do we see?

a cause

electro-magnetic force
magnifying

visionary super gene
starting mover

integrity of vision
ethical void

the greatest good

Possibilities of the Body

In Our Mind's Eye

FIGURE 8: CIRCLE OF ODNA, ALL QUADRANTS

The four quadrants shown here emerge from the center core of our circles (page 101) and i[n]teract dynamically (page 224).

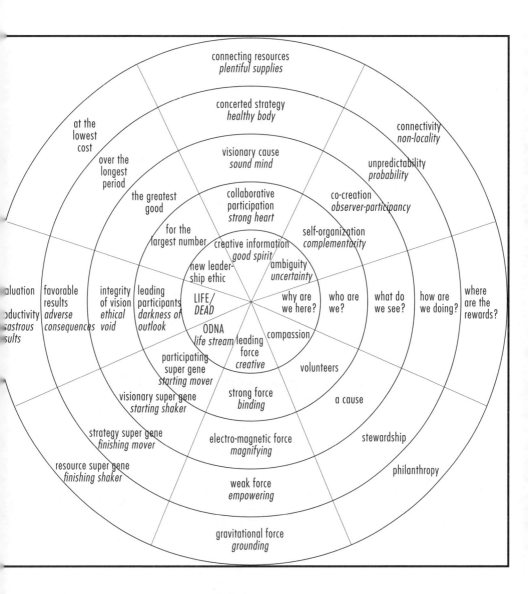

FIGURE 9: QUANTUM CIVICS PARADIGM D

Start reading from the north axis and read from the center toward the circumference, then proceed in like manner clockwise around the concentric circles to identify (1) the leading properties, (2) peculiar features and quantum principles, (3) key questions, (4) distinctive aspects of voluntary leadership, (5) the natural alignment of forces, (6) the ODNA super genes and their special roles, (7) LIFE/DEAD accountability, and (8) the new leadership ethic.

*"One prognosis is reasonably certain:
whether the course of humanity takes the
worst or the best possible turn will depend on
whether man finally learns what he has failed
to learn in the five millennia of his cultural
history, namely, to act rationally and sensibly
in the interests of humanity and to work
out well-defined rules of conduct.
The latter are analogous to a genetic program
and must be established as binding for all."
—Manfred Eigen*

8. ODNA:

The Code and the Equation

When an organization is seen as a super-organism, that is, as a community of interdependent organisms, we can envisage the organizational DNA or ODNA as containing Manfred Eigen's "genetic program" for its development. In my view, ODNA is analogous to the seed from which the organizational future germinates. It contains the genetic code in which is inscribed the set of evolving relationships that are integral to the organization's raw potential. Interactions of the five leading properties of ODNA actualize the evolution of an organization. These properties are what I suggest we envisage as the *super genes*, that is, the proposed organizational correlates of the genes scientists are discovering in living beings. Each super gene is an operating sub-system that functions in the memory of each member of the organization. In the discussion which follows, I will lay out the specifics that I see as the framework of leadership development, the new discipline of social science I am calling quantum civics.

As we have seen, the creative super gene functions as the ODNA *life stream*, the equivalent of the protoplasm inside a living cell, kind of a super fluid which feeds the DNA components guiding an organism's growth. The participating super gene functions as the ODNA *starting mover* which fires up the organic engine and gets it going. The visionary super gene functions as the ODNA *starting shaker* which clarifies direction and gives it the wave frequency to move on. The strategy super gene functions as the ODNA *finishing mover* that combines smaller size and greater excitability to generate greater velocity in the established direction. The resource super gene functions as ODNA *finishing shaker* that has the smaller size and steadier temperament for completing the cycle.

Now, let's revisit the four sets of complementary relationships among these proposed super genes of ODNA. These relationships are intended to correspond with the complex networks of relationships in the genes of individual beings. When one relates to another it brings along all its other relationships. As I look at the DNA of a human being, I envisage the A base not just as adenine, but also as adenine in relation to thymine plus adenine in relation to guanine, and adenine in relation to cytosine. I envisage the G base not just as guanine, but also as guanine in relation to cytosine, adenine, and thymine. The T base is not just thymine, but also its relations with adenine, cytosine, and guanine. And the C base is not just cytosine, but also its relations with guanine, thymine, and adenine. Context meets context. Situation encounters situation. Energy field is attracted to energy field. Each A, G, T, and C base is *both* a singularity *and* a complexity. It cannot escape either its individuality or its relationships. What meaning, then, can we draw from these sets of complex relationships to generate greater impetus for our leadership process?

Let's start with our base pair of *movers:* the participating super gene, collaborative participation, the proposed correlate of adenine, we'll call *p*, and the strategy super gene, concerted strategy, the proposed correlate of thymine, we'll call *s*. **Participation is ultimately a reflection of strategy and strategy actually is the embodiment of participation. Participation is what strategy enables it to be and strategy is what the participants think it is. These two leading properties together, participation and strategy, constitute *action* that we'll call *a*, people acting together as they go about doing something.**

Three voluntary leadership graduates of Chapman have helped me develop a pilot software program for assessing leadership development according to the quantum civics paradigm: Pat Melia, recently retired Probe Engineering Team Chief of NASA's Galileo Mission to Jupiter; Alex Bradley, president of Netus, Inc., an internet service provider; and Celso Morrison, a Project Engineer with Boeing. Our product in progress, the voluntary action TOOL (for Technology of Organizational Leadership) is still in the pilot stage. It uses ODNA and the $I=am^2$ leadership equation to interpret snapshots of leadership situations in voluntary organizations. We have conceived the TOOL to calculate numerical values for the leading properties of *p* and *s* which would allow us, in turn, to calculate a value for *a*. Thus, we can write a simple equation, *a=ps*, in which action equals the product of participants implementing their strategy.

We know how important action is. Nothing is happening if there is no action. But what is the action doing? Is it the action of people working together? This depends on how well the participants are collaborating and how concertedly their strategy is being carried out. For example, when the New Jersey Shakespeare Festival was re-founded at Drew University in suburban northern New Jersey after an artistically successful but financially unsuccessful beginning in Cape May of rural southern New Jersey, artistic director Paul Barry and I set out to recruit a new board with the power to lead. The people we knew were friendly

advisors who knew who the right people were. So we began by asking them for introductions to the powerful people they knew. We were given some excellent names. I called each one, explained the reason for my call, and asked for an opportunity to visit. Paul and I went to see each one to explain our mission and ask for advice. In each case our objective was to obtain their agreement to help in some way because we knew that their participation would lead to the action we needed to get the ball rolling.

As each prospective volunteer leader became increasingly convinced that our mission to re-found the Festival at Drew looked like a real prospect, he or she offered suggestions about going forward and referred us to others. It took nearly a year to recruit a board of a dozen and a half of these outstanding leaders and most of a second year in which they helped us prepare for the first season. While it took us longer than we anticipated, the attention to organizing powerful board leadership paid off not only in a first season of exceptional artistic and financial success, but also in the groundwork it laid for a long term future. I am convinced that our priority commitment to securing powerful leadership from the start was the key. A strategy that emphasizes collaborative participation at the highest possible levels is its own reward. It converts the impetus of such leadership to the momentum needed for success overall.

From its first year onward, the New Jersey Shakespeare Festival included a dozen and a half of the most influential theater aficionados in the region and a theater guild of more than twice that number of community ambassadors. Together, they gave us an enormous boost. Even a sympathetic *New York Times* drama critic made opening night and, despite a temporary blackout that petrified us, gave the show a fine review.

THE SHAKERS

In order to secure the necessary momentum, we must go from our base pair of *movers* to our base pair of *shakers*. The visionary super gene is the *starting shaker* we'll call v, and is the proposed correlate of guanine. The

resource super gene is the *finishing shaker* we'll call *r*, and is the proposed correlate of cytosine. **Vision is ultimately a reflection of resources, and resources lead to the embodiment of vision. Vision creates a horizon for resources and resources set a limit on actualizing vision. The two together, vision and resources, constitute *momentum* which we'll call *m*, individual people transformed into a unified group moving with greater speed toward a goal, reaching a velocity they otherwise would not have attained.** Thus, in the voluntary action TOOL, after assigning appropriate numerical values to *v* and *r*, we can write a second equation *m=vr*, in which vision multiplied by resources produces momentum, which is then squared. In this equation, the shared vision of the collaborating group is empowered, influenced, and adjusted by its attraction to certain resources that pay for its implementation. The momentum is actualized by the wheels of resources put on the wagon of vision.

We now have two factors, action and momentum, that we may use to produce a theorem akin to Einstein's equation, that with the right conditions will yield the impetus of leadership. We can envisage $I=am^2$, our leadership equation in which action is multiplied by momentum squared, as the counterpart of $E=mc^2$. However, as a practical matter, we are not quite ready to use the proposed new equation because we do not yet have a complete explanation. Let's take a closer look.

The action begun by collaborators who implement strategy does not automatically build into momentum. Action must be transformed by the impetus of leadership. Leadership impetus is essential for converting the potential energy of action into the kinetic energy of momentum.

At the New Jersey Shakespeare Festival, artistic director Paul Barry had a vision of excellence in which classical theater at its best would be performed in modern interpretations to give old meanings new life, and would translate into entertainment for the audience of today. The board of volunteer leaders, all northern New Jersey residents, had a vision of regional repertory theater at its best in a contemporary mode that many would find entertaining.

The two visions, classical theater and modern interpretations, had to become one, and they did. The Festival went on to win an impressive

string of regional awards for artistic excellence as well as generous support from wider audiences and sponsoring donors. It quickly acquired momentum, and artistic director Barry went on to become the first in history to direct all of the plays in the canon of Shakespeare. Today, three decades later, the Festival is housed in a beautiful new facility recently opened and made possible by the leading generosity of the family of a founding board member along with many other supporters.

Let's turn now to the two ODNA base types, participation and vision which are akin to the purine compounds, and strategy and resources which are akin to the pyrimidine compounds. In both cases their complexity matches but their flexibility does not, as it does in their base pair relationships. Let's take a closer look and see what this might mean.

THE STARTERS

Let's begin with the *starters*, collaborative participation and visionary cause. They are the larger and more complex set of partners. The participating super gene is the mover while the visionary super gene is the shaker. **Participation and vision are interdependent. That is, participation creates vision and vision gives life to participation. Participation is the initiator of its action factor in our equation, and vision is the initiator of the momentum factor in our equation.** The classic case of how they work together that I remember best is the time during my service at Dickinson College when the chance to compete for a major Ford Foundation challenge grant became a possibility. We were in the midst of a comprehensive institutional review and preparing for a capital campaign. With the help of several colleagues, I was given the task of preparing a way to connect the college with the foundation.

The Ford Foundation, then the largest in the world, was involved in a nation-wide attempt to identify several dozen of the most promising colleges and universities to which they were awarding multi-million-dollar challenge grants which usually had to be double or triple matched to qualify for the challenge funds. It was a spectacular opportunity for insti-

tutions with serious ambitions. I began collecting successful planning presentations from a few friends at institutions that had received early grants. We got board, staff, and faculty leaders together to draft a presentation of our own. We found a more successful history than we had realized, an increasingly dynamic present as the process unfolded, and surprised ourselves with how expansively we had begun to think as we went. A sense of momentum began to arise as our vision of a quantum leap in the college's potential became increasingly attached to the prospect of a major Ford grant. But we needed to attract the foundation's attention because it would not entertain any proposals it did not invite. And the foundation staff did not know us.

THE FINISHERS

What were we to do? This issue took us directly to the necessity of relating a prospective strategy to the prospective resources. The super genes of strategy and resources are the *finishers* in our equation. Strategy is the finishing mover and resources are the finishing shaker. Strategy is the concluding end of the *action* factor and resources are the concluding end of the *momentum* factor in our leadership impetus formula. **Strategy reaches out to resources and resources give back to strategy. They are interdependent.**

The message for us at Dickinson in the Ford situation was that we had to develop a strategy for getting Ford to be interested. I learned that alumnus Jim Shepley, then publisher of *Fortune* magazine and later CEO of its parent *Time, Inc.*, knew Roy Larsen who was one of the founders of the *Time-Life* empire and a member of the Ford Foundation board. I asked Jim if he would speak to Mr. Larsen. He did, and Ford sent a representative out to see us. We had been working all along with key leaders on campus and on the board, and we were ready. We got the invitation, submitted our proposal, and were awarded a $2.2 million dollar grant (worth at least ten times more in today's equivalent) that had to be matched three for one to receive the cash award. We were thrilled, and the college

succeeded in making the match on deadline three years later.

This is a classic illustration of how necessary it is to build a bridge of strategy to reach the resources being sought. It is also an excellent illustration of how resources are necessary for implementing a strategy that in turn fulfills a vision. With the new infusion of high profile investment, Dickinson went on to transform itself from a fine regional college into an excellent college of national reputation.

GENERATING MOMENTUM

Before we leave the field of ODNA relationships, we must look at the prospects of two more relationships, between participation and resources as well as between vision and strategy. Neither one has the closeness of an ODNA base pair nor of an ODNA family type. However, each base coexists with the others in the same ODNA molecule of life. Each is submerged in the same life stream of creative information. Each one, therefore, interacts with each other one in some exchange of energy. In the ODNA there are two forms of energy exchange. One is informational and the other is directional. I believe there must be both in DNA itself in order for evolution and growth to take place.

Participation's proposed correlate is adenine, larger in size and more flexibly bonded, and resource's proposed correlate is cytosine, smaller in size and less flexibly bonded. Adenine is not bonded to cytosine nor is it a member of the same family type. Their interactions seem to have inherent limitations beyond information exchange. They appear to be like genetic associates who don't know each other well enough to do very much together. Yet the resource base seems to renew the ODNA leadership life cycle by stimulating participation.

Is that because the power of creative energy that began at one level with collaborative participation has transformational effect as it moves through the phases of visionary cause and concerted strategy? Has creative energy, then, reached the connecting resource base with more force than when it began at the collaborative participation base? Could this

force be enough to overcome the distance that otherwise would arise between collaborative participation and connecting resources? Do collaborating participants get caught up in the dynamics of an ongoing process of which they are a part and in so doing increase the potential of connecting resources? I think so. Experience strongly supports this thesis. It worked for the New Jersey Shakespeare Festival at Drew University. It worked for Dickinson College in the Ford Foundation challenge. It works in any organization where leadership impetus has been released and is making an impact.

Finally, our ODNA proposition contains one more relationship we haven't yet explained, between vision and strategy. I am proposing that they correlate with guanine and thymine, which are neither a bonded pair nor members of the same family type. Guanine, we'll remember, is the larger less flexible base and thymine is the smaller, more flexible base. By the time the creative energy flow reaches the guanine base and the visionary cause phase of the leadership process, it has benefited from a strong informational exchange between collaborative participants and concerted strategy plus a strong directional force from collaborative participation to visionary cause.

By itself, the guanine base of visionary cause is larger and more stable than the smaller and less stable thymine base. It is movable by the impact of creative energy that needs to transform action into momentum via an electromagnetic force needing expression in newly directed action. This force appears to form a current of energy moving swiftly along a wire, like water running downhill. I believe that the momentum building through the speed of its vision requires an outlet through which to channel its energy for a creative purpose on its way to connecting resources, and that this outlet is found in the concerted strategy implemented by collaborating participants.

Had the vision of Paul Barry not connected with the vision of the volunteer board leaders the strategy of the New Jersey Shakespeare Festival would have failed for lack of leading impetus and the Festival would not have been reborn. Had the vision of Dickinson College leaders not reached the visionary Ford Foundation leaders via Jim Shepley, Dickin-

son would not have had the opportunity to develop as it has.

The ODNA process all adds up to a dynamic sequence of energized action and reaction, initiative and response, that can and does produce quantum leaps of increasing or decreasing energy that lead to dramatic results in growth or decay. Quantum leaps are unpredictable one by one. But they can be made more probable over frequency distributions of different types of activities. For the happening of quantum leaps to be made more probable, the quantizing process of leadership must be understood and mastered. ODNA can take us a big step in the right direction.

In summary, we now have seen how the super genes of participation and strategy combine to form *action*, and how the super genes of vision and resources combine to form accelerating *momentum* which, when multiplied and squared, gives us the leadership impetus we have been seeking. This leadership impetus is moving now at the velocity of the vision which magnifies it and the resources which support it. But, before we make our concluding observations, we need to see how our two college presidents are doing, and then how our new leadership ethic works to give us the proper lift-off.

TWO PRESIDENTS
ADJUST FOR RENEWAL

The aftermath of a strenuous capital campaign for Camden left him and his companions as exhausted with the effort as they were exhilarated by their success. When they met to begin preparing the transition from campaign to post-campaign activity, they took stock. Participation had never been higher, but the participants were very tired. The vision had never been more clear, but was nearing its horizon. The strategy was definitely working, but was not attracting new adherents in sufficient numbers. Resources had never been greater, but tended to be coming in larger gifts from primarily the same base of supporters. Obviously, real adjustments had to be made before the college would be ready for its next cyclic surge forward. And no real preparation was yet underway for that next cycle of life for the institution.

Jacqueline and her associates were also feeling exhaustion along with the exhilaration. As they made preparations for the final phase of their campaign, they launched a separate action team to begin work on the post-campaign priorities of their institution. The team found that participation had grown and was showing signs of greater growth potential. The clarity of vision was outstanding, but needed more refinement as new possibilities seemed to be coming into view. Strategy definitely would need some changes even though it continued to work well, because the expected intensity of its growth was due to peak soon. Connecting resources would also need a lot of work since they were still very new and not well established, though they were coming from an expanding base of supporters. Jacqueline's action team was aiming to have new plans in place, with the help of college leaders, in time for a smooth transition to post-campaign activity.

Camden appeared to have better position, but his momentum was declining. Jacqueline's momentum was growing, but she did not have the position Camden had. Both realized that position and momentum were ebbing and flowing, pulsing with the heart beat of the moment, surging and relaxing according to the unfolding energies of the leader-

ship process. While the physical universe might have a preference for the possibility of greater complexity and consciousness, how would each institution tap into that preference, because there obviously was no foregone conclusion so long as there was a choice the participants got to make. So, what degree of energy could be summoned by each for the next cycle of their two different approaches to leadership?

TWO PRESIDENTS ADJUST FOR RENEWAL

Camden Gould	Jacqueline Hope
Participation higher; participants tired	Participation greater and growing
Vision clear, but nearing horizon	Vision clear and opening wider
Strategy working, but fewer new volunteers	Strategy working, but needing changes
Resources greater, but base about same	Resources support base expanding
Next planning cycle delayed	Planning underway to smooth transition
Momentum declining	Momentum growing

Organizational DNA is the template and $I = am^2$ is the leadership equation.

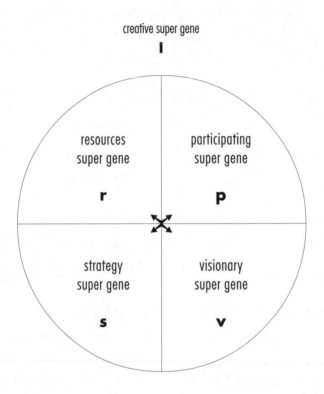

FIGURE 10: ODNA AND $I = am^2$

The impetus of leadership **I** is that which transforms the action of individual people **a** into the momentum of a unified group **m^2**.

p x s = a / action

v x r = m /momentum

m x m = m^2

I = impetus

I = am^2

"The lure of freedom and democracy cannot be extinguished—it is part of an irreversible parade of history. The people in the poor countries are leading the way in this revolution toward political and economic freedom. This push, this revolution, will fundamentally change the world."
—*Roberto T. Alemann*

9. A LIVING SYSTEM:

The New Leadership Ethic at Work

NATURAL SUPERCONDUCTOR

In every challenging situation leading by heart requires that we recall spontaneously what we value most, and act accordingly. Our proposed new leadership ethic can help us do that. It straightforwardly affirms what our hearts should reveal. The greatest good to which we may aspire is that which serves the largest number of people over the longest period of time at the lowest reasonable cost. These are the core values that govern the switching system of the micro-processing memory circuit we are developing in our hearts and minds, our leader chip. This fundamental way of looking at the world frames the quantum dynamics at work in a process that leads to empowerment of the many. In this way, the proposed new leadership ethic is the natural superconductor of the inextinguishable attraction that freedom has for all people. It goes with, rather than against, the grain of humanity. It flows with, rather than against, the

patterns of evolution. It runs with, rather than against, the currents of history. It responds to, rather than ignores, the demands of people seeking better lives. It is both good economics and good politics, leading *both* to prosperity *and* to peace.

As the human affairs counterpart of a natural superconductor, the new leadership ethic is self-energizing and self-sustaining. That is, it rests on the demonstrable premise that, as part of nature, we create our own futures. The future is something that is constructed. We actually build our own histories. Our choices are real. They do make a difference. We do not live in the iron grip of a predetermined future we cannot influence. But we must allow ourselves the freedom and responsibility to make the choices we have. This means we must leave room for others to grow toward their own potential, to take advantage of the possibilities that can be available. Intelligent human beings will gravitate toward what is perfectly natural for them in an environment that allows them the opportunity to do so. To do what is perfectly natural is human nature. And human nature is the birthright given to each of us by the infinite and finite sources of our being. This is what we mean when we refer to respect for humanity, human dignity, and humankind.

In fact, nature itself is the perfect organizer, and has been in the business of being so for all of history. Nature works according to built-in operating systems that drive its evolutionary growth. These operating systems are the genetic programs of living beings that are strung out along the strands of their own DNA blueprints. Natural phenomena prosper and die according to the circumstances in which they find themselves. All natural phenomena are self-organizing systems which evolve in healthy or unhealthy ways according to their own strengths and weaknesses and the externalities that influence them. All natural phenomena are also self-sustaining to the degree they are able to find sustenance in their own environments. So, the message for us is to nurture the most natural, that is to say the most organic, organizations we can in order to foster their greatest health as living systems with the least costly investment of time and money.

The new leadership ethic, then, is preeminently concerned with

fostering healthy societies, healthy economies, healthy organizations, and healthy people to work interdependently. To do so, it must be a living ethic which enhances the metabolism of each organic entity up and down the chain of life, as best it can. The quantum civics paradigm of leadership is *dedicated to creating kinetic energy out of potential energy for civic purposes, that is, those purposes that serve community life.* Let's look at the five leading properties of the quantum civics paradigm to see how we can put the new leadership ethic to work as a living ethic for greater community.

FOSTERING COMMUNITY METABOLISM

First, let's take a look at the medium of **creative information** through which the quantum system works. Creative information is the energy in the life stream of a quantum system. The information processing energy level *possessed* by any living system determines it potential strength. The energy level *used* by a living system reflects its actual strength. Metabolism is the chemical change by which energy is provided for vital processes. Quantum persons and quantum organizations literally feed off the creative information whose energy is metabolized for the vital processes that keep their systems going, hearty and healthy.

Thus, **the first task of the new leadership ethic is to focus on how best to develop and maintain a high rate of metabolism for the interactions among the people with whom it is concerned.** The greater the rate of metabolism the greater will be the potential for productivity. Since the new leadership ethic has a strategic view of humanity and community, it must be preoccupied at all times with the buildup of proper stores of creative energy among all its stakeholders.

Buildup of the proper stores of creative energy among stakeholders means at least that we must persistently work to minimize if not eliminate conflict situations wherever we can, that we assiduously negotiate our way past whatever conflict situations we meet wherever they cannot be avoided in the first place, and that we strive to build bridges between and among those who are strangers to each other and who could, by

working together, help build strategic community.

Conflict situations are not only a diversion of valuable energy, but also a waste of energy needed for more productive use in the struggle against abusive power which imperils a future of promise for all of us and for all of our children. The seven revolutions identified by the Center for Strategic & International Studies in their recent report that I mentioned in Chapter Two cannot be addressed effectively without urgent and continuing attention to a leadership revolution driven by a living ethic across the globe. **The leadership revolution needs to face** *both* **the more obvious active expressions of conflict** *and* **the less obvious passive potential of conflict that exists among strangers.**

Here in Orange County, California, now the fourth most populous county in America, we have what Joel Kotkin, then of the La Jolla Institute, called a "new kind of giant metropolis" where enormous creative energies have produced a "first-rate economic powerhouse, with a technological and business infrastructure matched by few cities in the United States—or anywhere else in the world." But he sees a "New Orange Curtain" that threatens the future as it divides the increasingly affluent, overwhelmingly Anglo communities clustered to the west and south such as in Newport Beach and Irvine, from the immigrant areas concentrated in such older communities as Anaheim and Santa Ana.

According to Kotkin, "The ultimate test for Orange County—the prototypical post-suburban metropolis—will be in how well it works for its increasingly diverse citizenry." For economically strategic regions such as Orange County, creative energy must be seen as a civic resource that must work well for the whole of the region if the whole is to prosper into the future. And this leads us to ask ourselves the first question we must answer in the leadership process. Why are we here? Can we say, and mean, that our answer is to build our future, not just mine or yours, but *ours* together?

Second, we must turn our focus toward the role of **collaborating participants,** the initiating super gene and starting mover of the quantum civics paradigm of leadership. Here we want to be steadily increasing the numbers of our active stakeholders, locally or globally or in any other par-

ticular universe, who are working on the actions we are taking. We want a growing number of our stakeholders to be economically and politically self-sufficient to improve the potential of their *collaboration* and reduce the potential of *resistance*. And we want this to happen as quickly as possible. The sooner our active stakeholders come to realize benefits from their participation, the sooner they will begin to share greater responsibility for sustaining collaborative actions and the better off we all will be.

As the process of collaborative participation spreads throughout a population of stakeholders, volunteer champions emerge to facilitate increasingly active participation. This fosters growth in the numbers of these stakeholders as these leading volunteers champion the cause. In addition, the most effective of the volunteer champions will groom others to be volunteer champions themselves. In this way, the ranks of collaborators will multiply.

Delhi Center, a Latino community-based organization in the poverty stricken southeast of Santa Ana, America's most youthful city, uses a strategy of bootstrap volunteerism where clients are encouraged increasingly to be their own teachers until they are able to share their knowledge with others as volunteers. Instructors are facilitators who educate clients about issues of concern and train them not only to become self-sufficient but also to teach others about these same issues.

As the numbers of collaborating participants grow, they need to be fed a constant diet of information about what is happening, brought into the councils of decision-making wherever and however possible, and generally treated as brothers and sisters of a dynamic quantum community. And as they come to feel this way, they will respond by acting out their feelings of ownership and by taking more responsibility for the good of the whole that they increasingly see. This is crucial for building momentum until the emerging cause becomes so strong that it is truly an idea whose time has come because it has a critical mass of influential opinion behind it.

In Orange County, the tremendous creative energy generated so far has overwhelmingly been used to develop highly entrepreneurial business success, but relatively little civic success to build healthy

communities. The substantial business leadership in the region has tended to focus in industrial clusters, such as medical devices where the region leads the world in production, but not nearly as well across the various industrial clusters. Furthermore, business leaders and leaders of government have not yet built multiple collaborative ties among public, private, and civic sector enterprises in communities across the region. Orange County leadership has been more often singular and less often collaborative. And this leads us to ask ourselves the second question we must answer in the leadership process. Who are we? Are we, all of us, able and willing to participate? Or, are we just our own interests, or just the special interests of particular groups?

Third, we must give attention to the visionary super gene, the starting shaker and incubating property of the quantum civics paradigm of leadership. In shaping the mission which brought together the collaborating participants into a visionary cause which would galvanize them to action, we are seeking the greatest good for the largest number of stakeholders. We are truly seeking to ensure that stakeholders receive the greatest possible value from the actions we take. We want them to share the visionary cause we espouse and make it their own. Actually, we want them to do even more. We want them to help us articulate the cause into an increasingly powerful message, because we know that will enhance their buy-in and enable them to be greater proponents of the cause.

As the greatest good becomes the visionary cause for which everyone is working, collaborating stakeholders and their volunteer champions will be empowered to take responsible and creative action of their own. Both their self-interest and their instincts to help others are stimulated. The visionary cause becomes their heartbeat, a strong pulse pumping lifeblood into an increasingly formative operating system. Potentially distracting forces play a decreasing role in the minds of the collaborating stakeholders.

The leaders among them, volunteers all, increasingly turn attention to how best to implement the great cause they are espousing with louder and more certain voices. They want to determine what are the best ways to use the energy they have to implement their emerging plans in

the ways most likely to ensure they happen. The collaborators represent in themselves just so much developing potential. They can give just so much developing energy and achieve only so much by themselves. So, naturally they are looking for the most productive ways to get things done. What will give them the biggest bang for the buck, the most for their money, the best buy. And they are continually looking for others to join them, knowing that new blood means new life, and new life means new strength.

The lingering image of Orange County as a "famously conservative" and "sometimes racist" region is fading and must be put to rest as the relic of a different past. This perception of Orange County as a "politically regressive region," in Kotkin's words, "serves as a stumbling block on its path to positioning itself as a globally sophisticated metropolis." The challenge for Orange County is to create a "civic culture in post-suburbia" in which "working together" must become the new standard. The region needs a new image of itself as an exciting place where a new economy and new politics are producing a new community of the future around a vision for which everyone can rally. The 1996 election to Congress of Democrat Loretta Sanchez, a Chapman graduate, and her re-elections since, reflect something of the change going on.

This leads us to ask ourselves the third question we must answer in the leadership process. What future do we see? A "Greater Orange" metropolitan region that is both a prosperous and a cohesive economic community? Finally now, an acrimonious decade-long struggle over whether an international airport should be built on the abandoned Marine Air Base at El Toro has been settled in a strong vote against the airport that favored a "Great Park" instead. Major differences are yet to be reconciled. Whether there will be a future of promise for the region ultimately will turn on whether an inclusive vision is developed out of the competing visions that are not.

Fourth, we must focus on **concerted strategy,** the super gene of implementation and the finishing mover of our quantum civics paradigm of leadership. We are already at work to deliver the greatest good for the largest number. Now we are concerned with doing so over the longest

period. Here we come to our concern for sustainability. This requires us to construct a mutually reinforcing and self-sustaining plan that produces more and more per unit of effort as it goes further and further in the direction of that effort. Eventually, we will have achieved a certain economy of scale, in which we are getting the most we can for the time and energy we invest. We know that, by then, we will need to have alternative plans coming on line to build on the momentum in place but which, by itself, cannot be sustained. The law of diminishing returns tells us that nothing can avoid running down, or can go on indefinitely, without change to develop new energy in place of declining energy.

Concerted strategies must, therefore, allow not only for the increased intermeshing of activities to implement a vision, but also must allow increasing replacement of aging parts with new ones. The creative processes of nature demand this of all phenomena whether or not they are organized by human beings. We cannot avoid the necessity of change, and therefore need to plan for orderly transitions to healthy futures.

The old saying "If it ain't broke, don't fix it" needs to be revised, because we will have to fix it after it breaks if we don't fix it before it breaks. So, a new philosophy needs to take its place. "If it ain't broke yet, prepare for when it gets broken." Now, more than ever in our global information age of increasing change and complexity, good maintenance requires constant attention to the law of diminishing returns. This is nature's way of providing new life for a healthy, hearty world. By following this logic of concerted strategy, then, we will most likely ensure the greatest good for the largest number over the longest period. And this leads us to ask the fourth question we must answer in the leadership process. How are we going to do it?

In Orange County, the strategy I have heard most often mentioned for launching region-wide collaboration is to bolster the education of a leading-edge citizen work force, that is, a pool of highly skilled, community-conscious professionals and technicians. Early discussions have been under way to help make this happen. The most difficult challenge in doing so will be just to bring together the business, government, and educational leaders from each of the diverse communities involved

so that it is possible to foster an inclusive dialogue from which answers will emerge.

Fifth, we must turn our attention to **connecting resources**, the super gene of renewal and improvement, the finishing shaker in our quantum civics paradigm of leadership. Here we are face to face with the issue of attracting investment beyond that of the initial collaborators. Whoever these investors may be, they will need to see a return on investment that makes it worthwhile in terms that make sense to them. The reward in non-monetary terms will be their perception of improved capability.

To secure investors we will need to bring them into our corps of collaborators in spirit and perhaps in body as well at the earliest possible point. The more we might expect from them, the more necessary will be their involvement in the process. The involvement of prospective investors needs depth, engagement that enables them to become deeply involved in what's going on. They should have a hand in shaping the vision and the strategy. They should have at least a working relationship with the key collaborators, the leading champions of the cause. They should have a working knowledge of how things are going.

In order to connect resources most effectively, the collaborators will need to adopt a policy of setting aside a portion of their resources for purposes of building more resources, that is, as an investment in their own future. These savings can be used as seed money for growing greater capacity than would otherwise be possible. Hard choices will have to be made. Some immediate desires will have to be foregone in order to focus only on the greatest potentials. In this way, we may more nearly realize our living ethic of providing the greatest good for the largest number over the longest period, and at the lowest cost.

In California there are now eighteen collaborative regional initiatives at work on workforce, education, and other pressing issues where business, government, and nonprofit leaders have convened to do together what they cannot do separately. Orange County recently has become one of them. But it is still a long way from connecting the extraordinary resources it has fully behind the civic initiatives it requires. This is a characteristic it shares with many other regions across the country. This will

change in Orange County, as it will in other regions, as aspiring leaders more clearly see that there is no good alternative to civic collaboration in these complex times. And this leads us to ask ourselves the fifth question we must answer in the leadership process. Where are the rewards? Are they going to the wealthy but not the rest of the community?

The resources of neither the private sector in business nor the public sector in government are by themselves sufficient for addressing the magnitude and the complexity of the issues we face. They need to be voluntarily pooled for community leverage. Civic collaboration is essential for connecting the resources from every potential source, including the voluntary organizations whose service to community has distinguished America. These voluntary organizations, led by their powerful volunteer champions, hold the power of what we have come to call voluntary leadership and now need to think of as civic entrepreneurship, grassroots empowerment, prime-time community leadership.

By pursuing a new leadership ethic, such as I am proposing here as a value system that frames whatever we are doing, we can nurture the inextinguishable attraction of freedom and democracy that pervades the deepest desires of people across the world. By doing so, we can make possible the better world of promise that is within our reach, as the Center for Strategic & International Studies report shows. It is a remarkable thought to know that such a world is possible, and that we can measurably contribute to its making.

A LEADERSHIP REVOLUTION

All this leads me to conclude that the same quantum energy sources and forces that powered the high technology revolution can power a high performance leadership revolution capable of guiding the future toward humanitarian ends. These ends are the only socially and politically practical ends that will ensure a secure and peaceful future for the world. The outlines of the quantum framework required are now emerging. This framework is discernible as a profile of organizational being that contains

many hidden connections we can only begin to see, and which will need in-depth study to be understood.

When C. P. Snow in 1959 published his little book, *The Two Cultures*, he saw across the boundaries of business, government, and what Americans call nonprofit organizations to a fundamental split between those who think predominantly with their left brains, identified with science, and those with their right brains, identified with the arts, regardless of exactly what their occupations may be. The message this carries for us today is that we must undertake a journey across the boundary of science and into the world of the arts in order to discover the connections between the invisible quantum world that supplies the inner workings of all that is with the material world of everyday affairs that we can reach out and touch. We must learn how to be frequent and regular boundary crossers, as Neal Peirce and Curtis Johnson suggest in the title line of their book, if we are to attain the powers of mind and matter that are now possible and which have such promising potential for us all. As boundary crossers, we must acquire the capability to cross the bridge going between these different but related worlds as part of a new nature of being that follows where our natural quantum world beckons us to go.

The ongoing confrontation of the scientific and artistic cultures ignores the very first quantum connection to which the physical universe invites our attention. This is that the most elemental stuff of existence is an invisible energy pattern in the form of a particle-wave duality which is called the quantum. It functions in complementary style with each being the inseparable mate of the other, both essential to make the world go round. The duality leads us to the ultimate realization that every coin has a flip side. Polarization is an apparent contradiction, not a real one, but two extensions of the same dimension.

The individuals and organizations which master the quantum leads, emerging as the twenty-first century is dawning, are those who will lead the world. That is, in the global information revolution already under way, they will be better informed to take the quantum leap into the future and, thus, will be the guides who create the future. They will honor and celebrate a civic code that places a premium on the creative informa-

tion of compassion, collaborative participation by volunteers, the sharing of a visionary cause, concerted strategy led by trustee stewardship, and connecting resources from philanthropic investment.

As the civic code emerges, it will define a new first sector in the global community, the *civic sector*. **The civic sector will comprise all organizations and associations that are not businesses or government agencies. It will be centered in voluntary organizations, now usually defined in various ways as not-for-profits.** It will embrace public-private partnerships and a variety of collaborations that cross the boundaries of business and government. It will be led by civic groups embracing the concept of the beyond-profit organization, a concept that can be adapted by business and government for their own purposes in order to survive in the twenty-first century.

TWO PRESIDENTS GO
DOWN TO THE WIRE

As Camden and Jacqueline came to terms with the futures of their institutions, and their own professional journeys, they had to face the impact of what they had led or let happen. This boiled down to how did they rate on the new leadership ethic scale? This would give us an idea of how well they were tapping the motivation and productivity potential that Drucker referred to in his far-seeing Harvard Business Review commentary of 1989.

The greatest good? Camden could lay a great claim to enhancement of the classical academic model. He and his institution had led the way in the last few years and deserved a lot of credit. The academic community recognized the contribution and saluted it. Jacqueline could lay a real claim to enhancement of the innovative academic model and also deserved a lot of credit. The wider business, educational, and professional communities of lay, non-academic people saw the potential and spread the word.

The largest number? Camden really wanted to reach everybody, but here is where he began running into brick walls. Prospective college students were generally not prepared and not motivated by their previous schooling to gravitate toward the traditional liberal arts experience. The selling job had to focus on peripherals that led to career enhancement. In other words, Camden was facing the fact that he was not selling his stated academic curriculum as his product, but instead was selling his unstated de facto curriculum, career advancement.

On the other hand, Jacqueline was running into fewer brick walls. She, too, wanted to reach everybody, but was appealing to prospective students in terms that were already on their minds. What is the best preparation to make it in life? I've got to earn a livelihood to make a life, so how do I do one in order to do the other? At least Jacqueline was asking the right questions, though she was still running into a mixed response. On the one hand, the academic community had what it had. On the other hand, the rest of the community needed what it needed. Jacqueline

and her institution were trying to respond to both, but it was not at all clear where the answer lay. At least her institution was deliberately working on how to reach the many.

Longest period? This would generally be a product of efficiency and productivity. Any downward trends in either would have to be countered by innovation in order to keep momentum going. Otherwise, final horizons would darken results. Camden's team was going all out and producing results, but the law of diminishing returns was closing in, and the numbers were still good but declining.

Lowest cost? Jacqueline's team was going strong. The numbers seemed to be fluctuating up and down, but on an upward slope. The cost-benefit ratio was ebbing for Camden but flowing for Jacqueline. Camden's effort was increasing in relation to results while Jacqueline's was decreasing. Jacqueline's innovation seemed to be making a positive difference for the future.

TWO PRESIDENTS GO DOWN TO THE WIRE

Camden Gould

Enhanced classic model

Saluted by academia

Sold enrollment peripherals

Faced law of diminishing returns

Ebbing cost–benefit ratio

Jacqueline Hope

Enhanced innovative model

Saluted by community

Sold enrollment programs

Faced growth of numbers

Flowing cost–benefit ratio

"To see or to perish is the very condition laid upon everything that makes up the universe, by reason of the mysterious gift of existence."
—*Teilhard de Chardin*, The Phenomenon of Man

10. CAN WE SEE IT?

The Civic Movement Arising

I'd like now to revisit the thoughts of Peter Drucker with which I introduced the "leading force" in Chapter Two. Remember that he said: "Our nonprofit organizations are becoming America's management leaders." I believe he was observing both the *leaders* of management and the *leadership* of managers. Either way takes us, in my mind, to the *leadership impetus* I believe we are solving for. Then he said: "In two areas, strategy and effectiveness of the board, they are practicing what most American businesses only preach." This leads directly, I think, to our *action* factor that is comprised of participation and strategy, which are led by board policy and potency. He went on to say: "And in the most crucial area—motivation and productivity of knowledge workers—they are truly pioneers, working out the policies and practices that corporations will have to learn tomorrow." This brings us directly to our *momentum* factor in which, because of its greater force, we square the product of vision and resources, corresponding to the most crucial area of motivation and productivity.

Drucker's forward-looking observation and the equation of leadership we see inscribed on our quantum leader chip demonstrate an amazing coincidence. With this fortuitous match up, I believe we are now able to link our quantum leader chip with Drucker's vision to offer the aspiring leaders of nonprofit organizations everywhere a promising

new paradigm of leadership based on the world as it really is. **The world as it really is, as I see it, is a global civic society that runs from the ground up, in an up-down grassroots movement that touches our universe in small brush strokes created one at a time by civic artisans everywhere.**

HABITS OF THE HEART

Of course, the organizational DNA must be used in order to have impact. It must be preferred to alternative choices if it is going to be used. It must become a routine choice if it is going to be used frequently. It must become habit if it is going to be used spontaneously. In short, it must become a reflex action. We don't have to think about it. It's just the way we do things here. And the way things will be done on this planet as the word gets around, in time.

Since our concern here is turning the actions of individual people into the momentum of a unified group, what about the spontaneous action of people in groups? Here we are considering a series of organized activities where people are working in concert for a cause. Here we are concerned with a movement in the making. In essence, a movement is a group of people that is experiencing growing numbers who are working more or less together in a succession of various activities intended to further a cause about which they feel strongly enough to take the time, make the effort, and invest their resources.

A movement not only has action it also has momentum. It has mass and it has velocity. It has energy moving in a direction, literally with massive acceleration. This is powerful. In the case of a group that is picking up participants and supporters, this can be very powerful. When it materializes, it constitutes that wonderful notion of an idea whose time has come. It is generating the commitment of enough people who believe in it to make it happen, whatever it takes. This is profoundly simple and profoundly true. It is the heart of the matter. Once we get it we are set to take off. But how do we do it?

How do we generate a *movement* out of the separate actions of

people who have "signed up" for a cause? We get them voluntarily to think in the same way, synchronously. This is our challenge. This is their choice of response. How do we pull *that* off? Before anything else, we work with them as partners. Real partners. Not just nominal partners. No lip service please. Partners who are collaborators. Mates. Sisters. Brothers. Family. Friends. **We want a group of people from across cultures who are thinking alike spontaneously as a matter of voluntary practice, who are living out a new leadership ethic as they pursue their common interests.**

These leading participants would share the same habits of thought relating to leadership as civic empowerment, and these habits of thought would have become part of their own culture. They would not need to be *instructed* at every move because they would know *intuitively* how to move. These habits of thought would be built into their way of life with the inflections their own cultures provide. Like the "habits of the heart" long ago observed by Alexis de Tocqueville and so vividly described more recently by Robert Bellah and his associates.

As a group shares such intuitive thinking and feeling, it begins to take on the characteristics of a movement. This is potentially a very big thing. At first, a micro-movement, one that has some impetus, some momentum born of action. As the momentum builds, it begins to take on a life of its own. And it can grow to any size, depending on the impetus and the circumstances. How can we get at *it*?

I believe the answer lies in leading by heart. We find it in looking at the ODNA as the foundation in a set of super genes, in looking at the new leadership ethic as the framework in a set of civic values, and by looking through a leadership looking glass right into the leadership equtaion of our futures. In order to do this, we must look at both the organizational DNA and the new leadership ethic as partners, really collaborators, even more so, as mates or siblings or by solemn pledge of fraternity. Fortunately, we have developed a way by which we can try to do this. I think of this as looking for the leader chip, and I think of the leader chip as containing a civic reflex movement. What do I mean by this?

The leader chip is a quantum energy system that transforms action

into momentum. Inscribed indelibly in the memory of this quantum energy chip is a code. This code holds the combination that unlocks the door to leadership. Deciphering the code requires a trained mind that works quickly and clearly under daily pressure to see what must be done and then acts accordingly. The leader chip functions in the memory of our hearts and minds as a living micro-processor containing stored instructions. The core of these instructions is the five leading properties of the quantum civics paradigm. These properties are organized to function through their super genes as the ODNA of the leadership process. The process, in turn, is framed by the new leadership ethic at work. Finally, the dynamics of the process grow in force according to our leadership equation.

In our equation, leadership impetus transforms the action of individual people into the momentum of a unified group, and is written as $I=am^2$. The leadership impetus, I, is creative energy at work. The action of people, a, consists of collaborating participants implementing a concerted strategy. The momentum of a group, m^2, consists of the visionary cause interacting with its connecting resources. The momentum, which is squared in the equation, is far more powerful than the action alone because it has velocity. In order to make a difference, action must have increasing movement or speed in a direction which is its velocity. And this is where momentum comes in, moving at the speed of its vision in relation to its resources.

The most significant implication of this leadership equation, $I=am^2$, is that it maps a way to turn dedicated ethical practice into joyous achievement and unforgettable memories. A new leadership ethic, such as is proposed here, can and does catapult organized efforts with an impossible task to breakthrough performance when faithfully followed. But not without risk. And not without strenuous effort.

William James said that "the greatest discovery of my generation is that a human being can alter his life by altering his attitude." We now have a proposition that can lead our visions at the speed of light, the speed of vision, the speed of attitude. Do we have a disposition to prepare ourselves and our organizations for the journey?

THE LEADER CHIP

The instructions of ODNA memory stored on our molecular leader chip constitute an integrated circuit that is leading from the heart to guide the organization of our activity. The key is how the ODNA memory is stored on the leader chip. An integrated leadership circuit can be designed and wired into the heart, mind, and nervous system to replace whatever may now be stimulating the current process. Danah Zohar has described how we may continually grow new neural connections that enable us to rewire our systems for increasing mental capacities and thinking effectiveness. It is these neural connections that make a difference in leading by heart.

Our life-giving molecular leader chip, designed and wired for high-energy leadership, helps to synchronize neural oscillations that lead to unified thought processes for storage in the memory system. There they are both liberated and constrained by the natural processes of the system. However, as Zohar remarks, there is no central control in the form of a "CEO neuron" that manages the process. Rather, the mental architecture provides a structure within which the process organizes itself. The heart and mind function, I believe, like a quantum system that is dynamic, creative, and self-energizing.

The leader chip works like a designer molecule which gives life to a group by helping evolve its heart and mind, body and spirit, and everything necessary for a healthy group of people working together. Just as the DNA of a human being guides the growth and maturation of a individual person, so does the inscribed ODNA of a group guide the development of a living organization. By supplying a new architecture, the leader chip makes possible the evolution of an integrated circuit that harmonizes and amplifies different currents of creative energy, and that, in turn, enables the collaborative instincts of living beings to rise up and be realized.

In a recent article, science writer K. C. Cole of the *Los Angeles Times,* reported how the latest Nobel Prizes in physics and chemistry were given for "work bringing to light the obscure inner world of atoms and making possible quantum leaps in the design of materials and drugs."

She explained how "chemistry laureates used knowledge about the smallest most fundamental particles and forces to understand molecules behind every material substance from bricks to brains." In a similar way, leadership is about the chemistry of people in relationship with each another. Chemistry is constrained by the physical nature of the universe and all the living beings that are part of it. Leading properties are deeply rooted in human origins tied to the world as it is.

In fact, as I write these words, I have in front of me another *Los Angeles Times* article (February 25, 2002) headlined "Lockyer's Elements in Ca. Political Chemistry" in which staff writer Patt Morrison is quoted as saying that "Atty. Gen. Bill Lockyer's latest literary enthusiasm is a book titled 'E=MC2: A Biography of the World's Most Famous Equation,' a bit of reading he put to good use at the recent state Democratic convention in Los Angeles." Among the Attorney General's astute observations was reported to be this one: "*Fundraisium:* some people believe that if you mix *Fundraisium* with *Grayvium* (in honor of Governor Gray Davis), it will inevitably produce *Governium*. One thing's for sure: so far it's impervious to *Reformium*." Having enjoyed the book myself, I appreciate the feel for political chemistry if not for physical science. In fact, I exult in a fancy that the equation may actually be catching!

Like the high value blue chips of poker or high-priced stock with a good record of earnings, **the leader chip is our blue-chip micro-processor for transforming the actions of individual people into the momentum of a unified group.** It holds the values of leadership excellence in a dynamic force field of energy that enables people on a mission to make a real difference.

A NEW ERA

About once a decade over the past fifty years my alma mater, Colgate University, has run a successful capital campaign for funds, each one bigger than the last. Each one has capitalized on the results of its predecessor, reflecting not only a growing stock market but also a dynamic institu-

tion. The one I ran was the one in the middle, back in the 70s, and there is a message in it about leadership impetus that I would like to conclude with.

Colgate has enjoyed a long history of academic innovation, and was in the midst of a particularly innovative period in the early seventies when it became apparent that it was time to mount the next major campaign. It also enjoyed a well-earned reputation for sending graduates into highly productive careers and upwardly mobile professors to positions of academic leadership in other institutions. But, the university in rural upstate New York was actually a small liberal arts college that was just converting to coeducation, putting new emphasis on minority recruitment, and doubling its size to an enrollment of some 2,500 students at the time. It had a history of playing David to various football Goliaths from much bigger universities as well as a robust intercollegiate program in other sports.

We decided that this combination of academics and athletics was actually doing better than many of us had previously thought. We had an institutional inferiority complex that we needed to get over. And the recent changes did not come without some pretty significant struggles that left their marks on the institutional psyche. We wanted to think we were as good or better than our academic competitors , but something kept us from believing that.

We had a small but strong campaign leadership team. We recruited and trained a substantial organization. We communicated with our constituency like we had never done before, in every way we could manage, in person, in meetings and social functions, in print and on video. We had an excellent story to tell and a formidable case to be made.

We thought we could position the campaign in a way that would raise more money by simultaneously boosting institutional self-esteem to where we thought it belonged anyway. It was time, we ventured, publicly to stake our claim to being "first rank," whatever that might mean to different people, and to campaign on the notion that we had a duty to keep it that way. This struck a chord. And, we decided, everything would depend on creating the good feelings of effective connections.

So, we decided to challenge everyone with a simple theme, "to keep Colgate first rank," unremarkable but direct. Then, we needed a title for the campaign. Shakespeare's admonition notwithstanding, when Juliet asked her famous question "What's in a name? that which we call a rose by any other name would smell as sweet," we invested real time in searching for just the right one, we hoped.

With apologies to Shakespeare, we ended up asking ourselves, "What about ERA?" It could be an acronym for the "Essential Resources for Achievement" that preoccupied us, and would allow us to be the Colgate ERA Campaign. Again, quite unremarkable, but again, it symbolized the point we wanted to make. The powers that be agreed. Little things *can* and often *do* mean a lot. The theme and title did.

But wait a minute. We had second thoughts. The new movement for women's liberation was touting a proposed equal rights amendment and new ERA bracelets were making their way into circulation all over the country. Right about the same time a new laundry detergent hit the market called, no kidding, ERA. Were sex issues and suds promotion going to sink us?

Silly as it may seem, one of the smartest decisions we made was to say thank you, we are who we are and in our universe we believe it is our time to step forward. Trivial as this appeared, it locked us into a constant stream of promotion with our primary donors—mostly alumni, but also plenty of families, foundations, companies, and individual friends—that confidently staked our claim, no matter what else was going on. I believe it also had an effect on campus, among professors and students, administration and staff. The message was, this campaign is for all of us. The voltage turned up. Whatever their views, most everyone was paying attention. The opportunity to state our case for support was never better. We were able to attract distinguished but previously absent alumni leaders.

Long story short, after a rise of the Dow Jones to 1,000 plus in our first year, there followed a fall to 500 plus in our second year. Remember, this was the mid-70s. Since most major campaign gifts are large gifts of appreciated securities from a relatively small number of donors, this was a

damaging blow to campaign prospects. After crisscrossing the country with appeals to one and all, and with an impossible situation facing us, we put all our efforts into a desperation matching gift challenge that invited our most generous alumni and friends to come forward once again, and they did.

Finally, with five weeks to go in April, 1977, we announced at our annual Presidents' Club banquet that we had gone over the top, with $30.3 million committed against the $30-million-dollar goal (the equivalent at the time of this writing might be something over $200 million). The impact on campaign leaders was triumphant. We had done it! The campaign was a confirmation that we were first rank. We could see the wagging forefingers flashing the victory sign. There was far more to it than I have described, of course, but our defining moments were truly those that captured the spirit and compelled our momentum.

I believe the reason the Colgate ERA campaign succeeded was that it was an idea whose time had come. That idea had to be *seen* by the participants. It had to be perceived as valid, not contrived. It had to connect with deeply held values and memorable experiences. By the time the campaign was over, we had already cranked up a successor "non-campaign" fund to carry us over with follow-ups to ERA. Preparations for the unknown next campaign blended into just keeping up with a period of transition. And the groundwork was laid for the future.

Leadership impetus is the invisible creative spirit, the energy that pumps life into the body, leading properties into the hearts and minds of those we seek to persuade. There is no substitute for this mysterious breakthrough energy. We had no particular equation, such as the one proposed here, that we consciously followed at Colgate. But I believe that if we had, we would have well reflected what we now know and done even better. Today, Colgate is annually rated as one of the top liberal arts colleges in the nation. More importantly, it continues to attract and graduate some of the most outstanding young people coming up through the generations of our nation's leadership.

CONCLUSION

Leading by heart is the primary challenge of our time. It is the most powerful force we have. It is something that everyone can do. It makes manifest the leading properties of the universe. It translates them into community values. It does so through the exciting new world of quantum civics. In this new world, we are able to transform scientific principle into organizational discipline. We can learn to do so through the new tools of ODNA, the new leadership ethic, and the I=am^2 leadership equation.

The scored performances of Camden Gould and Jacqueline Hope, our two Florida independent college presidents and nonprofit leadership professionals, are very interesting to consider. First, we notice that Camden outperformed Jacqueline eight to six on collaborative participation. However, Jacqueline outperformed Cameron on visionary cause eight to seven. Yet, Camden scored eight to Jacqueline's seven on concerted strategy. Finally, Jacqueline outperformed Camden eight to six on connecting resources. The total of both performance scores was twenty-nine. Was there no performance champion?

Let's see what happens when we apply our $I=am^2$ equation. Remember that the *a* for action is reached by multiplying the *p* score for collaborative participation and the *s* score for concerted strategy. Camden's action total exceeded Jacqueline's, sixty-four (eight times eight) to forty-two (six times seven). Now, remember that the *m* for momentum is reached by multiplying the *v* score for visionary cause and the *r* score for connecting resources. Camden's and Jacqueline's scores for momentum now reversed with forty-two (seven times six) for Camden and sixty-four (eight times eight) for Jacqueline.

The difference in leadership impetus generated by the two can be seen when we *square* the momentum factor as the equation requires. Camden's momentum computed to 1,764 (42 x 42). Jacqueline's momentum computed to 4,096 (64 x 64). When we multiply these momentum factors by their respective action factors we obtain a score for Camden of 112,896 (momentum of 1,764 multiplied by action of 64) and a score for Jacqueline of 172,032 (momentum of 4,096 times action of 42). The leadership impetus of Camden and Jacqueline were remarkably different because the value of momentum far exceeded the value of action.

Camden's action outpaced Jacqueline's action by 64 to 42, more than half again greater. However, Jacqueline's momentum factor was superior to Camden's, also by a score of 64 to 42. When this momentum factor was squared and then multiplied by her lower action factor, it

produced a leadership impetus that exceeded Camden's by greater than half, 172,032 to 112,896. Her higher momentum factor more than compensated for her lower action factor to produce greater leadership impetus. The impetus of Jacqueline's leadership transformed the action of individual people at her college into the momentum of a more highly unified college community more effectively on the move.

TWO PRESIDENTS IN SUM

Camden Gould

Eight for collaborative
 participation

Seven for visionary cause

Eight for concerted strategy

Six for connecting resources

Twenty-nine base score

112,896 final result

Action counted less

Jacqueline Hope

Six for collaborative
 participation

Eight for visionary cause

Seven for concerted strategy

Eight for connecting resources

Twenty-nine base score

172,032 final result

Momentum counted more

Outlook for the Future

The key to the fate of the two presidencies came down to the trend of momentum. The reputation of Camden's institution was great but not growing enough while the reputation of Jacqueline's institution was growing though not great enough. All along the way we have been tracking them, Camden's institution has been the apparent leader but Jacqueline's institution has been the up-and-comer. Which would have the more promising future prospects?

Jacqueline would. Here is a closer look. Remember how, at the close of the two campaigns, Jacqueline's institution seemed to have more left? The law of diminishing returns seemed to be making its way into Camden's institution. It was doing very well, but it was taking more and more energy and resources to get it done. Not so at Jacqueline's institution where they seemed to be on a roll. The wind seemed to be in their sails.

The reputation of Camden's institution rested on the academic community. The reputation of Jacqueline's institution rested on the wider community. Only the elite academic institutions seemed to be overcoming the external quality-cost pressures that affected just about all the others. Camden's institution was very good, but not in the elite class. He was fighting an uphill battle. Non-elite institutions, very much including Jacqueline's, had to pay very close attention to these external pressures and try to figure out strategies for successfully dealing with them.

Looking at the comparative scores of Camden and Jacqueline

through the phases of our quantum civics leadership paradigm produced an interesting result. The equation of leadership impetus, remember, is I=am². Jacqueline made up in momentum what she lacked in action, while Camden lost his advantage in action to his problems with momentum. Jacqueline started slow but finished strong. Camden started fast but finished exhausted. Jacqueline appeared to be looking forward to a more promising future for her institution.

It's all about momentum. We shift into forward gear. We get fuel injection. We pick up the pace. We accelerate and get more fuel injection. The pace quickens still more. We're on a roll. We have lift-off. We are in flight and rapidly gaining altitude. We are soaring above the clouds. We are on our way. Pilots are rigorously trained to follow standard operating procedures to guide their aircraft according to flight plans. Once settled in the cockpit, they activate the operating system designed to get them where they want to go. The system depends upon fuel for its power. The aircraft fuel capacity, along with other factors such as load, altitude, and flight speed, determine how far it can go before refueling is necessary. Always there must be fuel. It supplies the energy needed to make flight possible.

This energy comes to us courtesy of $E=mc^2$ according to which a mass of liquid petroleum is converted to the energy of gaseous vapor when ignited and burned as powerful fuel with thrust enough to make aircraft fly. The horrific events of September 11, 2001 were brought to the world via similar explosions of this potential energy, then still largely unused, as terrorist-hijacked aircraft flew into the World Trade Center, the Pentagon, and the Pennsylvania countryside. A small amount of mass can explode into a very large amount of energy when touched by a spark, and wreak terrible devastation as a result. Three thousand lives were lost on global television before the eyes of a nation and the world. It was a collective defining moment such as had never before been witnessed in history.

In the aftermath of this terrorist attack, there was an unprecedented explosion of outrage and compassion in the nation and around the world. It generated a collective civic energy such as has never before been

seen. Citizens were stunned, horrified, and driven to react. Their energy came to us courtesy of $I=am^2$, according to which a mass of individual people is converted to the energy of a unified group. This is the application of Einstein's equation that, by now, I hope does not surprise us. We, as humans, are part of the same system of creative energy as the rest of the physical universe. The big difference between it and us, of course, is that we can imagine it and reflect on it. We have the capacity in our hearts and minds to conceive that this is so. So far as we know, we are at the top of nature's food chain. Better, we appear to be at the crest of Teilhard's network of complexity and consciousness. We seem to be the epitome of intelligence among all the creatures in God's creation, and therefore, we bear a greater responsibility for its future.

Will we be able to sustain our creative energy, the fuel we need, to transform our reaction to the horror of September 11 at a new level of civic consciousness for the world? Or, better still, how will we sustain our new civic-mindedness as events lead us farther and farther from "Ground Zero"? Our quantum civics leadership paradigm provides a starting point. From there each of us can work locally to help build a global civic society with the capacity to learn from that awful tragedy. What it takes, above all, is awareness that we can create a future for all humanity that leads us to a higher and better place than where we were headed before it happened.

The world is run on voluntary action, as September 11 showed. More importantly, the world is guided by voluntary leadership, as the aftermath of September 11 has demonstrated. Now, our challenge is to take that lesson to heart in our voluntary associations and organizations in America and around the world.

OUTLOOK FOR THE FUTURE

Camden Gould

Institutional reputation
 great, not growing

Draining energy

Based in academia

Started fast;
 finished exhausted

More perilous future

Jacqueline Hope

Institutional reputation
 growing, not great

On a roll

Based in community

Started slow;
 finished strong

More promising future

BIBLIOGRAPHY

Appley, Lawrence A. *Formula for Success: A Core Concept of Management.* New York: AMACOM, 1974.

Babbie, Earl. *You Can Make A Difference: The Heroic Potential Within Us All.* Anaheim Hills, California: Opening Books, 1985.

Bak, Per. *How Nature Works: The Science of Self-Organized Criticality.* New York: Copernicus, 1996.

Bellah, Robert N. and Associates. *Habits of the Heart: Individualism and Commitment in American Life.* New York: Perennial Library, 1985.

Bennis, Warren and Nanus, Burt. *Leaders: The Strategies for Taking Charge.* New York: HarperPerrenial, 1985.

Berg, Paul and Singer, Maxine. *Dealing With Genes: The Language of Heredity.* Mill Valley, California: University Science Books, 1992.

Bodanis, David. *E=mc²: A Biography of the World's Most Famous Equation.* New York: Walker & Company, 2000.

Burns, James MacGregor. *Leadership.* New York: Harper & Row, 1978.

Calder, Nigel. *Einstein's Universe.* New York: Greenwich House, 1979.

Capra, Fritjof. *The Web of Life: A New Scientific Understanding of Living Systems.* New York: Anchor Books, 1996.

Carlson, Richard. *Don't Worry, Make Money: Spiritual and Practical Ways to Create Abundance and More Fun in Your Life.* New York: Hyperion, 1997.

Cheshire, Richard D. "Philanthropy in the New Economy: The Quantum Civics Paradigm of Leadership." *The Nonprofit Handbook: Fund Raising.* Third Edition. New York: John Wiley & Sons, 2001. 401–423.

Chopra, Deepak. *Quantum Healing: Exploring the Frontiers of Mind/Body Medicine.* New York: Bantum, 1989.

Cole, K.C. *First You Build a Cloud: And Other Reflections on Physics as a Way of Life.* San Diego: Harcourt Brace & Company, 1999.

Collins, Dennis A. and Bollman, Nick. *California Regions Take Action: The Emergence of California Civic Entrepreneurs.* San Francisco: The James Irvine Foundation, 1998.

Cruikshank, Jeffrey L. and Sicilia, David B. *The Engine That Could: 75 Years of Values-Driven Change at Cummings Engine Company*. Boston: Harvard Business School Press, 1997.

De Geus, Arie. *The Living Company: Habits for Survival in a Turbulent Business Environment*. Boston: Harvard Business School Press, 1997.

Drucker, Peter F. "What Business Can Learn From Nonprofits." *Harvard Business Review*, July/August, 1989.

Drucker, Peter F. *Managing the Non-profit Organization: Principles and Practices*. New York: Harper Collins, 1990.

Drucker, Peter F. *Post-Capitalist Society*. New York: Harper Business, 1993.

Drucker, Peter F. *The Five Most Important Questions You Will Ever Ask About Your Nonprofit Organization*: Participant Workbook. San Francisco: Jossey-Bass, 1993.

Farson, Richard. *Management of the Absurd: Paradoxes in Leadership*. New York: Simon & Schuster, 1996.

Ferris, Timothy. *Coming of Age in the Milky Way*. New York: Anchor Books, 1988.

Folsing, Albrecht. *Albert Einstein: A Biography*. New York: Viking Press, 1997.

Frantzreb, Arthur C. *Not on This Board You Don't: Making Your Trustees More Effective*. Chicago: Bonus Books, 1997.

Friedman, Edwin. *Reinventing Leadership*. New York: Guilford Publications, 1996.

Fritzsch, Harald. *An Equation That Changed the World: Newton, Einstein, and the Theory of Relativity*. Chicago: The University of Chicago Press, 1994.

Fukuyama, Francis. *Trust: The Social Virtues and the Creation of Prosperity*. New York: The Free Press, 1995.

Gardner, John W. "The Antileadership Vaccine." *Annual Report of 1965 Carnegie Corporation of New York*. New York: Carnegie Corporation, 1965.

Gates, Bill. *Business @ The Speed of Thought: Using a Digital Nervous System*. New York: Warner Books, 1999.

Gazzaniga, Michael. *The Mind's Past*. Berkeley: University of California Press, 1998.

Gleick, James. *Chaos: Making a New Science*. New York: Penguin Books, 1988.

Greenleaf, Robert K. *The Servant as Leader.* Indianapolis: The Robert K. Greenleaf Center, 1991.

Guzman, Patrick S. "Accountability for Leadership Volunteers." *The Nonprofit Handbook: Fund Raising.* Third Edition. New York: John Wiley & Sons, 2001. 424–435.

Henton, Douglas; Melville, John; and Walesh, Kimberly. *Grassroots Leaders for a New Economy: How Civic Entrepreneurs Are Building Prosperous Communities.* San Francisco: Jossey-Bass, 1997.

Herbert, Nick. *Quantum Reality: Beyond the New Physics.* New York: Anchor Books, 1985.

James, William. *Pragmatism.* Amherst, N.Y.: Prometheus Books, 1991.

Jaworski, Joseph. *Synchronicity: The Inner Path of Leadership.* San Francisco: Berrett-Koehler, 1996.

Kaku, Michio. *Hyperspace: A Scientific Odyssey Through Parallel Universes, Time Warps, and the 10th Dimension.* New York: Anchor Books, 1995.

Kaku, Michio. *Visions: How Science Will Revolutionize the 21st Century.* New York: Anchor Books Doubleday, 1997.

Kotkin, Joel. *Orange County: The Fate of a Post-Suburban Paradise.* Claremont, California: La Jolla Institute, 1997.

Land, George and Jarman, Beth. *Breakpoint and Beyond: Mastering the Future Today.* New York: HarperCollins, 1992.

Lederman, Leon with Teresi, Dick. *The God Particle: If the Universe Is the Answer, What Is the Question?* New York: Delta, 1993.

Luttwak, Edward N. *Strategy: The Logic of War and Peace.* Cambridge, Massachusetts: The Belknap Press of Harvard University Press, 1987.

Mapes, James J. *Quantum Leap Thinking: An Owner's Guide to the Mind.* Beverly Hills, CA: Dove Books, 1996.

Martin, Mike W. *Virtuous Giving: Philanthropy, Voluntary Service, and Caring.* Bloomington & Indianapolis: Indiana University Press, 1994.

Nadeau, Robert and Kafatos, Menas. *The Non-Local Universe: The New Physics and Matters of the Mind.* New York: Oxford University Press, 1999.

Nanus, Burt. *Visionary Leadership: Creating a Compelling Sense of Direction for your Organization.* San Francisco: Jossey-Bass, 1992.

Nanus, Burt and Dodds, Stephen M. *Leaders Who Make a Difference: Essential Strategies for Meeting the Nonprofit Challenge.* San Francisco: Jossey-Bass, 1999.

Oshry, Barry. *Seeing Systems: Unlocking the Mysteries of Organizational Life.* San Francisco: Berrett-Koehler, 1995.

Pagels, Heinz R. *The Cosmic Code: Quantum Physics as the Language of Nature.* New York: Simon & Schuster, 1982.

Pearsall, Paul. *The Heart's Code: Tapping the Wisdom and Power of Our Heart Energy.* New York: Broadway Books, 1998.

Peat, F. David. *Infinite Potential: The Life and Times of David Bohm.* Reading, Massachusetts: Addison Wesley, 1997.

Peirce, Neal and Johnson, Curtis. *Boundary Crossers: Community Leadership for a Global Age.* College Park, MD: University of Maryland James MacGregor Burns Academy of Leadership, 1998.

Peterson, Eric and Smith, Anthony. "The Seven Revolutions: Toward a World of Peril or Promise?" Presentation of the *Center for Strategic & International Studies* at Chapman University, October 1, 1996.

Pinchot III, Gifford. *Intrapreneuring: Why You Don't Have to Leave the Corporation to Become an Entrepreneur.* New York: Harper & Row, 1985.

Prigogine, Ilya. *The End of Certainty: Time, Chaos, and the New Laws of Nature.* New York: The Free Press, 1996.

Provenzano, Joseph P. *The Philosophy of Conscious Energy: Answers to the Ultimate Questions.* Nashville: Winston-Derek, 1993.

Rosenberg, Jr., Claude. *Wealthy and Wise: How You and America Can Get the Most out of Your Giving.* Boston: Little, Brown & Company, 1994.

Salamon, Lester M. and Anheier, Helmut K. *The Emerging Sector: An Overview.* Baltimore: Johns Hopkins University Institute for Policy Studies, 1994.

Schad, Jerry. *Physical Science: A Unified Approach.* Pacific Grove, CA: Brooks/Cole Publishing, 1996.

Schrodinger, Erwin. *What Is Life? The Physical Aspect of the Living Cell.* Cambridge, England, U.K.: Cambridge University Press, 1967.

Senge, Peter M. *The Fifth Discipline: The Art and Practice of the Learning Organization.* New York: Currency Doubleday, 1990.

Shakespeare, William. *The Complete Works of William Shakespeare.* Garden City, New York: Doubleday, 1936.

Snow, C. P. *The Two Cultures and the Scientific Revolution.* New York: Cambridge University Press, 1961.

Talbot, Michael. *The Holographic Universe.* New York: HarperPerrenial, 1992.

Talbot, Michael. *Beyond the Quantum.* New York: Bantam Books, 1988.

Teilhard de Chardin, Pierre. *The Phenomenon of Man.* New York: Harper Torchbooks, 1961.

Wheatley, Margaret J. *Leadership and the New Science: Discovering Order in a Chaotic World, Second Edition.* San Francisco: Berrett-Koehler, 1999.

Wilson, Edward O. *Consilience: The Unity of Knowledge.* New York: Alfred A. Knopf, 1998.

Wolf, Fred Alan. *Taking the Quantum Leap: The Physics for Non-scientists.* New York: Harper & Row, 1981.

Youngblood, Mark. *Life at the Edge of Chaos: Creating the Quantum Organization.* Dallas: Perceval, 1997.

Zohar, Danah. *The Quantum Self: Human Nature and Consciousness Defined by the New Physics.* New York: Quill/William Morrow, 1990.

Zohar, Danah and Marshall, Ian. *The Quantum Society: Mind, Physics, and a New Social Vision.* New York: Quill/William Morrow, 1994.

Zohar, Danah. *Rewiring the Corporate Brain: Using the New Science to Rethink How We Structure and Lead Organizations.* San Francisco: Berrett-Koehler, 1997.

INDEX

THE AUTHOR

Dick Cheshire is director of the Institute for Voluntary Leadership having recently retired as professor of organizational leadership and director of the Center for Nonprofit Leadership at Chapman University in Orange, California. He is a former president of the University of Tampa, executive director of the Shakespeare Globe Centre of North America, president of the New Jersey Shakespeare Festival, as well as chief development officer for the Center for Strategic & International Studies, Chapman University, Colgate University, Dickinson College, and Drew University. He helped lead campaigns that raised the equivalent of half a billion dollars over forty years, and has consulted or volunteered with many national, state, and local nonprofits.

He received a bachelor's degree from Colgate University, a master's degree from the University of New Hampshire, and his doctor's degree from New York University. He and his wife Bobbie divide their time between Anaheim Hills, California, and Hamilton, New York. They have three children and six grandchildren.